OF TIME

AND PLACE

American Figurative Art from the Corcoran Gallery

Essays by
Edward J. Nygren and Peter C. Marzio

Catalogue entries by
Julie R. Myers
with the assistance of Edward J. Nygren

Published by the
Smithsonian Institution Traveling
Exhibition Service
and the
Corcoran Gallery of Art

Coordinated by Andrea Stevens

Edited by Diana Menkes

Designed by Beveridge and Associates, Inc.

Printed by Garamond/Pridemark Press, Inc.

Composed by Carver Photocomposition, Inc.

SITES is a program activity of the Smithsonian Institution that organizes and circulates exhibitions on art, history and science to institutions in the United States and abroad.

This exhibition was supported in part by the National Endowment for the Arts, a Federal agency, Washington, D.C.

Front cover: George Bellows, *Forty-two Kids,* 1907 (Cat. No. 30)

Back cover: Abastenia St. Leger Eberle, *Girls Dancing,* 1907 (Cat. No. 31)

Library of Congress Cataloging in Publication Data

Corcoran Gallery of Art.
 Of time and place.

 Bibliography: p. 192
 Includes index.
 1. Figurative art—United States—Exhibitions.
2. Art, Modern—19th century—United States—
Exhibitions. 3. Art, Modern 20th century—
United States—Exhibitions. 4. Humans in art—
Exhibitions. 5. Genre (Art)—United States—
Exhibitions. 6. Corcoran Gallery of Art—Exhibi-
tions. I. Nygren, Edward J. II. Myers, Julie R.
III. Marzio, Peter C. IV. Smithsonian Institution.
Traveling Exhibition Service. V. Title.
N6510.C69 1981 704.9'42'0973074013 81-607836
ISBN 0-86528-010-X AACR2

Contents

Acknowledgements

The outstanding collections of American art at the Corcoran Gallery provided the inspiration for this, our first cooperative exhibition, with the knowledge that many people throughout the country would share the visual riches of this museum.

Seventy-five objects in "Of Time and Place" present not only a diversity of stylistic approaches to the depiction of the figure, but also serve as documents of American social history. By focusing on genre themes, ordinary people involved in everyday activities, a deeper understanding of our cultural history emerges. Not only are details of costume, furnishings, and locale recorded, but the evolving ideals and social concerns of America are likewise documented.

Edward J. Nygren, Curator of Collections at the Corcoran Gallery of Art, superbly guided the concept, selection, and interpretation of the exhibition. His sensitivity to the material and concern with all aspects of its presentation have made the organization of this exhibition most rewarding. Peter Marzio, Director of the Corcoran, has provided substantial and critical support to this project. Our efforts have also been greatly facilitated by the assistance of Cathy Card, Administrative Officer; Judy Riley, Registrar; and Lynn Berg, Assistant Registrar, Corcoran Gallery of Art. Special thanks go to Julie Myers for her extensive research on the objects in the exhibition and provocative catalogue statements. Julie has also been actively involved in the conceptualization and development of many aspects of the educational programming for "Of Time and Place."

The implementation of "Of Time and Place" has called upon a number of joint efforts. Special Smithsonian Institution Outreach Funds have enabled SITES (the Smithsonian Institution Traveling Exhibition Service), in conjunction with other Smithsonian Institution departments and the Corcoran Gallery, to generate substantial complementary programming for this exhibition. The Smithsonian's Office of Museum Programs is assisting with the organization and presentation of two outreach seminars on exhibition interpretation for museum professionals, which will be held at the Corcoran Gallery of Art and the San Diego Museum of Art. Jane Glaser, Program Manager, and Nancy Welch, Program Coordinator, have been most helpful in these efforts. Janet Solinger, Director, Smithsonian Associates, has lent vital support to the development of related activities in the form of lectures, a symposium, film series, and workshops, which will be sponsored with the showing of "Of Time and Place" in Washington. Resident Associate Program Coordinators Carol Malmi, Alice Spencer, and Tina Parker have lent substantial assistance with these aspects. At SITES, the coordination and development of these extensive outreach efforts have been made possible through the enthusiasm and attention of Marjorie Share, Head of Education, and Deborah Lerme, Education Coordinator. Barbara Moore, Curator of Education, Corcoran Gallery of Art, has also provided superb expertise and constant encouragement and support. The exhibition coordinator of SITES, whose academic and administrative capabilities facilitated the over-all coordination of the many parts mentioned was Janice Driesbach. Anne Gossett, Assistant Director for Exhibition Development, brought her valuable experience and resources to the advanced stages of planning for the exhibition and to the implementation of its tour. To Jan, Anne, and to all SITES colleagues and friends, we extend our congratulations and sincere thanks.

Peggy A. Loar
Director, SITES

Preface

The catalyst for this exhibition was the Corcoran collection itself. Although individual works such as William Sidney Mount's *The Long Story,* Thomas Eakins' *The Pathetic Song,* and George Bellows' *Forty-two Kids* are textbook paintings familiar to the casual student of American art, generally speaking the Gallery's figurative pieces are less well known than its outstanding nineteenth-century landscapes. This exhibition allows the Corcoran to focus attention on this somewhat overlooked aspect of its collection and to study seventy-five works in depth.

Certain overriding concerns affected the choice of objects. From the outset it was decided that all media should be represented (paintings, sculpture, drawings, prints, photographs) and that the images should deal only with life in America. Because of the desire to have as wide a chronological range as possible, no one time period could outweigh another in number of objects, and redundancy in subject matter was avoided. The selection was also limited by the collection itself and does not try to survey American figurative art.

The initial selection was made more than two years ago with the aid of two graduate summer interns: Patricia Thompson and Andrea C. Wei. These women contributed substantially to the initial plans for the exhibition and also did some preliminary work on several objects selected. It is Julie Myers, however, who deserves the major credit for researching most of the pieces in the exhibition and for writing the enlightening commentaries. She has pursued this task untiringly over the past year with incredible results. Her findings will, I think, contribute significantly to our appreciation of these art objects as cultural artifacts.

Among the organizations whose resources have facilitated research on the works and artists are the library of the National Museum of American Art and the Archives of American Art. The staffs of these institutions deserve recognition for their assistance and cooperation.

Scholars who have contributed information on specific works have been acknowledged in individual entries; however, I want to express here my gratitude to the many curators at the National Museum of American History who have discussed a variety of points with me, especially Rodris Roth and Anne Golovin. Ms. Myers wishes to thank Susan Hobbs, Visiting Scholar at the National Museum of American Art, for freely sharing her thoughts on certain ideas and themes covered in the exhibition.

A number of works were restored for the exhibition. Robert S. Wiles and his assistant, Elizabeth Gould, treated paintings, and Donald Etherington, works on paper. Fern Bleckner, of the Corcoran, also deserves a special note of thanks for her work with the drawings, prints, and photographs.

Many staff members of the Gallery contributed to the exhibition and catalogue. Special thanks are due Lynn Kahler Berg, Assistant Registrar, for overseeing photography and coordinating the exhibition; Elizabeth Punsalan and Adrianne Humphrey for their assistance on checking many details; Katherine Kovacs, Archivist, for information on artists and works; and Barbara Moore and her staff for work on labels and complementary materials.

I would especially like to thank Janice Driesbach of the Smithsonian Institution Traveling Exhibition Service, who served as gadfly and guardian angel of the project, for her patience, understanding, and advice. Finally, I am grateful to Diana Menkes for sensitive editing of essays and entries.

The exhibition and catalogue would not have been possible without a grant from the National Endowment for the Arts and the support of the Smithsonian Institution Traveling Exhibition Service. Through the help of these organizations the Corcoran was able not only to take a new look at works from its collection, but share its riches with other museums in the country.

Edward J. Nygren
Curator of Collections
Corcoran Gallery of Art

American Genre: Its Changing Form and Content

Edward J. Nygren

In America representation of the human figure has been a major artistic concern for over three hundred years. Although initially this interest was almost exclusively limited to portraiture, in the late eighteenth century the range of figurative art was extended, and throughout the nineteenth it ranked with landscape as a major form of artistic expression. In this century the importance of figurative art has fluctuated since the famous Armory Show of 1913 and the advent of abstraction in the United States. With the recent revival of realism has come renewed interest in the human form as subject matter.

Figurative art can be divided into several broad categories: history painting, portraiture, decorative figure pieces, imaginary images, and scenes from everyday life. Although the distinctions between these categories are not always clear, this exhibition is concerned primarily with the last group, which—since the mid-nineteenth century—has been referred to as *genre*.[1]

The focus on scenes from everyday life has both its strengths and its weaknesses. On the plus side, the viewer can quickly assimilate what is depicted and place the image within a familiar historical context. The particular activities, architecture, decoration, and fashion document when the work was created, reveal something about the life of a given time and place, and establish the class of the people portrayed. On the other hand, because the content is so accessible, the viewer may not go beyond what is readily apparent to seek additional levels of meaning. For example, *Leisure and Labor* (Fig. 1) by Frank Blackwell Mayer is ostensibly an accurate record of a blacksmith shop in rural Maryland in mid-nineteenth century. As such it has a certain charm and historic interest. The viewer may even relate the subject to contemporaneous treatments of horse-shoeing scenes by European artists such as Géricault.[2] A

Fig. 1. Frank Blackwell Mayer, Leisure and Labor *(Cat. No. 6).*

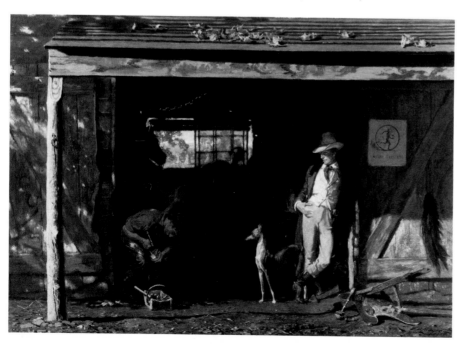

closer look at Mayer's painting will, however, reveal that it alludes to the transient nature of life and the rewards of hard work. The fact that the painting is a variation on Aesop's fable of the ant and the grasshopper may be lost on the modern viewer unfamiliar with moral precepts common in Mayer's day.

Realistic depictions consciously or unconsciously incorporate the attitudes and concerns, myths and aspirations of a society, as well as reproduce the minutiae of time and place. Thus cultural and social preconceptions need to be explored when reconstructing the meaning of a work to the artist and, by extension, to the society that created it. It is also important to remember when considering works as historical documents that what artists neglected to portray is equally significant in determining how they saw themselves and America. Therefore, the human element may facilitate the viewer's associative response to the images presented, but it does not necessarily make figurative art easier to understand than abstract art.

"Of Time and Place" includes only works that treat the fabric of American life: human beings in real or seemingly real places, interacting with their environment. Missing are historical, literary, and European subjects, as well as portraiture and the abstracted treatments of the figure which occur in so much modernist art. It is their involvement with the particular, the immediate, the contemporary, as related to America, that links the objects chosen. Those qualities fix each piece firmly within a specific time and place. While this approach excludes, by definition, major categories of artistic expression involving the human figure, it is hoped that the works included provide insight into the dynamic nature of American art and life.

Introduction

The emergence of genre as an important art form in the early nineteenth century was made possible by an aesthetic shift away from an idealized treatment of nature and man to a more accurate rendering of specific details. This shift undermined the hierarchical view of art that had dominated Western European painting since the seventeenth century. The development of genre in America was an extension of the European revival of this art form, with local themes and figural types to give the works a distinctive American flavor and to express the burgeoning pride of the young nation. Although examples of scenes from everyday life can be found in American art prior to the end of the eighteenth century, it was not until the later 1790s and early 1800s that works that can be classified as genre began to be created. By the 1830s it was a well-established art form. Some contemporary writers saw genre as more expressive of the American spirit than landscape, but both modes of expression contributed significantly to the development of a national identity by recording the regional variations in geography and customs.

Like most types of artistic expression in the young United States, genre was derivative in subject matter and form. Initially the British influence was dominant, as it was in the cultural, political, economic, and social life of the new country, whose population was mainly Anglo-Saxon. The earliest practitioners of genre had come from England, had studied there, or had seen engravings after such late-eighteenth-century British artists as George Morland, Francis Wheatley, W. R. Bigg, and James Ward.[3] The sentimental subjects treated by these artists, sometimes in serial compositions, were creations of the imagination rather than paintings from life. As such they were referred to as "fancy" pictures; that is, they were products of the artist's fancy. Stressing such homely bourgeois virtues as obedience, fortitude, abstinence, and hard work, these moralizing images project an air of sober earnestness. Designed to be engraved and intended for a middle-class audience, they portray ordinary people with whom the potential purchaser could identify. This emphasis on the common man and his limitations differentiates genre from the noble subjects and elevating sentiments of a history painting.[4] Although genre usually depicted contemporary scenes,[5] the figures were in fact idealized or generalized in accordance with the aesthetic dictates of the time.

The British influence extended through the first two decades of the nineteenth century. For example, the debt of John Lewis Krimmel, one of the first American painters of genre subjects, to the innovative work of the young Scottish artist David Wilkie is well known, and the impact of Wilkie on subsequent artists such as William Sidney Mount (Cat. No. 2) and George Caleb Bingham (Cat. No. 5) is also demonstrable. In this exhibition, the earliest example of British influence occurs in *Mishap at the Ford* by Alvan Fisher (Cat. No. 1). At that time, American art in general was essentially a provincial echo of British art, and Fisher's work, which places a humorous incident within a picturesque landscape, is a case in point.

In the second quarter of the nineteenth century, American artists turned to genre subjects in earnest. By then the young nation, whose frontiers now extended from the Atlantic to the Pacific and from Canada to the Gulf of Mexico, was one of the largest countries in the world. The visual arts reflected the resultant growth in national pride. History painting treated important events of the past as well as subjects from American literature. Landscape

painting glorified the land and showed America to be the recipient of God's beneficence. A hundred years before, Dean Berkeley had predicted America's future greatness, and educated Americans must have felt the country was on the brink of realizing his prophesy.[6]

If landscape painting made manifest the physical potential of America, genre championed the wholesome virtues of its population and the benefits of its democratic system. As James Jackson Jarves observed in *The Art-Idea* when discussing the growth of genre painting in America:

Any art which bases itself upon the purer instincts of humanity at large, such as a healthful enjoyment of nature, domestic love, and the sentiments and passions that dignify the human race, holding fast the great principle of elevating the entire people to the full stature of manhood, such an art is, in virtue of its birthright, essentially democratic.[7]

American genre of the pre–Civil War period is replete with images that convey the blessings of a democratic society—images that were widely disseminated as illustrations in periodicals and as engravings for sale to the public or to members of art associations (Cat. Nos. 3, 5). There are scenes of the healthy yeoman tilling the soil and taking delight in music, country dances, and friendly political argument; scenes of his innocent children romping barefoot in green fields, fishing in sparkling streams, sledding on snowy hills; scenes of his unaffected wife sewing, cooking, and caring for family and home. While paintings depicting the dangers of a frontier society were not uncommon, there was nothing like the socially conscious European pictures prompted by the upheavals of 1830 and 1848. America had its problems, as the Civil War would demonstrate, but its artists generally ignored these issues except in caricatures (Cat. No. 11). They took pride in their country's form of government, its material well-being, and its supposedly classless society.

The artists portrayed America as a land of limitless opportunity and promoted the concept that all men are created equal. They showed Americans as robust, good-humored, natural folk, while focusing mainly on the rural majority in the population. What emerged was a view of agrarian America as a modern Eden where, despite rough living conditions, labor was never backbreaking and people enjoyed the simple pleasures of life. The artists also showed a male population heady with the process of democracy: politics was a frequent theme in American art, particularly the grass-roots politics of rural America such as depicted in Alfred Jacob Miller's *Election Scene* and Bingham's *County Election* (Cat. Nos. 8, 5). Even when a work such as Bingham's is tinged with criticism of the system,[8] good humor exudes from every smiling face and proclaims the joys of living in a society where every man's vote ostensibly counts. This myth, of course, persists till this day, and the images created by Mount, Bingham, and Miller more than a century ago still epitomize for many the American way.

Fig. 2. William Sidney Mount, The Long Story *(Cat. No. 2).*

American Eclecticism

For most of its history, American art has been marked by eclecticism. The practice of borrowing from the art of the past has been a conspicuous feature of Western art since the Renaissance and came into wide acceptance in the late eighteenth century. The composite nature of America's population and the absence of a unique national culture made eclecticism a recognized characteristic of artistic expression in the United States in the nineteenth century.

Sources of inspiration and influence were extremely varied. Waves of immigration brought new cultural impulses, but there were also many direct and indirect contacts with European art. It is difficult, for example, to assess the impact on American artists of European works and aesthetic ideas available through prints and publications. Moreover, the proliferation in the 1840s and 1850s of art dealers specializing in European art and of exhibitions showing foreign works contributed to the dissemination of themes and styles. In addition, American artists in increasing numbers

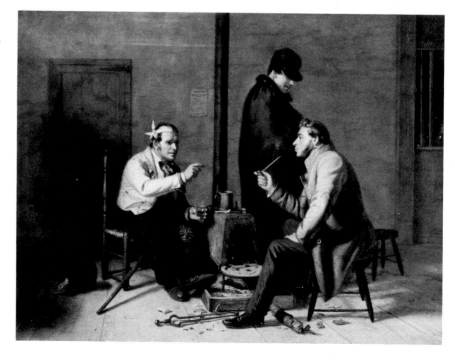

traveled abroad for training. In the process they studied the Old Masters and also came in contact with contemporary artists and their theories. While some of the Americans remained in Europe, most returned home, bringing with them improved technical facility and new ideas which they then employed in the depiction of American scenes.

British art continued to exert an influence on American genre, but by mid-century the artistic sources were diverse. Starting in the early 1840s, Americans went to Dusseldorf, a German center for history and sentimental genre painting. Emanuel Leutze (Cat. No. 10) was among the first to make the trip, but other artists followed, including Eastman Johnson, Enoch Wood Perry, and George Caleb Bingham (Cat. Nos. 14, 15, 5). For a decade or more the Dusseldorf style, with its firm drawing, meticulous attention to detail, and ornamental use of color, was dominant in America—abetted in large measure by the establishment in New York in 1849 of the Dusseldorf Gallery. These characteristics are particularly apparent in Benjamin F. Reinhart's *An Evening Halt* (Cat. No. 13).

Although eclecticism was not just an American phenomenon, it did express the derivative nature of the young country's culture and its artistic aspirations. Borrowing the best from the art of other times and nations to forge a national style was expected, given America's lack of an artistic past. Beyond that, eclecticism was considered by some to be a positive factor in American society.[9] This view presumed artistic freedom of choice and implied a progressive view of art. Eclecticism is evident in the works of Bingham, Mount, Frank Blackwell Mayer, and John M. Stanley, all created within a few years of each other.

Although Mount's *The Long Story* (Fig. 2) owes a thematic debt to the work of David Wilkie, its format, painting style, and palette are derived from Dutch seventeenth-century art. In a letter to William Dunlap, Washington Allston had recommended that Mount look at the work of Jan Steen and

Adriaen van Ostade. *The Long Story,* painted a few years later, displays an awareness of the so-called Little Masters of Holland, whose work influenced the development of early-nineteenth-century genre painting in general, European as well as American. The Dutch flavor, evident in a number of Mount's paintings from this period, may have in this case been suggested by Robert Gilmor of Baltimore, who commissioned the piece and owned several seventeenth-century Dutch genre scenes. Like its Dutch prototypes—*The Lesson* by Frans van Mieris the Elder (Fig. 3) is a typical example—Mount's work is small in scale, executed on a panel, and highly finished. The firmly drawn figures, strongly lighted from the left and silhouetted against a neutral background, are arranged in a shallow space suggestive of a stage set, thus reinforcing the dramatic narrative quality of the composition.

Fig. 3. *Frans van Mieris the Elder (1613–1675),* The Lesson, *n.d., oil on panel, 13½ x 15¾ in. (34.3 x 40 cm). Corcoran Gallery of Art, bequest of William A. Clark.*

Mount, like the Dutch Masters, minimized the inherent properties of the painting medium by blending the pigments to achieve an imperceptible modeling. Because of this, the technique is quite distinct from that found in Mayer's *Leisure and Labor* (Fig. 1), where the evident brushwork and high coloring add visual excitement to the painting and give it a freshness and spontaneity not found in the studied composition and tight execution of Mount's piece. Mayer's sketchy style and bright palette suggest that the artist had a knowledge of contemporary French art.

Although *The Long Story* and *Leisure and Labor* differ stylistically, they share certain characteristics. Anecdotal in content and small in size, both paintings are rigidly composed; the rear wall of the room in the former and the front of the building in the latter are parallel to the picture plane; the *dramatis personae,* arranged in a triangular friezelike composition, occupy center stage; and the human action is framed by architectural elements. These qualities exist in seventeenth-century Dutch interiors, and some are also present in contemporary works such as Stanley's *The Dis-*

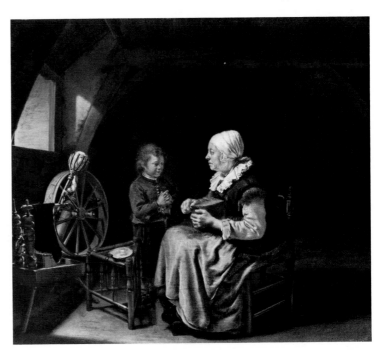

9

puted Shot (Cat. No.7). Bingham's and Miller's election scenes (Cat. Nos. 5, 8), because of their outdoor settings and exciting subject matter, employ more dynamic compositions.

The pre–Civil War painter of genre subjects assumes the role of raconteur or moralist. The compositions frequently suggest that the artist was an observer of the scene, and they encourage the viewer to assume a similar relationship to the action depicted. The tone is usually one of detachment. The artist (and his surrogate, the viewer) maintains an ambivalent position to the

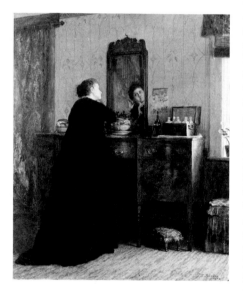

Fig. 4. Eastman Johnson, The Toilet *(Cat. No. 14).*

characters portrayed; he identifies with them yet is removed from them. This effect is an integral part of the Nathaniel Currier print *Shakers near Lebanon* (Cat. No. 3), in which the viewer becomes a member of the audience depicted.

Genre pieces from this period have other qualities in common. First, they usually involve two or more people interacting. Pictures of solitary figures occur, but even then man is presented as a social creature, and artistic interest focuses on external incidents. Second, the subjects are anecdotal if not narrative in content. When a story is not actually told, a specific moment in an incident, event, or activity is depicted. This moment often seems static because of the stylized gestures that give a context for the arrested action. Third, the scenes are usually views of rural or frontier life. Henry T. Tuckerman observed in *Book of the Artists* that "there is nothing in this life of our cities which may be deemed original," and artists such as Mount and Bingham undoubtedly shared his view that "it is in our border life alone that we can find the materials for national development."[10] Stanley's *The Disputed Shot* (Cat. No. 7) and Seth Eastman's *Lacrosse Playing among the Sioux Indians* (Cat. No. 4) both faithfully record for posterity aspects of American life that were disappearing. This historical documentation is quite distinct from the nostalgia found in later treatments of similar subjects by Frederic Remington and A. Phimister Proctor (Cat. Nos. 26, 36) after the closing of the frontier at the end of the century. It should be noted, however, that the insistence that a national art be created through the recording of rural types and life was not solely an American phenomenon but rather was an artistic manifestation of nineteenth-century nationalist movements in general. Parallel developments had already taken place in literature and theater.

The fourth and perhaps most important quality shared by the genre pieces was the attempt to blend idealism and realism. Both realism and idealism have long traditions in Western art. Less

historic styles than artistic responses to the world, they became in the hands of seventeenth-century French academicians criteria for creating an artistic hierarchy that echoed the Great Chain of Being on which contemporary philosophers arranged all living things in an ascending order.[11] Because a realistic representation attempted to imitate accurately the details of nature, it was, throughout the eighteenth century, considered of lower artistic value than the ideal, which improved on corrupt nature by generalizing the particular. With the breakdown in the artistic hierarchy in the nineteenth century, realism achieved respectability; however, it was a realism tempered by idealism.

The dichotomy between the real and the ideal, between the imitation and generalization of nature, was central to American aesthetic theory of the nineteenth century.[12] As early as 1829, John Neal, an art critic, lamented that "there is not a landscape nor a portrait painter, who dares to paint what he sees, *as he* sees it. . . ."[13] Emerson, on the other hand, argued that the artist must follow ideal nature and eliminate the particular to arrive at a universal, timeless truth.[14] And Jarves discussed at some length "the two fundamental distinctions" that underlie art: Realism "applies to the portraiture of the external world, and partakes more or less of copying and imitation. It affects local and particular truths; is circumscribed in action and motive, inclines to inventories of things. . . . Idealism bases itself on universal truths. It deals more with emotions and ideas than facts and action. . . ."[15]

The attempt to blend idealism and realism is one of the underlying currents of nineteenth-century art. This attempt is especially evident in genre, which was intended to be both particular in appearance and universal in appeal. Tuckerman, for example, in praising the work of an American artist, quoted from an admiring letter: "It is a painting of an Italian child, so life-like that it must be a portrait, so intellectual that it cannot be a real face, just enough

idealized."[16] Because incidents and characters had to be universally understood, the setting was particularized through accurate details while the figures were visualizations of recognizable human types. The end result gave the appearance of being true to life but did not imitate life. In the final analysis, it was the idea behind the work, not observation, that determined the character of the piece.

Post–Civil War Realism

American genre in the second half of the nineteenth century is marked by a diversity in style, subject matter, and format which reflects a variety of artistic influences. Jarves gave credit to France for the growth in American interest in genre and expressed pleasure with "the development for something beside landscape,"[17] but the influences came from a number of other places also, including Italy, Holland, Belgium, England, and Germany. Aware of past achievements in this area, Jarves foresaw the imminent dawn of "a respectable school of *genre* and home painting," the latter referring to scenes of domestic life especially popular in Europe at the time. It was, however, the approach to a subject as much as the subject itself that separated the works of the second half of the century from those produced earlier.

The Civil War is generally considered a watershed for American art. While the war undoubtedly had a profound effect on the national psyche and provided artists with subjects (Cat. Nos. 9, 11, 12), the differences between post- and prewar art cannot be attributed solely to this traumatic episode in American history. Other factors, not least of which was increased contact with European artistic activity and thought, contributed significantly to the changes.

A new feature of post–Civil War genre is the solitary figure. Although humorous and social scenes continue, particularly in the realm of masculine activities, scenes of quiet reflection occur with great frequency, especially in paintings dealing with women.

Eastman Johnson's *The Toilet* (Fig. 4) is typical of this kind of subject, but Winslow Homer's *Woman Sewing* (Cat. No. 18) and Enoch Wood Perry's *Seated Young Lady, Writing* (Cat. No. 15) attest to the proliferation in the 1870s of artistic interest in the single female figure caught in a moment of reverie. The frequent portrayal of ladies in a variety of domestic settings may, as William Gerdts has suggested, reflect the compartmentalized life of the sexes as well as an increase in the number of women as artists and patrons.[18] However, the female figure is a traditional symbol of beauty, and in these works her introspection probably alludes to sensitivity as a desirable human trait in an increasingly aggressive, industrial culture.

The emergence of the solitary reflective contemporary woman as a major theme in European painting at mid-century was perhaps due in part to the rediscovery of Vermeer and to the fascination with Japanese prints, in which women frequently appear alone in domestic settings. Among the many European artists who treated the subject repeatedly was the Belgian Alfred Stevens (Fig. 5). His careful observations of women posed in actual interiors are almost photographic in their detail. Stevens, who spent most of his career in Paris, began to receive recognition for his pictures of women in modern settings in the mid-1850s. His success was probably not lost on Eastman Johnson, Enoch Wood Perry, Winslow Homer, and Thomas Eakins, all of whom were in Paris when Stevens was receiving critical acclaim and popular attention; and his work influenced the next generation of American artists, especially members of the Boston School such as Edmund Charles Tarbell and William Paxton (Cat. Nos. 32, 34).

Unlike the genre pictures of the previous period in which the artist assumed the compositional role of a detached observer, these intimate domestic scenes preclude the physical presence of the viewer, psychologically forcing him to become a kind of voyeur. The undetected intrusion on the privacy of an individual gives such works a slice-of-life quality quite distinct from the anecdotal compositions of Mount or Bingham. It also imparts an air of immediacy and objectivity that perhaps reflects the impact of photography on the pictorial arts.

It is well known that the advent of photography reduced the demand for portraiture and that photographic detail was a quality sought by certain portraitists. Works such as Johnson's *The Toilet* (Fig. 4) and Eakins' *The Pathetic Song* (Fig. 6) suggest that photography may have had a special impact on genre painting. Particularization of

Fig. 5. Alfred Stevens (1823–1906), Autumn Flowers, c. 1867, oil on canvas, 29½ x 21⅝ in. (74.9 x 55 cm). Courtesy Musées Royaux des Beaux-Arts de Belgique, Brussels.

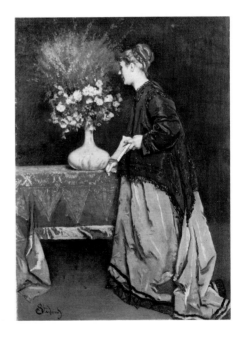

individuals, attention to incidental details, and depiction of seemingly arbitrary moments in inconsequential activities all may be painterly adaptations of photographic effects. The absence of prescribed gestures and moralizing anecdotes makes the compositions seem free of contrivance. The artists appear to have objectively recorded, like a camera, the visual facts, and as a result the subjects project a naïveté and freshness.

In *The Toilet* the sense of immediacy is further emphasized by the sketchy quality of the painting itself. The sketch was, at the time, just beginning to be admired by connoisseurs for the insight it gave into artistic creativity, and the seemingly unfinished work of art reflected this interest. While the rich brown glazes thinly applied over a light ground define the woman's robe in Johnson's painting and owe a debt to Rembrandt, they also have an *alla prima* freshness that is, in figurative art, the equivalent to *plein air* painting in landscape.

Johnson is a transitional figure between the earlier genre painting and the works produced in the last quarter of the nineteenth century. A student in Dusseldorf, The Hague, and Paris, his highly eclectic style reveals the diversity of his training. His subjects, taken from American life, were admired for their sincere sentiment. In some part this sincerity came from his recording the world he knew personally: his figures were observed with sympathy but dispassion. Unlike Mount, Johnson is less concerned with anecdote than with incident. His people are particularized; they appear to be portraits of individuals rather than characterizations of human qualities; they seem real because they have little symbolic meaning or narrative content; they are, in effect, only themselves. Nevertheless, a residual idealism pervades even the most naturalistic of Johnson's compositons. True to nature, the images still conform to an overriding theory of aesthetic beauty.

The photographic objectivity fleetingly expressed in Johnson's *The Toilet*

finds its ultimate statement in Eakins' *The Pathetic Song* (Fig. 6). The painting defies categorization: group portrait and genre piece, the ecstatic gaze of the singer also suggests the transcendant nature of music and art. The activity, while not as commonplace as that of

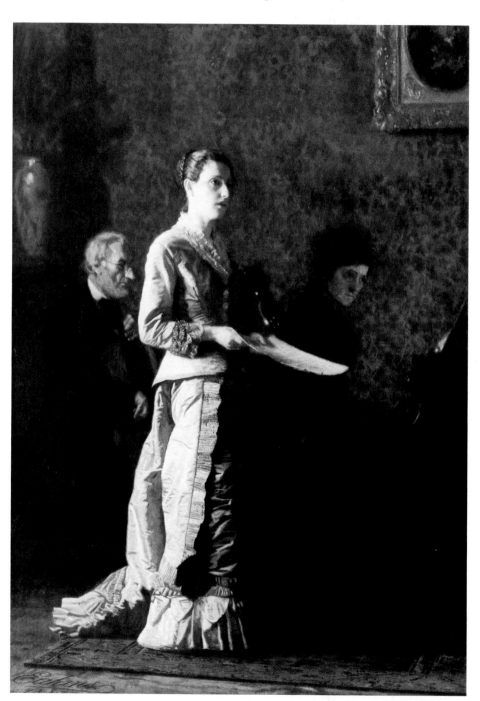

Fig. 6. Thomas Eakins, The Pathetic Song *(Cat. No. 21).*

fixing an earring, nevertheless conveys an accurate picture of the entertainments enjoyed by middle-class, educated Philadelphians in the closing decades of the nineteenth century. The solid detail reinforces the viewer's acceptance of the painting as a faithful record of a specific event at a particular time and place. While the exact rendering of the singer's anatomy points to Eakins' passion for scientific observation, the high degree of finish, the texture of the singer's dress, the softness of the secondary figures reinforce the picture's verisimilitude, underscore its optical reality, and invest it with a kind of photographic honesty. These features also reveal Eakins' academic training in Paris with Jean-Léon Gérôme and Léon Bonnat.

Among the other artists who studied with Bonnat, one of the leading academicians of his day, were Horace Bonham and Richard Norris Brooke (Cat. Nos. 17, 20). Brooke was particularly proud of his training and acknowledged his master in the inscription to the work. The large format of *A Pastoral Visit* (Fig. 7) identifies it as a salon painting; the blacks serve as American counterparts to European peasants found in works by artists such as Jules Breton and Josef Israëls (Fig. 8).

Bonham's more modest-sized painting of spectators at a cockfight shares with John George Brown's *Longshoremen's Noon* (Cat. No. 19) and Charles Ulrich's *In the Land of Promise* (Cat. No. 22) a thematic interest in America as the melting pot. All three display a range of ethnic types. Bonham goes further by presenting people drawn from various social classes, and the painting may, in fact, be more a political commentary than a representation of a sporting event. All three works also record in almost a photographic way the salient characteristics of their models and settings; yet none is a candid portrayal, for they all make reality conform to a thesis. Brown's remark in regard to another painting is equally relevant to *Longshoremen's Noon* and the work of his contemporaries: "I did precisely what a good reporter would have done. . . . I

did not copy them as they stood before me as models. I put J. G. Brown into them. And a good reporter in like manner would have put himself into them."[19] This view of the artist as a reporter or commentator rather than raconteur or moralist persisted well into

the twentieth century. It is not surprising that it came into prominence at a time when newspapers were becoming easily accessible to a growing literate population and when artists were frequently employed as illustrators for these periodicals.

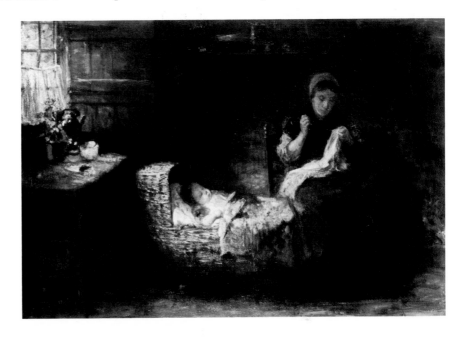

Fig. 8. *Josef Israëls (1824–1911),* Interior of a Cottage, *n.d., oil on canvas, 44¾ x 66¼ in. (113.2 x 168.4 cm). Corcoran Gallery of Art.*

Fig. 7. *Richard Norris Brooke,* A Pastoral Visit, Virginia *(Cat. No. 20).*

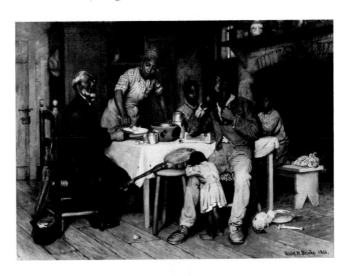

A series of international exhibitions, in Europe and America, in the last decades of the nineteenth century brought Americans into contact with contemporary European art. Art journals on both sides of the Atlantic disseminated images from these exhibitions as well as information on specific artists and artistic developments. It was during this period, as Michael Quick has pointed out in his study of expatriate artists, that American painters in increasing numbers settled in Europe and their works assumed, both in style and subject, a pronounced European flavor.[20] These artists contributed significantly to the growing acceptance of American art on an international level. Other artists such as Johnson and Eakins returned to America and devoted themselves to contemporary American themes. While they were undoubtedly aware of international artistic concerns, they did not distance themselves physically or psychologically from the American public nor did they objectify aesthetic theories by creating exotic images of people or situations foreign to the national experience.

Paris was a key artistic center of the period with its many ateliers and academies. But other places, especially Munich, attracted American students in the last quarter of the century. Toward the end of the 1870s, Charles Ulrich and Louis Charles Moeller (Cat. Nos. 22, 24) studied in Munich at a time when a meticulous style devoid of visible brushstrokes was in the ascendance.[21] The anecdotal element implicit in both their works was, however, old-fashioned. The elimination of content in favor of an art-for-art's-sake approach to the figure was fundamental to developments at the turn of the century.

The Beautiful and the Vulgar

The art-for-art's-sake aesthetic with its international flavor offered a welcome alternative to the parochialism of late-nineteenth-century realism; it also served as a target for the Urban Realists of the next generation. The paintings of Tarbell and Paxton and the sculpture of

Bessie Potter Vonnoh (Cat. Nos. 32, 34, 25) are unmistakably American in their glorification of young womanhood, but they are international in their concern for ideal beauty and playful allusions to the art of the past. Since the time of Winslow Homer and Eastman Johnson, the American female had been a major artistic theme. Deified by the end of the century in literature and art, she replaced the Indian maiden of the eighteenth century as a symbol for America. Charles Dana Gibson provided the most ubiquitous image of her in the self-confident "Gibson Girl" (Fig. 9), but she was recognized everywhere and accepted in polite society on both sides of the Atlantic. Samuel Isham, an art critic at the turn of the century, summarized upper-class American infatuation with this ideal:

They [the American people] *have no goddesses or saints, they have forgotten their legends, they do not read the poets, but something of what goddess, saint, or heroine represented to other races they find in the idealization of their womankind. They will have their idealization decorous; there is no room for the note of unrestrained passion, still less for sensuality. It is the grace of children, the tenderness of motherhood, the beauty and purity of young girls which they demand, but especially the last. The American girl is placed upon a pedestal and each offers worship according to his abilities, the artist among the rest. . . .*[22]

While Tarbell and Vonnoh did not idealize their women as much as Abbott Thayer and George de Forest Brush, for example, they clearly enjoyed representing this paragon of national virtues; for the young woman, like the art in which she appeared, was spiritually and physically removed from the aggressive industrial society that created her.

The delight in pure form, beautifully rendered, evident in these works was as satisfying as the subject matter. Abstract concepts of grace and ideal beauty, according to the dictates of the time, transcended particular truths. As Isham pointedly observed: "the tendency has been to make a thing of

beauty rather than to give one 'true truth.' Not only the artists but their patrons preferred it so. The American man finds enough of prose in the day's work. . . . he demands that art shall do its duty in furnishing delight. . . . he wants his pictures beautiful or at least pretty."[23] The genteel subject matter combined with technical facility must have delighted artist and patron alike. Free of any trace of cultural inferiority, the works exude an artistic confidence that mirrored America's optimistic view of its society.

Just about the time that Isham was writing rapturously about America's goddess and commenting on the American male's desire for beauty rather than prose in his art, the art-for-art's-sake aesthetic was being challenged by a young group of painters centering on Robert Henri. Unlike the artists Isham praised, Henri felt life and art could not be separated.[24] His circle, which included John Sloan, George Luks, William Glackens, George Bellows, Edward Hopper and others (Cat. Nos. 41, 46, 30, 39), revitalized the realist tradition by turning away from the rarefied atmosphere of elegant summer resorts and upper-class houses to the proletariat of America's largest city. New York's working-class girl replaced Gibson's as their symbol of America; the city with its burgeoning population spoke of the self-renewing dynamic nature of American society.

Although the subject matter was exuberantly American and had no European counterpart, the members of the so-called Ash Can School owed as profound a debt to European art as their opponents. Henri had studied for several years in Paris, and he and Glackens both enjoyed extended stays in France. His bold brushwork and dark palette were adaptations from Hals and Manet. Henri championed the quick sketch, a teaching device he had learned in France, and urged his students to work rapidly and from memory; he looked upon observation as mere data gathering.[25] These techniques, when successful, give the works spontaneity: the figures do not seem static or rigidly

composed; their dynamic movement is expressed by the application of the pigment. The techniques also insured that the paintings were not objective records of the period (this could be more readily achieved with the camera) but rather subjective expressions of the artist's opinions and feelings.

Henri with his passion for relevancy almost seems to have rediscovered for himself Baudelaire's *la vie moderne* and Courbet's living art:

. . . there is only one reason for the development of art in America, and that is that the people of America learn the means of expressing themselves in their own time and in their own land. In this country we have no need of art as culture; no need of art as a refined and elegant performance; no need of art for poetry's sake, or any of these things for their own sake. What we do need is art that expresses the spirit *of the people of today.*[26]

He urged his disciples to be historical painters of their own time; to treat only those subjects they knew personally; to record the manners and customs within their own experience.[27] But he made it clear that the artist was not to copy na-ture: "A work of art is not a copy of things. It is inspired by nature but must not be a copying of the surface."[28]

While Henri's attitude does not seem verbally at odds with older views regarding the generalization of nature, in practice it was quite different. The fundamental gap between Henri and the painters he spurned was in the conception of beauty. Scenes of lower-class life were ugly and vulgar to the proponents of ideal beauty, who considered that the purpose of art was to elevate public taste, which depictions of common people could never do. Unlike his opponents, Henri stressed that it was not the subject which determined that a work was beautiful: "The subject can be as it may, beautiful or ugly. The beauty of the work of art was in the art itself."[29] Art was to be true to life, not true to some ideal or preconception of beauty; therefore, subjects drawn from any walk of life were equally valid. Beauty was the product of the artist's emotional response to life and the portrayal of this response in his art. Thus, the urban poor and working class were as worthy subjects as genteel ladies; perhaps even more worthy since, in Henri's view,

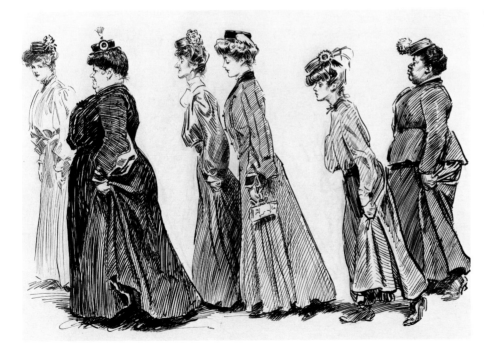

Fig. 9. Charles Dana Gibson, The New Hat *(Cat. No. 28).*

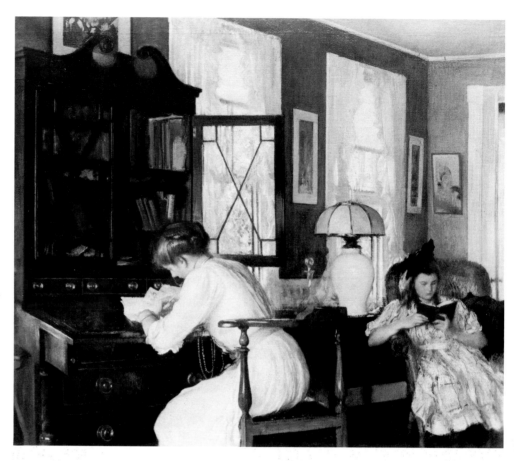

Fig. 10. Edmund Charles Tarbell,
Josephine and Mercie (Cat. No. 32).

Fig. 11. John Sloan, Sunday, Drying
Their Hair (Cat. No. 41).

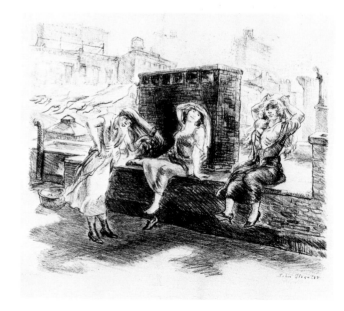

they were unrepressed and therefore had the capacity to enjoy life more fully. This attitude is best understood through a comparison of the sedate young ladies portrayed in Tarbell's *Josephine and Mercie* (Fig. 10) with those robust women in Sloan's *Sunday, Drying Their Hair* (Fig. 11), and of Vonnoh's languid aesthetes with Eberle's exuberant children (Figs. 12,13).

The most vital subjects for Henri's circle were then found in New York among the working class. The city pulsated with life, and this dynamism was conveyed through technique. The works were not executed on the spot but in the studio from memory undoubtedly reinforced by visual notations. The dark palette, dramatic chiaroscuro, slashing brushwork, and dynamic placement of the figures evident in Bellows' *Forty-two Kids* (Fig. 14) captured the passion and excitement of city life as did the rhythms and cadences of the poetry of Walt Whitman, one of the group's inspirations. Their works no more displayed the prose of contemporary life than did those of Tarbell and Vonnoh; they too were concerned with poetry and beauty, only in a different

guise. Documenting the external facts of contemporary life was the realm of photography (Cat. No. 33) and illustration (Cat. No. 35).

Although many of Henri's circle—Sloan, Luks, Glackens, Bellows—had illustrated articles and stories, their painting was directed toward another end. Neither illustrators nor reporters of contemporary mores, they strove to interpret life, to capture the inner essence rather than the outward facts of American urban existence. They wanted to be, in effect, visual poets of the city, which they considered the hub of American life and democracy just as rural and frontier America had been its center fifty years before for Mount and Bingham. The genteel painters had artistically disenfranchised the country's urban, working-class population by focusing on the elitist world of the affluent. The increased industrialization and relaxation of immigration laws had turned America into an urban, highly heterogeneous civilization, which made it distinct from any other in the world. This development threatened the Anglo-Saxon establishment—the patrons of the artists who provided de-

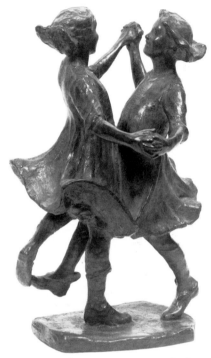

Fig. 13. Abastenia St. Leger Eberle, Girls Dancing *(Cat. No. 31).*

Fig. 12. Bessie Potter Vonnoh, Day Dreams *(Cat. No. 25).*

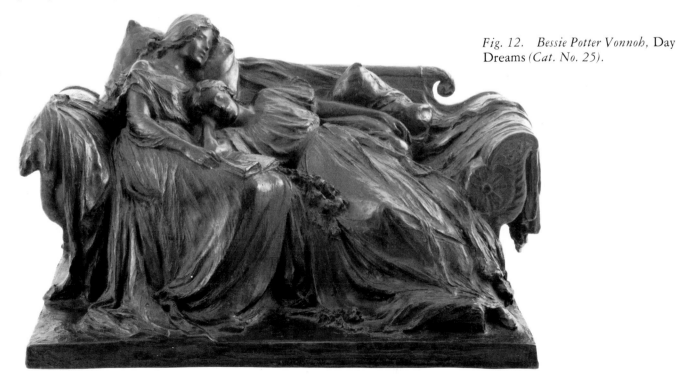

lightful images of a gracious life style and ignored the democratic nature of American society.

Henri and his circle sang the praises of working people, seeing in their lives the promise if not fulfillment of the American dream. Their interpretation, realistic in its emphasis on the hustle and bustle of the city as a metaphor for modern life, was idealistic in its images, which are devoid of the misery that confronted the working class in their daily struggle to survive. Filled with boisterous, fun-loving crowds living life to the fullest, these fundamentally optimistic visions of the lower echelons of American society say less about the individual than they do about the potential of the system. Social comment and criticism, although present in contemporary photography and the graphic arts, was not a significant factor in the fine arts until the American dream itself came into question at the time of the Depression.

The Ash Can style did not spring full-grown from Henri's head. Its roots were in the French naturalism of the nineteenth century and in the realism of Dutch, Flemish, and Spanish seventeenth-century Baroque art. Echoes of Daumier and Forain, Courbet and Manet, Degas and Renoir, Hals and Velázquez can be found in the compositions and techniques of Henri and his followers. And like these painters, they were concerned with the artist's relationship to the world at large. Their art was for the people and about the people; in every way it was accessible. It employed familiar techniques on uniquely American subject matter. By glorifying the vulgar and commonplace, it revolted against an elitist art created for the few. Having successfully attacked the art-for-art's-sake aesthetic, it enjoyed a moment of glory until traditional artistic preconceptions came under attack by the modernists after the Armory Show of 1913.

Between the Wars

After the New York Armory Show of 1913, which introduced the American

public to the avant garde, representational art went on the defensive. Response to the exhibition from artists as well as the public ranged from rapture to disgust. The show split American art into three distinct camps—conservative, progressive, and modernist. It also made art newsworthy.

The impact of the exhibition on the figurative tradition was pronounced. There were artists who embraced abstraction wholeheartedly, others adopted some of its characteristics, and still others rejected it completely. Some, like Max Weber (Fig. 15), explored Cubism and treated the human figure as just one of many formal elements within a composition. But the modernist aesthetic influenced a number of artists in a variety of ways. Works such as Charles Demuth's *In Vaudeville* (Cat. No. 37) and Bernard Karfiol's *Summer* (Cat. No. 43) display a stylization and linearity inconceivable in American painting except in folk art before 1913. Karfiol in his conscious allusion to archaic Greek sculpture reflects an avant-garde interest in primitive art, and Demuth blatantly manipulates form, line, and color to achieve a patterned composition. Both works retain a specificity of activity and place.

Daniel Garber (Cat. No. 38) is representative of the conservative camp, which included such artists as Frank Benson, Edmund Tarbell, and Childe Hassam, who extended the art-for-art's-sake aesthetic well into the twentieth century. The modest setting of Garber's painting projects a naturalism that unites it with the progressive art of Henri's followers at the same time that the preoccupation with light allies the work to Impressionism.

It is the progressive group—artists who followed Henri or embraced his principles—that dominated representational figurative art in America between the Armory Show and World War II. Many of the older artists such as George Luks, John Sloan, and Jerome Myers (Cat. Nos. 46, 41, 45) continued for the next two decades to explore themes that had interested them before

1913. In the 1920s the dynamism of urban life seemed to be a living testimony to the progressive nature of American society. This progressive attitude was expressed in the urban subject matter of the period; for example in John R. Grabach's *Waterfront* (Cat. No. 40).

The Depression fragmented American figurative art into discernible subgroups: Urban Realists, Regionalists, and Social Realists. The former two are frequently grouped into one category—American Scene painting—since the artists were concerned with portraying American life. Unlike Social Realists, they did not criticize American society or use art for protest and reform. There is, however, a distinct difference between those who portrayed rural America and those who depicted urban life; the difference echoes political divisions that are as relevant today as they were fifty years ago. Unlike the art of Bonham and Brown, which portrayed America as a melting pot, these disparate images emphasized the fundamental divisions in American society.

Among the many Urban Realists who carried on in the Henri tradition were Raphael Soyer, Reginald Marsh, and Isabel Bishop (Cat. Nos. 55, 48, 58). They were involved with the Fourteenth Street School, so called because their studios were located in that area and they tended to depict the working-class people who labored or shopped there. The monumental simplicity and fine linear drawing of the figures in Bishop's *Two Girls Outdoors* recall Italian Renaissance art. Although Marsh's work seems less conscious in its allusion to the art of the past, one detects traces of Forain in the sketchy, almost caricatured figures, and of Renaissance art in the use of tempera, then enjoying a revival. Soyer's naturalism seems styleless in comparison, but the red of the woman's hairnet and the arbitrary composition declare his debt to the French school, especially Degas.

Each of these works is typical of the artist's oeuvre in style and theme. Soyer's figures endlessly wait; Marsh

frequently depicted Bowery derelicts; and Bishop was fascinated by female intimacy. The artist (and viewer) assumes the position of an outside observer. In the case of Bishop and Marsh, however, their techniques force the viewer to experience their paintings as works of art, not as imitations of nature: the viewer is made aware of the painting process and becomes detached from the subject. The naturalism of Soyer's composition, on the other hand, encourages the audience to become part of the action.

Edward Hopper ranks as one of the key American Scene painters of the twentieth century. A student of Henri, he never was exclusively committed to urban subjects nor can he be classified as a Regionalist. The psychological isolation of his people gives his work a stark realism, quite distinct from the sympathetic view of humanity found in

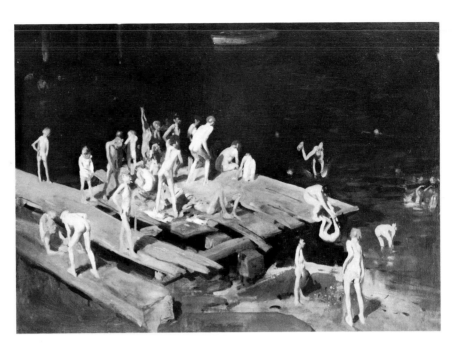

Fig. 14. George Bellows, Forty-two Kids *(Cat. No. 30).*

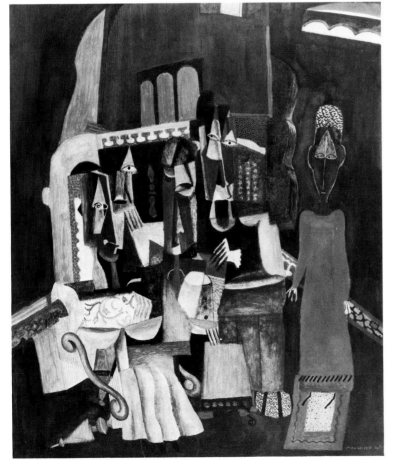

Fig. 15. Max Weber (1881–1961), The Visit (A Family Reunion), *1917, oil on board, 36¼ x 30 in. (92.1 x 76.2 cm). Corcoran Gallery of Art, museum purchase through a gift of Mrs. Francis Biddle.*

other figurative artists of the period. The two works in this exhibition (Cat. Nos. 39, 54), despite their differences in setting and class, project an air of loneliness which is reinforced by the light that seems to isolate the figures in space.

Although the majority of figurative artists eschewed abstraction, there were several who embraced the tenets of modernism but then rejected it as a European style inappropriate to the American experience. Among these was Thomas Hart Benton (Cat. No. 61), who became one of the leading figures in the so-called Regionalist movement of the second quarter of the century. Benton came to believe in the moral superiority of the agrarian way of life and had a populist view of art. He sought to release American art "from its subservience to borrowed forms"[30] and tried to establish an indigenous mode of expression by returning to rural America for subjects. His focus on agrarian themes and his development of a visual vocabulary to express them, consciously or not, harkened back to the view of American society held by Bingham and Mount almost a century before. Benton's works deal with contemporary subjects, but the mannered and stylized forms, human and non-human, infuse his organic landscapes with a mythical quality; his works are not so much images of reality as visions of an ethos. His thematic influence on a number of artists, including John de Martelly and Peter Hurd (Cat. Nos. 51, 52), was substantial.

Benton's exploration of down-to-earth American subjects paralleled a number of other developments in the 1930s. The Depression hit artists just as hard as it did the rest of the country. Although the establishment of the Federal Arts Project under the WPA alleviated the situation, a kind of cultural isolationism that bordered on xenophobia emerged. Thomas Craven, for example, in his book on *Modern Art* derided artists for capitulating to foreign influences, and sarcastically referred to Bluemner, Kuniyoshi, Lachaise, Stella, Walkowitz, Zorach, and others as "sci-

ons of our colonial aristocracy."[31] This artistic equivalent to America First politics was sufficiently widespread that Moses Soyer in a review of the 1935 Whitney Biennial remarked: "Artists, therefore, should not be misled by the chauvinism of the 'Paint America' slogan. Yes, paint America, but with your eyes open. Do not glorify Main Street. Paint it as it is—mean, dirty, avaricious. . . ."[32]

The period from the mid-twenties to the mid-forties also saw serious examination of America's artistic heritage. American folk art was explored in a series of exhibitions, one purpose of which was to show that the roots of an American abstract aesthetic could be found in the flat, linear, brilliantly colored portraits of itinerant limners. But there was increased scholarly interest in American arts in general: specific artists and fields, including nineteenth-century genre, became subjects of books and catalogues. It was also at this time that a number of print clubs and societies were formed across the country.

These associations contributed to the growth of interest in printmaking; they also were a means by which a number of artists augmented their incomes. But they did more than this. Like the art associations of the mid-nineteenth century they got art to the people, art that dealt with various regions and presented a fundamentally positive view of American life. The images tended not to depict Soyer's dirty Main Street; rather they complemented attitudes presented in the popular media in advertising (Cat. No. 53), magazine illustrations, and movies. In fact, movies assumed a major role in fostering myths that were also explored in the graphic arts and, to a lesser extent, in the fine arts. Films with their animated, anecdotal narratives had their intellectual if not visual roots in the sequential images of a rake's progress or of a woman's fall from grace treated in prints and paintings of the eighteenth and early nineteenth centuries. Martin Lewis' *Chance Meeting* (Fig. 16) and Robert Riggs' *Club Fighter* (Cat. No. 50) re-

flect cinematographic influence on the customs as well as the art of the time.

The relationship between photography and painting was extended in this period. From the outset, the ability of photography to document the details of an event or place was recognized, and painters quickly realized that they could not compete with this new technique in the accurate depiction of the world. Photography also supplied artists with *aide-mémoires* and changed artistic conceptions, for example, in the area of motion. In the twentieth century photography remained an artistic tool but also developed as a separate medium. During the Depression photography as documentary achieved new heights. There was a great need to record the life of the times for future generations; this function was not dissimilar from that provided by genre painters of the mid-nineteenth century. There was, however, about the photographic image an immediacy and a presumed truthfulness which added a note of poignancy to the representation of humanity. In the hands of a master such as Walker Evans, these seemingly documentary visual records achieved artistic greatness (Cat. No. 49).

There were also areas in which the fine arts and photography influenced each other. Lewis Hine's photographs of newsboys, for example, were carefully posed and their compositions seem indebted to the paintings of J. G. Brown. On the other hand, a number of artists attempted to suggest the momentary quality of a snapshot. In Hopper's *East Side Interior* (Cat. No. 39), the woman, presumably distracted by something outside, has just turned away from her sewing to look out the window; Sloan's girls (Cat. No. 41) are laughing as they dry their hair; and Soyer's yawning woman, in the left middle distance, looks out and establishes fleeting eye contact with the viewer (Cat. No. 55).

While photography documented the misery created by the Depression, the graphic and fine arts commented on that misery in an effort to stimulate reform. Some of the figurative artists were

Communists or Socialists, and their works speak of their concern for modern man in a capitalist society. Until the Depression, there was little social protest in American art except in graphics. The expansion of protest in the arts was undoubtedly encouraged by the emigration to America of George Grosz, a German Expressionist, whose cynical views of capitalists and militarists would not have been lost on socially conscious American artists. Grosz's influence is detectable in Philip Evergood's *Sunny Side of the Street* (Cat. No. 63) although the painting is less an indictment of American society than it is an expression of human hope.

The graphic arts remained a convenient forum for social protest and comment. In *Wake Up, America* (Cat. No. 60), Rockwell Kent, one of the most outspoken critics of the capitalist system, combined a contemporary image with a traditional representation of the archetypal American to warn the country about threats to its constitutional freedoms. It is a powerful but complex image that requires careful reading in the same way that earlier genre often did.

The Inner and Outer Worlds of Contemporary Figurative Art

The Armory Show had drastically affected artistic development in America by raising questions about the relevance of content in contemporary art. The Depression, on the other hand, pushed figurative art into the social and political arena. World War II obscured these issues as the nation focused on pressing concerns. With the return to peace they surfaced once again, but figurative art of a realist nature emerged from the war handicapped, having been used to sell nationalism on both sides. Contemporary figurative art is still, in a sense, reacting to or recovering from the stigma realism received as a propaganda tool in this country and elsewhere.

Abstract art had been revitalized in the late 1930s by the arrival of a number of European practitioners. After the war, it became a major force, particularly on the two coasts. Although abstract art had its own *raison d'être,* it also offered an alternative to the overt human content of representation at a time when increased tension between the United States and the U.S.S.R. made suspect any art that was critical of America. Abstract art was ostensibly free of political implications; the issues it treated were aesthetic and personal. Abstraction provided a private area where the artist could employ line, color, and composition to express feelings. Like music, it could appeal to the

Fig. 16. Martin Lewis, Chance Meeting *(Cat. No. 56).*

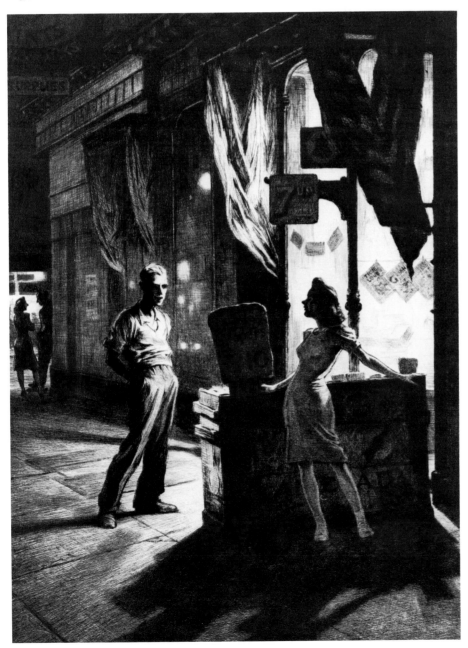

emotions directly through the senses since it was unencumbered by a narrative element. It was, in a way, not so much art-for-art's-sake as art-for-artist's-sake, with humanist concerns conveyed through emotional content rather than images.

In the figurative realm, artists shied away from social comment, and many rejected naturalism as a viable artistic style. Realism's faith in humanity as expressed in an illusionistic presentation of man within a specific context seemed inappropriate to the times. There was a growing sense of the individual's inef-

fectuality in a world capable of destroying itself. An expressive treatment of spectral images and undifferentiated human forms conveyed the potential for horror and destruction in the contemporary world. Such images (Fig. 17 is an example) recur frequently in the art of Rico Lebrun, Balcomb Greene, Leon Golub, and Leonard Baskin, among others. These fundamentally pessimistic statements about the human condition did not dwell on man's existence in a real environment but rather on the philosophical dilemmas of modern life. As such, they provide a visual parallel to postwar existential thought. Because this kind of work is not naturalistic, not concerned with the specifics of time or place, it has not been included in the exhibition. It constitutes, however, a major element in figurative art, particularly in that decade of political protest and social unrest, the 1960s.

Not all figurative artists eschewed the particular. Some of the older painters

such as Raphael Soyer, Isabel Bishop, and Joseph Hirsch (Cat. Nos. 55, 58, 59) continued to produce naturalist works dealing with American society. Other artists used the techniques of abstraction in their depiction of modern scenes. For example, David Park's *Sophomore Society* (Cat. No. 64) and Richard Diebenkorn's *Girl in a Room* (Fig. 18) employ bold brushstrokes and unnatural colors to make a statement about contemporary life. While the figures function as abstract elements in a composition, they also reveal the artist's personal response to the world—a response that is more concerned with mood or remembrance than with the mundane actualities of everyday life. As Diebenkorn has observed: "A figure exerts a continuing and unspecified influence in a painting as the canvas develops. The represented forms are loaded with psychological feeling."[33]

The conscious avoidance of detail and the anonymity in the figures (the faces

Fig. 17. Rico Lebrun (1900–1964), Night Figures #2, n.d., oil on canvas, 78¾ x 108⅝ in. (204.7 x 282.4 cm). Corcoran Gallery of Art, gift of the Friends of the Corcoran Gallery.

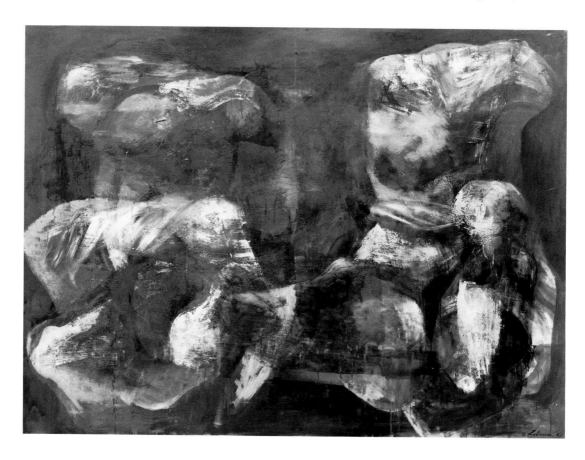

are ill-defined or schematized) emphasize the subjective nature of the images. These anonymous people seem to epitomize the existential dilemma, to visualize the alienation diagnosed in current books by David Riesman and Colin Wilson; but they, and later variations on a similar theme by Ruth Abrams and William Clutz (Cat. Nos. 71, 72), are no more vocal on this issue than, for example, the paintings and prints of Edward Hopper (Cat. Nos. 54, 39).

The dreamlike quality of these works acknowledges the pervasive Freudian orientation of American intellectual postwar thought. They seem concerned not so much with the external but the internal world. Even when details are minutely rendered, giving the essence of palpable reality, as in Robert Vickrey's *Signs* (Cat. No. 66) and Joseph Shannon's *Tasmania* (Cat. No. 68), the world portrayed is not the real world but a dream world filled with disturbing images that transmit the artist's fears and anxieties without defining them exactly. Alienation is a relevant issue in these essentially surreal works: Vickrey's youth sits amidst a plethora of

Fig. 18. Richard Diebenkorn, Girl in a Room *(Cat. No. 65).*

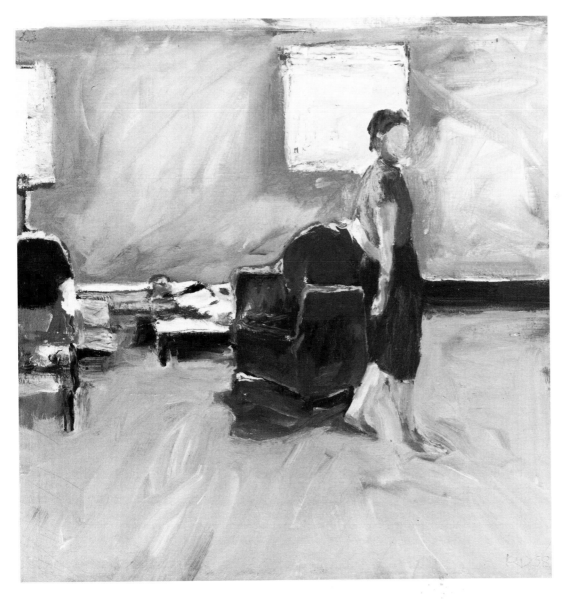

conflicting signals; Shannon's antagonists, human and canine, invade the conscious as symbols of a hostile world. These works with their subjective content are quite distinct from the new realism of Philip Pearlstein (Fig. 19) which objectifies the figure and Pop Art which ridicules contemporary values by making commonplace objects bigger than life.

Today, genre's preoccupation with depicting man in a real environment has been preempted by the naturalistic sculpture of George Segal, Duane Hanson (Fig. 20), and others and by photography. The idealism that plagued so much realistic art of the nineteenth and early twentieth centuries has no place in

these arresting images; the traditional distinction between reality and art seems irrelevant. In sculpture, the figures, cast from life, are arranged in environments of the artist's design. The sculptor decides on a subject, then fashions and arranges the elements that help him realize his statement. For the figurative photographer, the art of creativity is in selection, in sensitivity to a myriad of visual stimuli rather than in the creation of a composition according to some preconceived idea. The photographic image combines the inherent objectivity of a technological device (camera) with the subjectivity of its human agent (photographer). Having picked the locale and taken the shots,

the photographer then chooses the image that best expresses the points that should be made (Cat. No. 75).

Photography perhaps more than any other medium has succeeded in capturing the salient geographic features, regional characteristics, and local mores that nineteenth-century painters sought in their visual records of national types and customs. Like those genre scenes of the past, the photograph records external details—the everyday facts of a given time and place—and reflects the artist's view of America. Its ability to be simultaneously objective and subjective as well as its technical qualities have significantly affected the other visual arts within the last two decades.

Footnotes follow Color Plates

Fig. 19. Philip Pearlstein (b. 1924), Reclining Nude on Green Couch, *1971, oil on canvas, 60 x 48 in. (152.9 x 121.9 cm). Corcoran Gallery of Art, gift of the Friends of the Corcoran Gallery.*

Fig. 20. Duane Hanson (b. 1925), Janitor, *1973, polyester and fiberglass, 65½ in. (166.3 cm). Milwaukee Art Museum Collection, gift of the Friends of Art.*

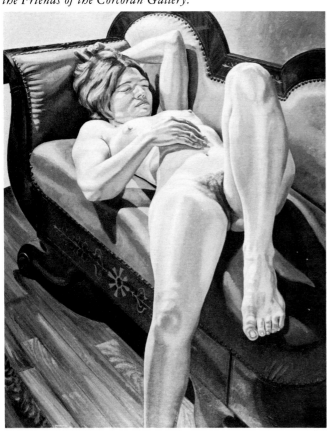

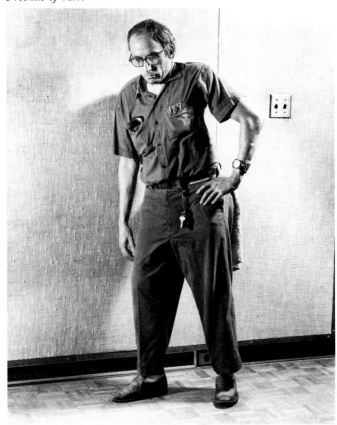

Color Plates

2 **William Sidney Mount** (1807–1868)
The Long Story, 1837

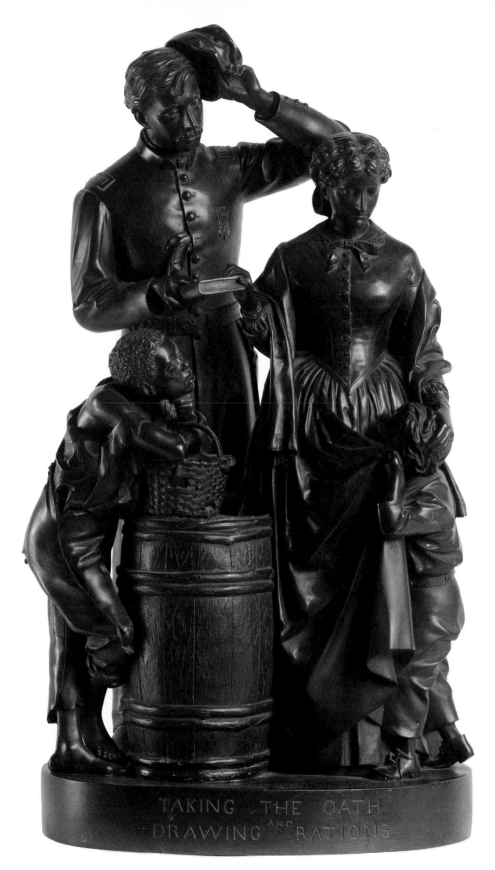

TAKING THE OATH
DRAWING AND RATIONS

12 After **John Rogers** (1829–1904)
*Taking the Oath and Drawing
Rations*, 1866

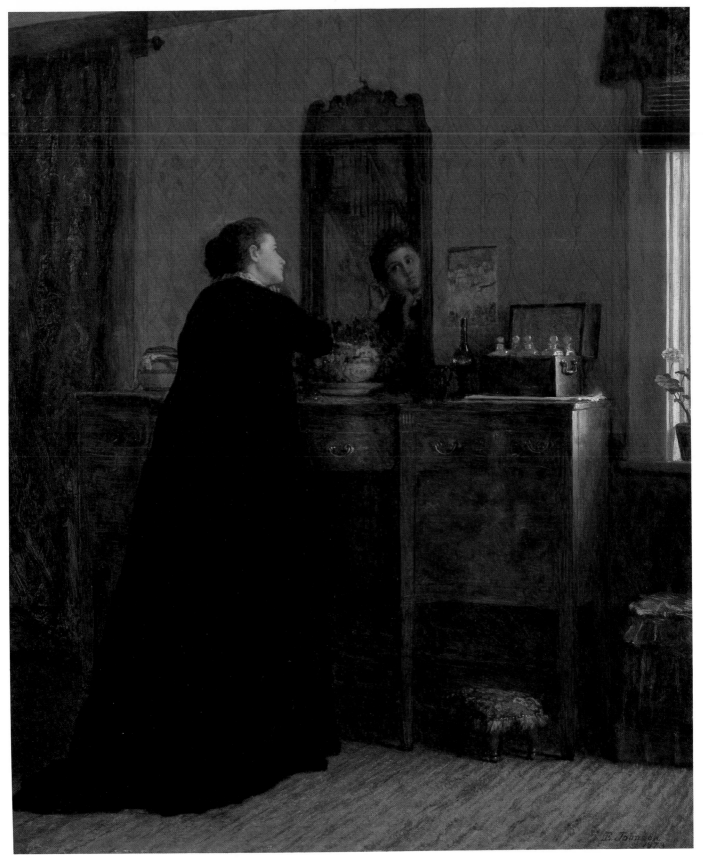

14 **Eastman Johnson** (1824–1906)
The Toilet, 1873

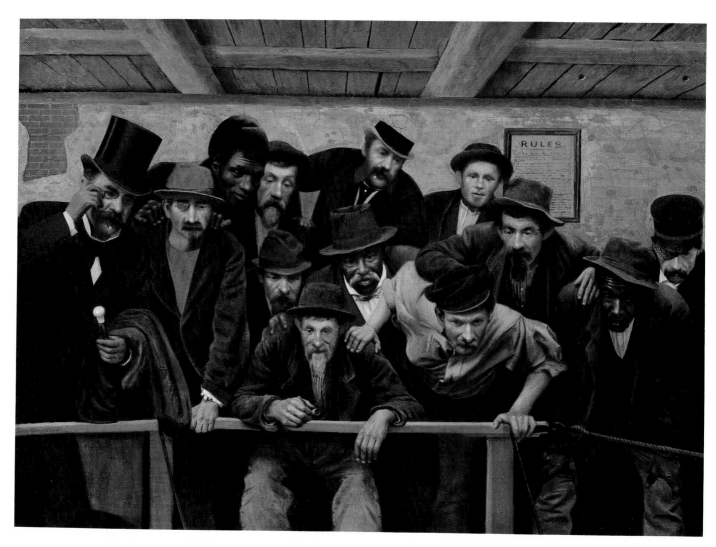

17 **Horace Bonham** (1835–1892)
Nearing the Issue at the Cockpit, 1878

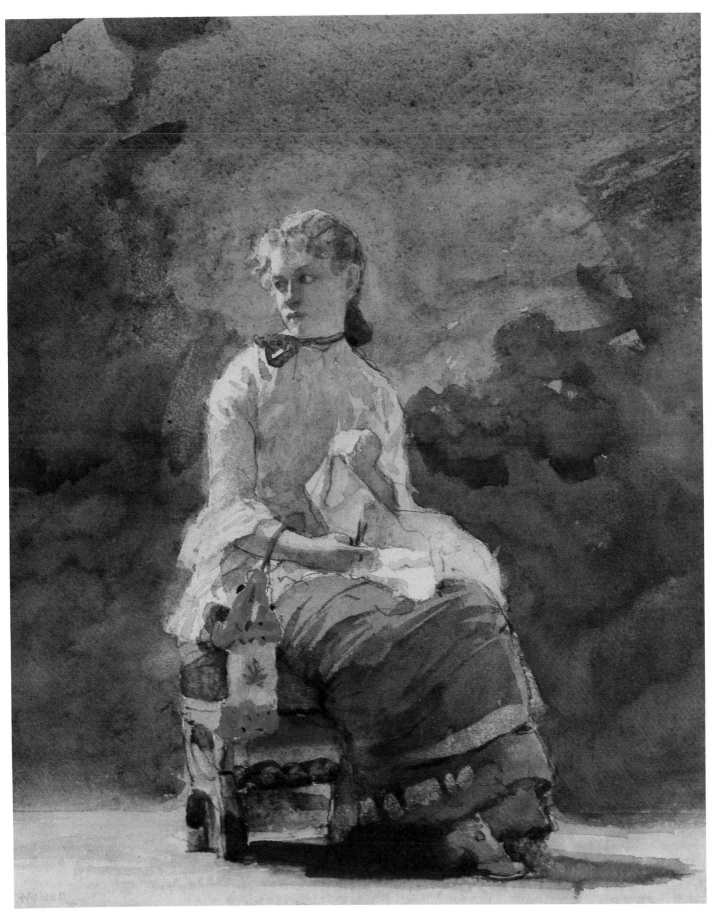

18 **Winslow Homer** (1836–1910)
Woman Sewing, 1878–1879

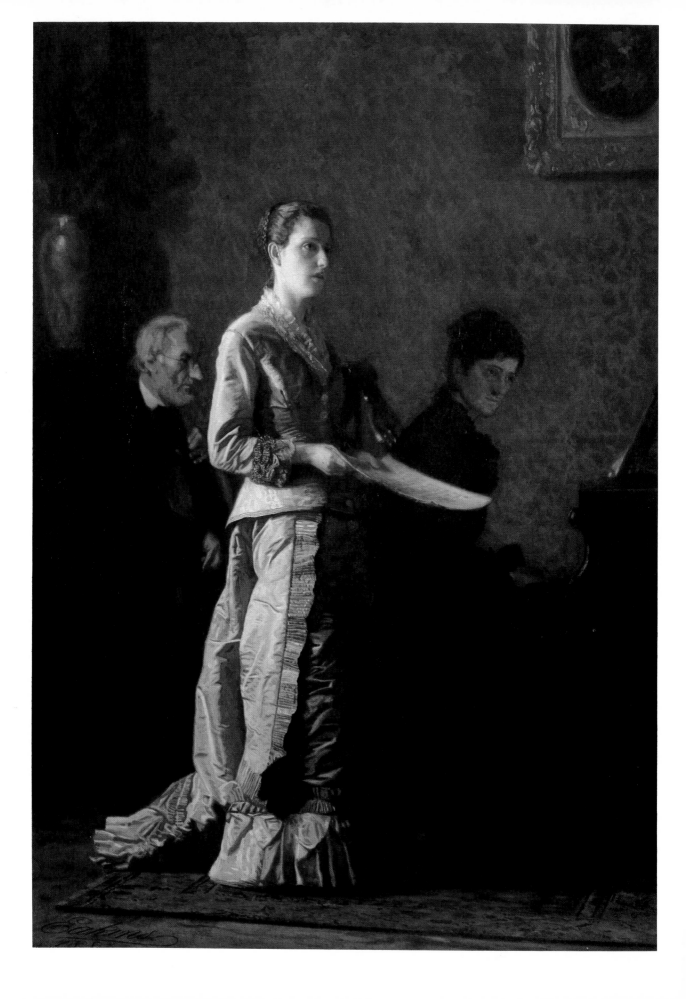

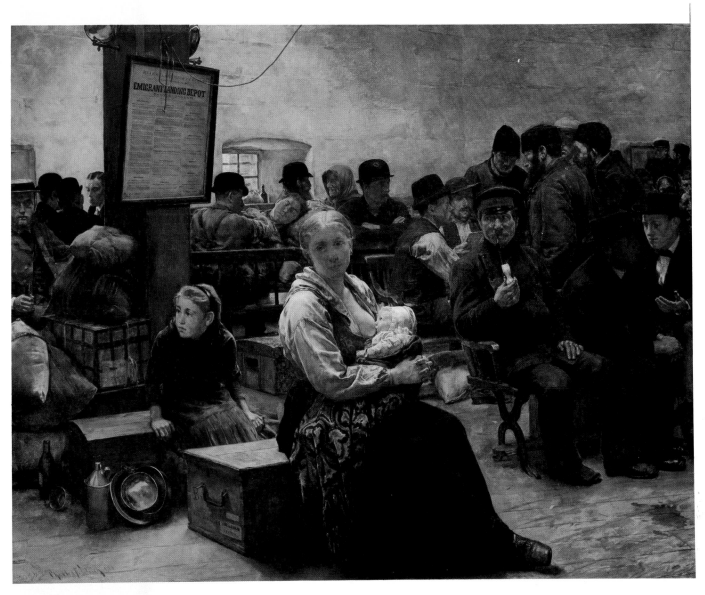

22 Charles Frederic Ulrich
(1858–1908)
*In the Land of Promise—Castle
Garden,* 1884

21 **Thomas Eakins** (1844–1916)
The Pathetic Song, 1881

30 **George Bellows** (1882–1925)
Forty-two Kids, 1907

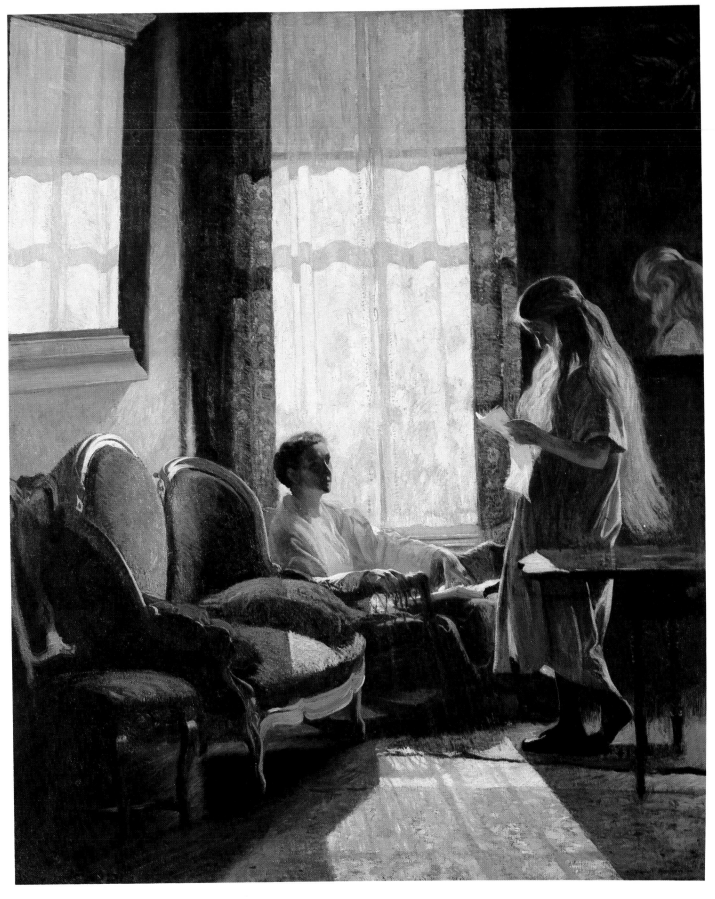

38 Daniel Garber (1880–1958)
South Room—Green Street, 1921

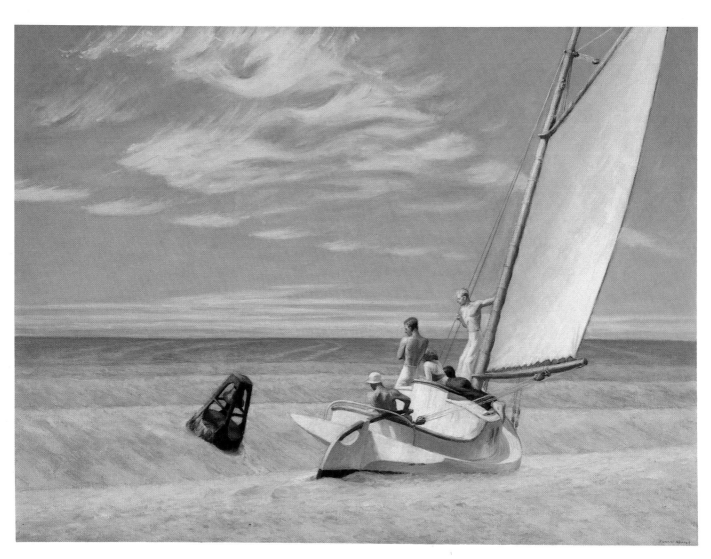

54 **Edward Hopper** (1882–1967)
Ground Swell, 1939

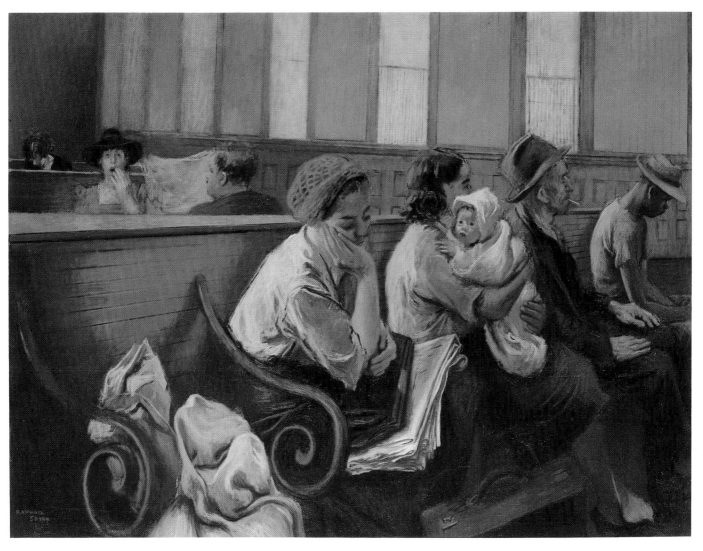

55 **Raphael Soyer** (b. 1899)
Waiting Room, 1939–1940

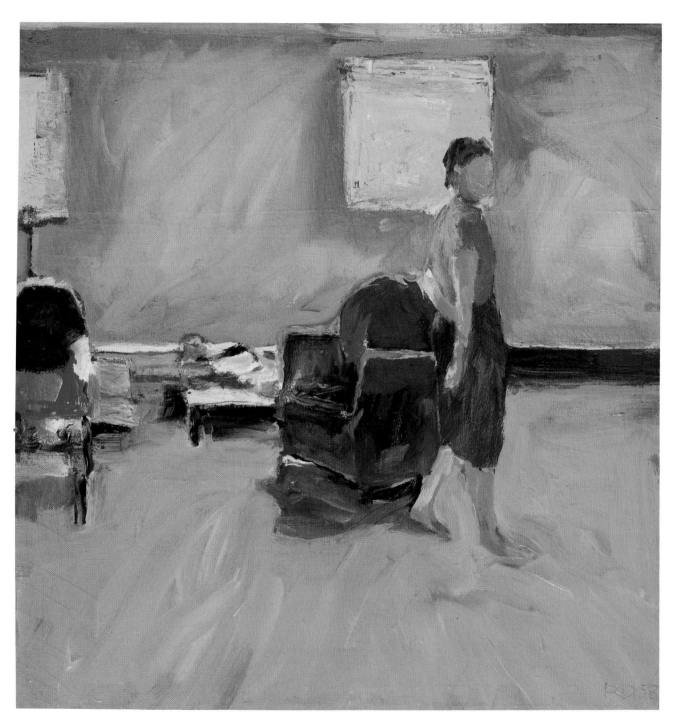

65 **Richard Diebenkorn** (b. 1922)
Girl in a Room, 1958

Notes

1. Although the term was used in the late eighteenth century, its use did not become widespread until the 1830s and 1840s. For a discussion of the origin of this term see Wolfgang Stechow and Christopher Comer, "The History of the Term *Genre*," *Allen Memorial Art Museum Bulletin,* 33, No. 2 (1975–1976): 89–94. Also see William Gerdts, "Figure Painting in the United States," *From All Walks of Life: Paintings of the Figure from the National Academy of Design,* exhibition circulated by the Smithsonian Institution Traveling Exhibition Service, 1979, pp. 7–14. The basic survey of American genre of the eighteenth and nineteenth centuries is Hermann Warner Williams, Jr., *Mirror to the American Past* (Greenwich, Conn.: New York Graphic Society, 1973).

2. Géricault executed several lithographs of farriers in the early 1820s; see Kate H. Spencer, *The Graphic Art of Géricault* (New Haven, Conn.: Yale University Art Gallery, 1969), Nos. 17, 36, 37, 50–53. The subject was also treated in English art in the late eighteenth and early nineteenth centuries. Mayer could have been familiar with the Géricault lithographs or prints after English works. Other American artists also handled similar subjects; for example, James William Glass painted *The Blacksmith* in 1846.

3. These British artists had their counterparts on the Continent; Jean-Baptiste Greuze (1725–1805) is just one of many artists in France working in a similar vein. Prints of Continental subjects were also available.

4. There are four basic types of history painting: religious, mythological, literary, and contemporary. The last dealt with heroes and events of the immediate or near past, as exemplified by John Trumbull's scenes of the Revolutionary War.

5. In the nineteenth century, historical genre evolved; the subject, placed in the past, could deal with ordinary people, but more frequently it was a domestic scene involving a famous personality such as George Washington.

6. George Berkeley (1685–1753) was an Anglo-Irish philosopher and clergyman. He came to America in 1728 with the intention of establishing a college in Bermuda. When this plan did not materialize, he returned to Great Britain, where in 1734 he was made Bishop of Cloyne. He brought to America in his entourage the artist John Smibert, whose group portrait of the Berkeley party is at the Yale University Art Gallery. Berkeley's prophesy appears in a poem, a stanza of which is:

Westward the course of empire
 takes its way;
 The four first acts already past,
A fifth shall close the drama with
 the day
 Time's noblest offspring is the last.

The poem is quoted in William Dunlap, *History of the Rise and Progress of the Arts of Design in the United States* (1834, reprinted New York: Benjamin Blom, 1965), Vol. I, p. 19.

7. James Jackson Jarves, *The Art-Idea* (1864; reprinted Cambridge, Mass.: Harvard University Press, 1960), p. 182.

8. For a persuasive discussion of Bingham's criticism of the American political system in *The County Election* and elsewhere, see Robert F. Westervelt, "The Whig Painter of Missouri," *The Art Journal,* 2, No. 1 (Spring 1970): 46–53.

9. Jarves, *The Art-Idea,* p. 166.

10. Henry T. Tuckerman, *Book of the Artists: American Artist Life* (New York: G. P. Putnam's Sons, 1867), p. 424.

11. See Arthur O. Lovejoy, *The Great Chain of Being: A Study of the History of an Idea* (1936; reprinted Cambridge, Mass.: Harvard University Press, 1964).

12. For a discussion of this issue, see Barbara Novak, *American Painting of the Nineteenth Century: Realism, Idealism, and the American Experience* (New York: Praeger, 1969). Novak has written about this problem on other occasions as well, most recently in *Nature and Culture: American Landscape and Painting 1825–1875* (New York: Oxford University Press, 1980).

13. Harold Edward Dickson, ed., "Observations on American Art: Selections from the Writings of John Neal," *Pennsylvania State College Bulletin; Pennsylvania State College Studies, No. 12,* 37 (February 5, 1943). Neal's article "Landscape and Portrait Painting" appeared in *The Yankee.*

14. Ralph Waldo Emerson, "Thoughts on Art," *The Dial* (January 1841); quoted in John W. McCoubrey, ed., *American Art 1700–1960* (Englewood Cliffs, N.J.: Prentice-Hall, 1965), p. 76.

15. James Jackson Jarves, *Art Thoughts* (New York: Hurd & Houghton, 1870), p. 5.

16. Tuckerman, *Book of the Artists,* p. 418.

17. Jarves, *The Art-Idea,* p. 182. For an understanding of the type of French genre picture Jarves saw as an influence on American art, see Gabriel P. Weisberg, *The Realist Tradition: French Painting and Drawing 1830–1900* (Cleveland: Cleveland Museum of Art with Indiana University Press, 1980).

18. Gerdts, "Figure Painting," p. 12.

19. Quoted in G. W. Sheldon, *American Painters* (New York: Appleton, 1879), p. 141.

20. Michael Quick, *American Expatriate Painters of the Late Nineteenth Century* (Dayton, Ohio: Dayton Art Institute, 1976), p. 14.

21. Michael Quick and Eberhard Ruhmer, *Munich and American Realism in the 19th Century* (Sacramento, Calif.: E. B. Crocker Art Gallery, 1978), p. 32.

22. Samuel Isham, *The History of American Painting* (New York: Macmillan, 1905), pp. 468–469.

23. *Ibid.,* p. 500.

24. Robert Henri, *The Art-Spirit* (1923; reprinted Philadelphia and New York: Lippincott, 1960), p. 111.

25. *Ibid.,* pp. 26–27.

26. Robert Henri, "The New York Exhibition of Independent Artists," *The Craftsman* (1910); quoted in McCoubrey, *American Art,* p. 174.

27. Henri, *The Art-Spirit,* p. 218.

28. *Ibid.,* p. 172.

29. *Ibid.,* p. 166.

30. Thomas Hart Benton, *An Artist in America* (1951); excerpted as "On Regionalism," in McCoubrey, *American Art,* p. 202.

31. Thomas Craven, *Modern Art* (New York: Simon and Schuster, 1934), pp. 315–316.

32. Quoted in Patricia Hills and Roberta K. Tarbell, *The Figurative Tradition and the Whitney Museum of American Art* (New York: Whitney Museum of American Art, 1980), p. 82.

33. Quoted in Gerald Nordland, "The Figurative Works of Richard Diebenkorn," *Richard Diebenkorn* (Buffalo, N.Y.: Albright-Knox Art Gallery, 1976), p. 31.

Catalogue
of the
Exhibition

Height precedes width in the dimensions. The paper size is given for drawings, plate size for etchings and engravings, and image size for lithographs.

Catalogue entries are by Julie R. Myers (JRM), Edward J. Nygren (EJN), and Andrea C. Wei (ACW).

1 **Alvan Fisher** (1792–1863)
Mishap at the Ford, 1818
Oil on panel
28½ x 35 in. (72.4 x 89 cm)

Inscribed lower center: *A. Fisher Pinx.
Feb.ʸ 1818*
Museum purchase 57.11

*M*ishap at the Ford typifies the kind of painting Alvan Fisher created in the early part of his career from about 1815 to 1820.[1] It is related to several sketches the artist made, presumably from nature, in 1817.[2] Although the locale has not been identified, it seems likely that the setting is somewhere in Massachusetts, where Fisher lived.[3]

An apprentice of the ornamental painter John R. Penniman (1783–?), known for views of Boston, Fisher was one of the earliest practitioners of landscape and genre painting in the United States. In *Mishap at the Ford* he combined these two interests by placing a human episode within a picturesque landscape.

A coaching accident, while perhaps a novel subject in American painting of this time, was a familiar one in British art of the early nineteenth century. Fisher may well have been aware of this visual tradition through prints.[4] The type of coach depicted, a barouche, was a pleasure carriage generally used for a jaunt into the country rather than for an extended journey. Sometimes called a German wagon after its place of origin, the barouche was an open carriage with seats at either end; only the rear seat could be protected from inclement weather when the folding hood was opened. Such an expensive carriage was not common in the United States at the time. It attests to the social position and wealth of its owner, presumably the man in the center, whose hat identifies him as an officer of high rank; the man on the left wears a "tombstone" cap, adopted by the Regular Army in 1814 as part of the uniform of a junior officer.[5] The elegant dress of the ladies confirms the fashionable character of the party.

The painting affords an interesting insight into travel in the rural areas of the United States in the early nineteenth century. All the basic forms of transportation are depicted: foot, boat, horse, and carriage. Only the carriage experiences difficulty. Although the country folk might have been impressed by the elegance of the barouche and its occupants, they must have felt that the vehicle was inappropriate for the rough terrain.

EJN

1. See William Dunlap, *History of the Rise and Progress of the Arts of Design in the United States,* 3 vols. (1834), ed. Alexander Wyckoff (New York: Benjamin Blom, 1965), Vol. III, pp. 32–33.
2. For Fisher's use of sketches, see Robert C. Vose, Jr., "Alvan Fisher 1792–1863," *Connecticut Historical Society* BULLETIN, 27, No. 4 (October 1962): 105. Two sketches are in the M. and M. Karolik Collection, Sketchbook IV (1817–1820), Museum of Fine Arts, Boston. A related, undated painting is at the Wadsworth Atheneum, Hartford, Connecticut.
3. Such scenery can be found in the western part of the state. Fisher may well have taken sketching trips in the summer of 1817, and since he sometimes traveled beyond his native state on such trips, a site in New York or other areas of New England cannot be ruled out.
4. The use of English prints by American artists as sources for their own compositions is well known. Fisher, for example, painted *The Young Hunter* based on a work by Penniman, which his master had adopted from an English print (Vose, "Fisher," p. 112).
5. I am grateful to the following curators at the National Museum of American History, Smithsonian Institution: Don H. Berkebile for information on the carriage; Craddock R. Goins, Jr., and Donald E. Kloster for information on the military costumes.

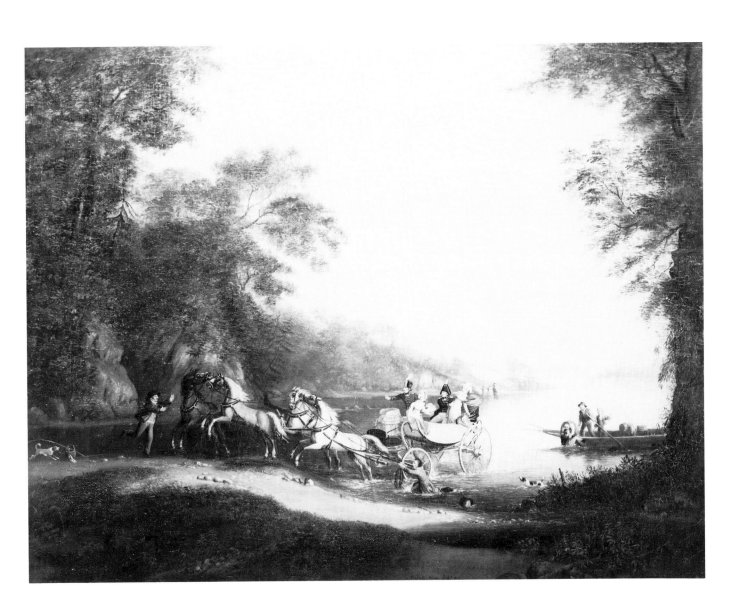

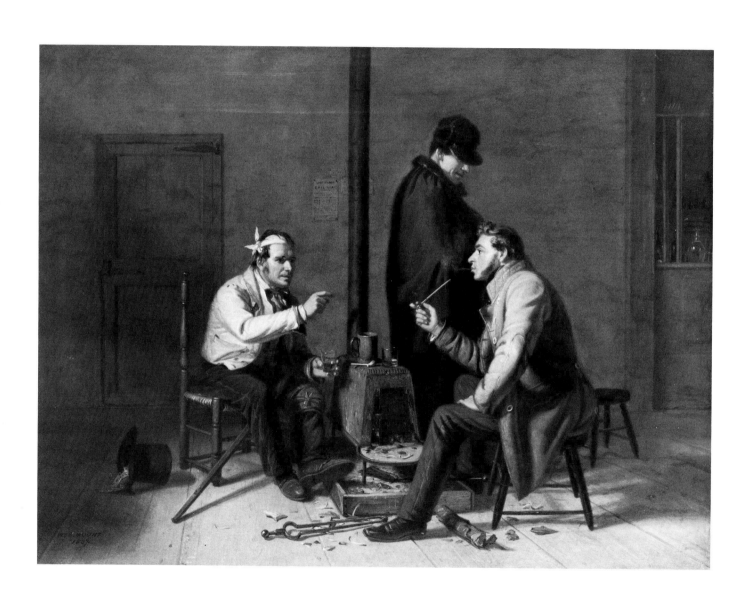

30

2 **William Sidney Mount** (1807–1868)
The Long Story,[1] 1837
Oil on panel
17 x 22 in. (43.2 x 55.8 cm)

Inscribed lower left: *Wm. S.*
MOUNT./1837
Museum purchase 74.69
See Color Plate

During the summer of 1836, Robert Gilmor of Baltimore commissioned William Sidney Mount to paint a work for him, the choice of subject being left to the artist. Mount set the picture in a country tavern of his native Long Island. While there is no evidence that *The Long Story* was painted specifically to complement works by Dutch seventeenth-century masters in his patron's collection, its size, composition, chiaroscuro, palette, and finish would have been compatible with Gilmor's pictures by Adriaen van Ostade and Jan Steen, artists undoubtedly known to Mount.[2]

Genre was a relatively new art form in America when Mount first gained recognition in 1830 for his efforts. Although artists before Mount treated everyday subjects (see Cat. No. 1), he is generally credited with having established genre as a major mode of expression in the United States. By the time he executed *The Long Story,* he was already hailed as the "American Wilkie," in reference to David Wilkie, the Scottish artist and seminal figure in the development of nineteenth-century genre painting on both sides of the Atlantic.[3]

In a letter to Gilmor, dated December 5, 1837, Mount explained the scene:

. . . The man puffing out his smoke is a regular-built Long Island tavern and store keeper, who amongst us is often a Gen. or Judge, or Post master, or what you please as regards his standing in society, and as you say has quite the air of a Citizen.

The man standing wrapt in his cloak is a traveller as you supposed, and is in no way connected with the rest, only waiting the arrival of the stage—he appears to be listening to what the old man is saying. I designed the picture as a conversation piece. The principle interest is to be centered in the old invalid who certainly talks with much zeal. I have placed him in a particular chair which he is always to claim by right of profession, being but seldom out of it from the rising to the going down of the sun. A kind of Bar room oracle, chief umpire during all seasons of warm debate whether religious, moral, or political, and first taster of every new barrel of cider rolled in the cellar, a glass of which he now holds in his hands while he is entertaining his young landlord with the longest story he is ever supposed to tell, having fairly tired out every other frequenter of the establishment.[4]

From this lengthy narrative it is clear that the artist invented personalities for his characters as full as those devised by any writer. His analysis of the two protagonists requires no elaboration; however, it has been suggested that the cloaked figure, in its detachment, reflects Mount's own aloofness from the subject of his art, the rural community where he lived.[5] Certainly the man is a visualization of the literary device of the detached narrator-observer and functions as a substitute for the artist-viewer.

An insignificant detail in the painting establishes the currency of the image and provides perhaps an insight into the artist's attitudes. The first two legible lines of the notice attached to the rear wall read "Long Island Railroad." In 1837 the railroad was in its infancy, extending only to Hicksville. In fact, work on the line stopped in April of that year, in part because of the financial crisis, and did not resume again until 1840.[6] The superfluous allusion to the railroad may reflect Mount's mixed feelings about life in the country. It is possible that the artist saw in the coming of the Long Island line the promise of easy access to the stimulating city he enjoyed visiting and the means of escape from the provincial world he loved to paint.

EJN

1. The painting has sometimes been called *The Tough Story;* for variations on the title, see Bartlett Cowdrey and Hermann Warner Williams, Jr., *William Sidney Mount 1807-1868* (New York: Columbia University Press, 1944), pp. 18, 40.
2. For a list of works in Gilmor's collection, see William Dunlap, *A History of the Rise and Progress of the Arts of Design in the United States* (1834, New York: Dover, 1969), Vol. II, Part 2, pp. 459–461. Washington Allston recommended that Mount study Ostade and Steen (*ibid.,* p. 452). Prints and copies of works by these artists were available in New York at that period.
3. I am grateful to Catherine Hoover for allowing me to see in galley proofs her article "The Influence of David Wilkie's Prints on the Genre Paintings of William Sidney Mount," to be published this year in the *American Art Journal,* 13, No. 3.
4. Quoted in Alfred Frankenstein, *William Sidney Mount* (New York: Harry N. Abrams, 1975), pp. 75–76.
5. *Ibid,* p. 8.
6. I wish to thank Barbara Shikler, of the New York Historical Society, for this information.

3 **Nathaniel Currier** (1813–1888)
Shakers near Lebanon, c.1840
Hand-colored lithograph
8 x 12¾ in. (20.4 x 32.4 cm)

Typeset lower left: *Lith & Pub. by N. Currier;* center: *SHAKERS NEAR LEBANON;* lower right: *2 Spruce St., N.Y.*
Museum purchase 53.49

This lithograph is one of several versions of the identical subject published by different New York printmakers in the second quarter of the nineteenth century.[1] Which version was the original design has not been established; but the proposed date of this piece, which is based on the fact that Currier moved to the address listed in 1838, makes it an unlikely candidate. The prints agree in most details and are approximately the same size. Their differences suggest, however, that they were not all pulled from the same stone and that some were redrawn. In the case of the Currier, color may have been added to increase the work's appeal.

The earliest possible year of execution for the original print is 1824. The placement and style of the windows suggest that the structure depicted is New Lebanon's second meeting house, completed in that year.[2] A date in the late 1820s is supported by the fashionable dress of the lady on the left.

Shakerism, an English offshoot of a French Protestant sect, was brought to America in 1774 by Mother Ann Lee Stanley (1736–1784). The refusal of Shakers to take oaths or bear arms aroused suspicion and even hostility in times of war, while their rule of celibacy undoubtedly struck people as unnatural. Although Shakers experienced periodic persecution, when this print was published they enjoyed good relations with their worldly neighbors.

In 1787 the Shakers began to live in communistic communities removed from the rest of the world. New Lebanon was the first of these established; by 1840 more than two dozen had been founded from Maine to Indiana. The communities welcomed visitors and many came for the public service on Sundays to see the measured, regimented dance which is the subject of this lithograph. Reactions by outsiders to the spectacle were varied. For the Shakers, however, the dance embodied the belief that man's hands and feet should be used in God's service as well as for man's benefit.[3]

Shakers near Lebanon is typical of the inexpensive picture, aimed at a general public, produced in nineteenth-century America. The existence of several versions attests to the popularity of this particular subject and underscores the fact that Currier (later Currier & Ives), although today perhaps the best known of the firms, was just one of many publishing prints for a mass market.

EJN

1. At least five variations or versions are known; several are in the collection of the New York Historical Society. The one by Anthony Imbert (active 1825–1835) may be the earliest, although its drawing is cruder than an unsigned print which may have served as the basis for the Currier piece. Another version by an unidentified printer is illustrated in John G. Shea, *The American Shakers and their Furniture* (New York: Van Nostrand Rheinhold, 1971), p. 13. The variation by Henry R. Robinson (active 1833–1851) is reversed. I am indebted to Gordon Wright Colket, Gladstone, New Jersey, for bringing to my attention information on Imbert, Robinson, and the unidentified publisher. The exact publication dates on these works are not known.
2. See the photograph showing the exteriors of both meeting houses in New Lebanon in Elmer R. Pearson and Julia Neal, *The Shaker Image* (Boston: New York Graphic Society, 1974), p. 31.
3. *Ibid.,* p. 43. Reactions of visitors are also cited therein, pp. 42–43.

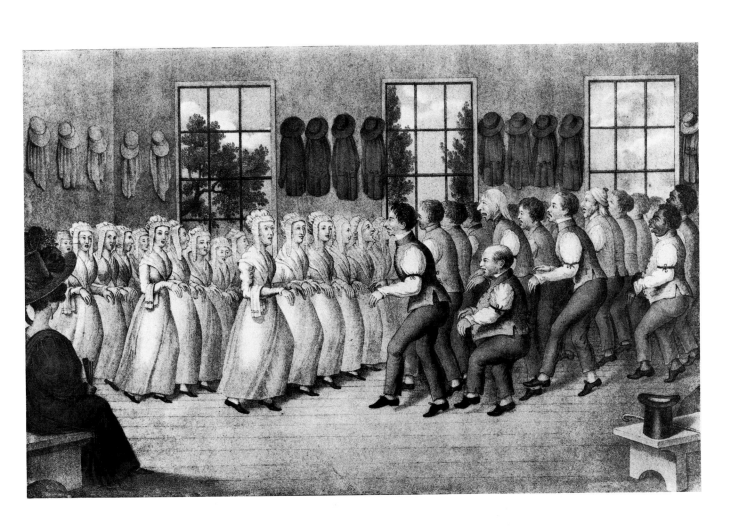

4 **Seth Eastman** (1808–1975)
*Lacrosse Playing among the Sioux
Indians,* 1851
Oil on canvas
28¼ x 40¾ in. (71.8 x 103.5 cm)

Inscribed lower right: *S. Eastman/1851*
Gift of William Wilson Corcoran 69.63

*Lacrosse Playing among the Sioux In-
dians* is typical of Seth Eastman's
work in its portrayal of a commonplace
incident of Indian life. Working in the
tradition of such artist-ethnographers
as Titian Ramsay Peale, Karl Bodmer,
and George Catlin, Eastman sought to
record the manners and customs of
what was then generally considered to
be a dying race. Eastman was a lifelong
student of the Indian. As a career army
officer he was stationed in Indian terri-
tory for about eleven years, seven of
them (1841–1848) at Fort Snelling in
Sioux country. He spoke the Sioux lan-
guage fluently, had many Sioux friends,
and with his wife spent most of his lei-
sure time studying the traditions of the
tribe. The Eastmans had an enlightened
view of the Indian at a time when many
people considered them savages: they
respected the native Americans and
their heritage and treated them, as one
traveler put it, "in a uniformly kind and
courteous manner."[1] In his paintings of
Indians, Eastman avoided sensational
themes and, perhaps because of his
training as a military topographer, ap-
proached his subjects with objectivity.

Lacrosse was a game played by many
North American Indian tribes. It was so
named by the French because its
racket—a three-foot-long stick with a
webbed circle on one end—resembled a
bishop's crozier. The object of the game
was to move the ball into a goal using
only the racket; this required complex
strategy and skillful maneuvering. The
winning team received all manner of
goods—horses, guns, blankets,
beads—and there was also heavy bet-
ting on the results. In some tribes the
games also had spiritual associations.

Eastman created three ball-game
subjects while at Fort Snelling: *Squaws
Playing Ball on the Prairie, Ball Play on
the Ice,* and *Ball Play on the Prairie.*[2] Re-

portedly commissioned for William
Wilson Corcoran,[3] *Lacrosse Playing
among the Sioux Indians* was derived
from *Ball Play on the Prairie* but is con-
siderably more dramatic than that work.
The figures are larger and more indi-
vidual in pose and dress, the landscape
is more panoramic and wild, and there is
greater emphasis on violence. Visitors
to the West often gave exaggerated ac-
counts of Indian ball games (one report
has it that human heads were used as the
ball[4]), and Eastman may have
heightened the violence somewhat to
conform to the Easterner's idea of the
game. Nevertheless, the game was
rough—Mary Eastman wrote, "limbs
are often broken and lives lost"[5]—and
Lacrosse Playing quite successfully con-
veys its ferocity.

JRM

1. John Francis McDermott, *Seth Eastman: Picto-
rial Historian of the Indian* (Norman: University
of Oklahoma Press, 1961), p. 27.
2. The last two were published as engravings in
Henry Rowe Schoolcraft's six-volume *Historical
and Statistical Information . . . of the Indian Tribes
of America* (Philadelphia: Lippincott, Grambo,
1851–1857), for which Eastman was the principal
illustrator. *Ball Play on the Prairie* is known only
through the engraving.
3. McDermott, *Eastman,* p. 95.
4. Wells Twombly, *200 Years of Sport in America:
A Pageant of the Nation at Play* (New York:
McGraw-Hill, 1976), p. 35.
5. McDermott, *Eastman,* p. 58.

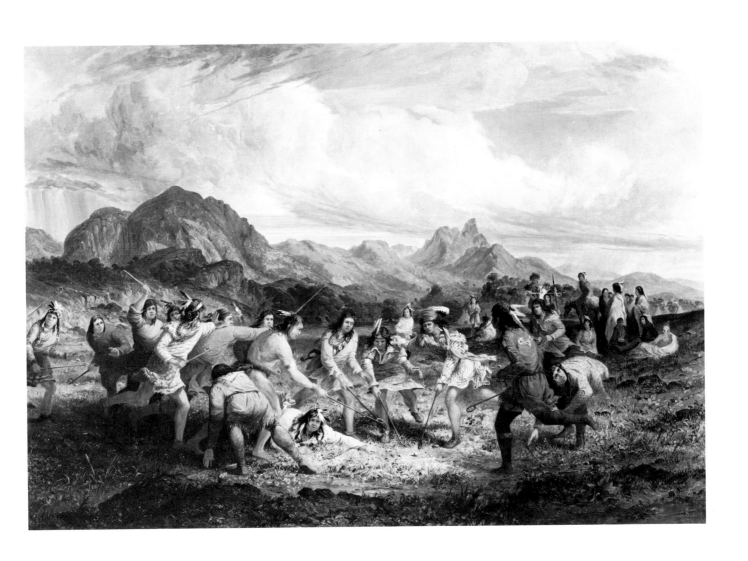

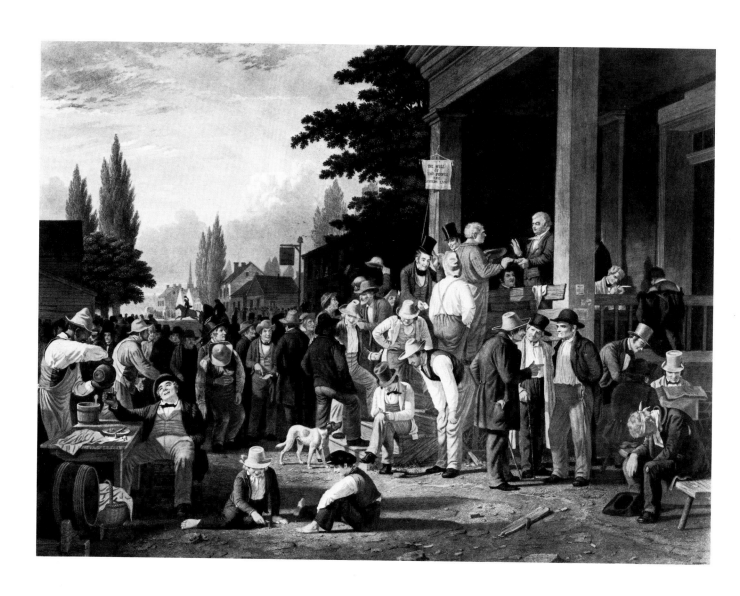

5 **John Sartain** (1808–1897)
After **George Caleb Bingham**
(1811–1879)
The County Election, 1854
Hand-colored engraving [1]
26⅝ x 32⅝ in. (68.3 x 83.5 cm)

Printed lower margin: *PAINTED BY
G. C. BINGHAM ENTERED. . . . IN
THE YEAR 1854 . . . DISTRICT OF
NEW YORK ENGRAVED BY JOHN
SARTAIN/THE COUNTY
ELECTION./PUBLISHED BY
GOUPIL & CO . . . BERLIN.
PRINTED BY JAS. IRWIN.*
Museum purchase (Mary E. Maxwell
Fund) 49.36

The County Election was one of several political scenes George Caleb Bingham created from 1847 to 1855 at a time when the artist was actively involved in the politics of Missouri. As a Whig candidate in 1846, he narrowly won election to the state legislature, only to have the results challenged by his opponent and rejected by the Democratic majority of the state house of representatives. Two years later he ran again and defeated his old opponent.

Bingham painted two versions of this subject within a few months of each other in 1851–1852.[2] The original served as the model for this print, executed by John Sartain of Philadelphia, one of the leading engravers of the day. Bingham selected him after consulting with several printmakers during a trip East in the summer of 1852 for the Whig convention in Baltimore. Bingham's well-documented efforts to obtain subscriptions for the engraving in advance of its publication reveal much about the promotion and selling of art in mid-nineteenth-century America.[3]

Critical as well as popular reaction to the painting and the print was almost universally enthusiastic. One newspaper predicted that it was "destined to become one of the most popular paintings on the continent."[4] The response was as much due to its subject matter as to its technical merits. Bingham's friend Major James S. Rollins expressed this viewpoint when he wrote in 1857: "The elective franchise is the very corner stone upon which rests our governmental superstructure and as illustrative of our fine institutions, the power and influence which the ballot box exerts over our happiness as a people, the subject of this painting was happily chosen. . . . "[5] At least one contemporary observer, however, was outraged by the work and found the dis-reputable types portrayed an insult to the democratic process.[6] A modern scholar has convincingly argued that *The County Election* incorporates Bingham's own misgivings about universal suffrage and Jacksonian egalitarianism.[7] Certainly it is reasonable to assume that because of his personal experiences in politics Bingham would have salted his view of "the will of the people" in action with a pinch of justifiable criticism.

EJN

1. For a discussion of the various states, see E. Maurice Bloch, *George Caleb Bingham: A Catalogue Raisonné* (Berkeley and Los Angeles: University of California Press, 1967), pp. 220–221.
2. Bloch, *Bingham,* pp. 89–90. The first version is in the collection of City Art Museum, St. Louis, Missouri; the second, in the Boatmen's National Bank of St. Louis.
3. See John Frances McDermott, *George Caleb Bingham: River Portraitist* (Norman: University of Oklahoma Press, 1959), pp. 94–102. See also E. Maurice Bloch, *George Caleb Bingham: The Evolution of an Artist* (Berkeley and Los Angeles: University of California Press, 1967), pp. 140–145.
4. *Weekly Missouri Statesman,* October 29, 1852, quoted in Bloch, *Evolution of an Artist,* p. 145.
5. Quoted in Bloch, *Evolution of an Artist,* p. 145.
6. McDermott, *Bingham,* p. 99.
7. Robert F. Westervelt, "The Whig Painter of Missouri," *American Art Journal,* 2 (Spring 1970): 46–53.

6 **Frank Blackwell Mayer**[1] (1827–1899)
 Leisure and Labor, 1858[2]
 Oil on canvas
 15⅝ x 23 in. (39.7 x 58.4 cm)

Inscribed lower right: *F. B. Mayer/1858*
Gift of William Wilson Corcoran 69.95

Like many genre paintings, *Leisure and Labor* presents a moral in symbolic terms. There is no question that the painting accurately depicts a blacksmith shop in the Maryland countryside on an autumn morning in the nineteenth century. The work is, however, more than a truthful rendering of a rustic scene, and the poster tacked on the right door provides the clue to its true meaning. Father Time is shown running within a circle created by a snake whose tail is in its mouth, the traditional symbol for eternity. Underneath is the legend: "Stop Theif [sic]." The moral of the painting is that time is running out, an idea reinforced by the season and the broken plow. The placement of the poster directs the warning at the languid young man who, with his greyhound, watches the blacksmith work on the hoof of his horse. These elements identify the composition as a visualization of Aesop's fable of the ant and the grasshopper.[3]

Mayer executed several other paintings dealing with farriers, including one from about the same time of Elihu Burritt, known to his contemporaries as "the learned blacksmith."[4] Like *Leisure and Labor,* some of these pictures were based on sketches made years before, a practice Mayer may well have picked up

from his teacher Alfred Jacob Miller (Cat. No. 8). In this case there are numerous sketches dating from 1845 to 1857 of details and figures as well as compositional studies,[5] including a watercolor in the Corcoran collection which is identical in almost all respects to the oil. However, from a sketch in the Maryland State Library (Annapolis) it is clear that the original design dates from 1845. Although the young artist probably felt ill-equipped to execute an oil so early in his career, why he waited so long or when he decided to invest the subject with symbolical overtones is not known. The painting's technical facility indicates that other efforts in oil must have preceded this early example.

Mayer may have been inspired to contrast labor and leisure by William Hogarth's series on the industrious versus the idle apprentice, with which he was familiar.[6] Although a moralizing tone exists in nineteenth-century American genre (for example in William Sidney Mount's *Loss and Gain),* it is not usually accorded the complex treatment Mayer employs here; this practice is more typical of the eighteenth than the nineteenth century. While the subject matter reveals the artist's playful but erudite approach, his technique and palette demonstrate a familiarity with contemporary French art and translate this rustic scene into an exciting and vibrant visual image, full of life and light.

EJN

1. The artist was baptized Francis but was known throughout his life as Frank.
2. I wish to express my gratitude to M. E. Sigmond and Jean Jepson Page, who are both engaged in studies of Mayer, for sharing information and observations on this work with me. I have acknowledged their individual contributions in other footnotes. The painting has also been called *Doing and Dreaming;* a watercolor study in the Corcoran collection bears a faint inscription with the alternate title.
3. Mrs. Page in conversation speculated that the painting may have political overtones. Such an interpretation is supported by another painting of the same year, *Independence* (National Museum of American Art), in which a man lounges on his porch, smoking a pipe, staring into the distance. Although the figures in both have been tentatively indentified as two different people (see Jean Jepson Page, "Francis Blackwell Mayer," *Antiques,* 109 (February 1976): 317–318), they do share certain similar physical characteristics as well as clothing and may have been conceived as variations on a theme.
4. I wish to thank Miss Sigmond for bringing this information to my attention.
5. Related drawings are in the collections of the Baltimore Museum of Art and the Maryland State Library, Annapolis. I am indebted to Miss Sigmond for bringing all of these works to my attention.
6. Miss Sigmond suggested the Hogarth series as the possible source of Mayer's composition, noting his reference to Hogarth in his diary.

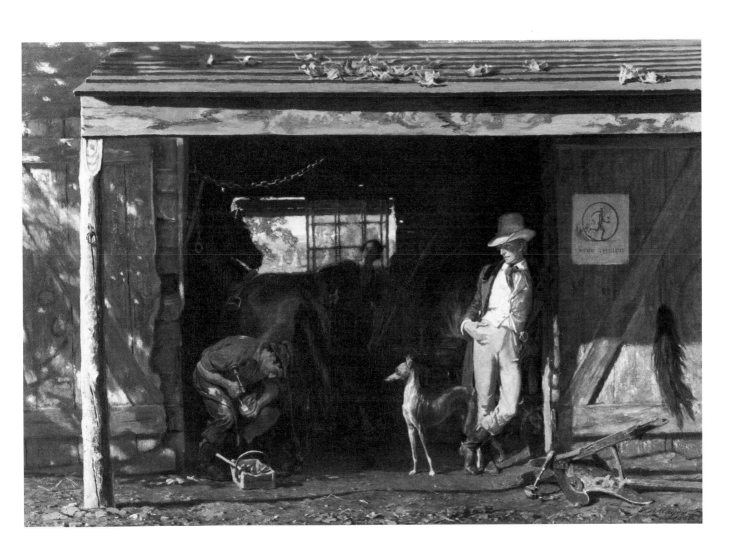

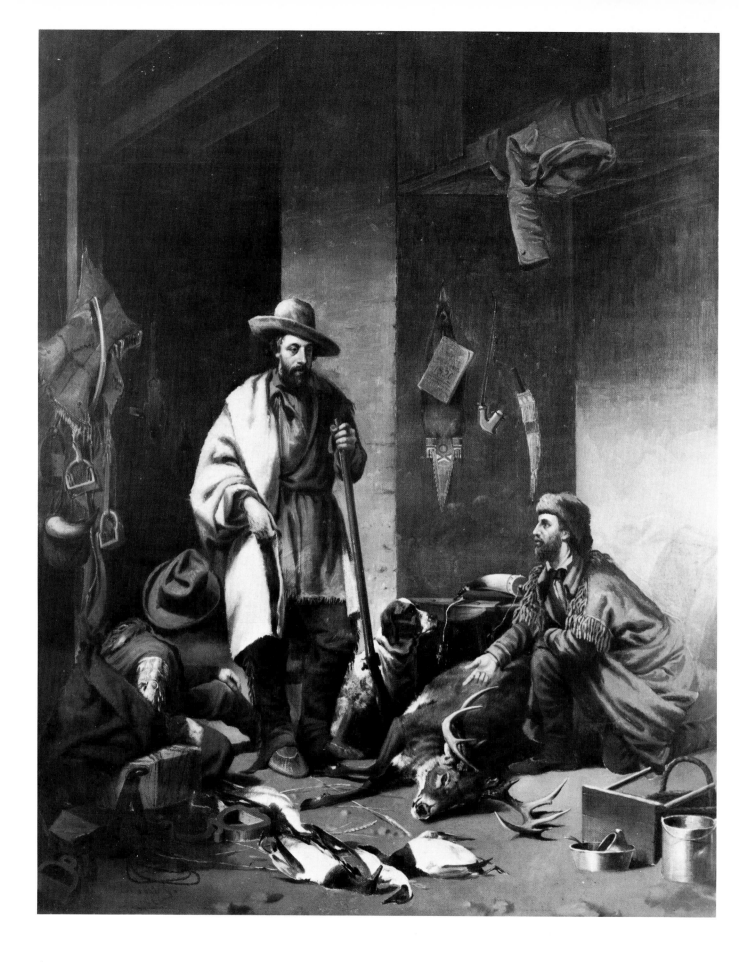

7 **John Mix Stanley** (1814–1872)
The Disputed Shot, 1858
Oil on canvas
36 x 29 in. (91.4 x 73.7 cm)

Inscribed lower left: *J. M. Stanley./
1858*
Gift of William Wilson Corcoran 69.5

The Disputed Shot portrays three mountain men, hardy trappers who hunted beaver in the Rocky Mountains before the Civil War. Prior to the 1840s the mountain man—infrequently portrayed in either art or literature—was considered a colorful, individualistic character who had difficulty living within the constraints of civilization. However, during the 1840s and 1850s the mountain man's image changed, and he became a national hero immortalized in countless narratives and paintings. These decades were ones of great expansion and settlement in the West, and the mountain man, still tough and self-reliant, came to be viewed not as an uncivilized outsider but rather as the very vanguard of civilization, the first explorer of the West.

The Disputed Shot perpetuates the idea of the trapper as hero. The middle figure in particular commands attention: his inward gaze isolates him and gives him an air of utmost seriousness. Tall and handsome, he is literally someone to be looked up to. Moreover, certain anomalous elements point obliquely to his role as civilizer. A slain deer, frequently a symbol for plenty in pictures of the West, combines with the unusual elements of ducks and wheat to form an informal cornucopia. With the inclusion of the wheat, the cornucopia alludes not only to the natural abundance of the West but to its potential for farming—the basis of America's civilization.

Among the many pictures of trappers from the 1840s and 1850s, *The Disputed Shot* is unique in its indoor setting, presumably one of the many forts built by the fur companies to protect the men from the Indians.[1] The interior setting was undoubtedly adopted to allow the artist to display the trapper's gear as a sort of miniature mountain-man

museum. Of particular interest are, to the right, the Indian tobacco pouch and pipe (the pouch made out of a whole animal skin with the teeth still visible at the top), the decorated knife sheath, the powder or water horns, the Indian-style buckskin saddle to the left, and the beaver traps, one far left and the other on the back wall. The trappers wear buckskin clothes and moccasins and wrap themselves in trade blankets. Hanging from the right rear wall is a pamphlet dated 1820, perhaps intended to set the painting in that year when the Rocky Mountain fur industry was entering its heyday.

Trappers were rarely portrayed in John Mix Stanley's oeuvre, which is basically devoted to Indian subjects. Executed when the artist was living in Washington, D. C. (1854–1863) and actively seeking commissions, *The Disputed Shot* was probably created in part to capitalize on the current popularity of the trapper theme. Stylistically the painting seems to have been designed to appeal to a cultivated Eastern audience. With its high finish, large-scale figures, and academic composition, it is quite different from the freely composed and executed scenes that characterize Stanley's earlier work. However, these artful differences give the painting a monumental and heroic quality that Stanley was seeking in his presentation of the mountain man.[2]

JRM

1. William H. Goetzman, *The Mountain Man* (New York: Buffalo Bill Historical Center and Visual Books, 1978), p.59.
2. I wish to thank Julie Schimmel, of the National Museum of American Art, who is writing her dissertation on Stanley and freely discussed with me her ideas on *The Disputed Shot,* some of which are incorporated in this entry.

Alfred Jacob Miller (1810–1874)
Election Scene, Catonsville,
Baltimore County, c. 1860
Oil on academy board
11¼ x 15½ in. (28.5 x 39.3 cm)

Inscribed lower right: *AJM*
[monogram]; on paper attached to back:
Election Scene/Catonsville Balt
County/Md Miller ᵖᵗ/Balt
Gift of Mr. and Mrs. Lansdell K.
Christie 60.3

Election Scene, Catonsville is an unusual subject for the artist and the times. Although Alfred Jacob Miller painted an occasional view of life in and around his native city of Baltimore, he is known primarily for his paintings of Indians and for his portraits. This particular work is a close variation on a watercolor he executed in 1845.[1] The fact that Miller reworked a sketch done fifteen years before is not surprising since this was his general practice with his Indian subjects. What is surprising is when this work was created.

It is believed that *Election Scene* is the painting of that title exhibited in 1861 at the Pennsylvania Academy of the Fine Arts, Philadelphia.[2] In view of the fact that the election of Lincoln in 1860 precipitated the sequence of events that led to the outbreak of hostilities in April 1861, a jubilant election scene must have struck some viewers at the Academy in May and June of that year as bizarre. Nor can it be forgotten when looking at this work that Maryland was divided on secession and remained loyal to the union largely because of measures taken against Southern sympathizers in 1861.

What prompted Miller to undertake such a charged subject in that memorable year is open to speculation. Ostensibly *Election Scene,* like Bingham's *The County Election* (Cat. No. 5), provides an exuberant view of grass-roots politics. However, the riffraff depicted, like the disreputable types in Bingham's composition, suggest that a criticism of the political system may have been in-

tended. Moreover, the work, though small in scale, is indebted to one of the most famous political paintings of the early nineteenth century—Eugène Delacroix's *Liberty Leading the People on the Barricades* (1830). The pyramidal composition, the placement of figures close to the picture plane, the use of a building in the right distance to establish pictorial space—not to mention the dramatic sky and coloration—echo the masterpiece of an artist Miller admired and copied when he was a student in Paris in the early 1830s.[3] That Delacroix's painting celebrated the July Revolution of 1830, in which the common people of Paris rose up against the oppressive reign of Charles X, would have been well known to Miller. Miller's people are far less noble and the artist's attitude toward them is ambiguous, but the ominous sky seems a portent of the violence that was to come.

EJN

1. In the M. and M. Karolik Collection, Museum of Fine Arts, Boston.
2. See Mary H. Forbes, "Election Scene, Catonsville, Baltimore County by Alfred Jacob Miller," *Corcoran Bulletin,* 13 (October 1963): 15–17, for a discussion of the history of this work and its probable date of execution.
3. Wilbur Harvey Hunter, Jr., *Alfred Jacob Miller: Artist of Baltimore and the West* (Baltimore: Peale Museum, 1950), n.p.

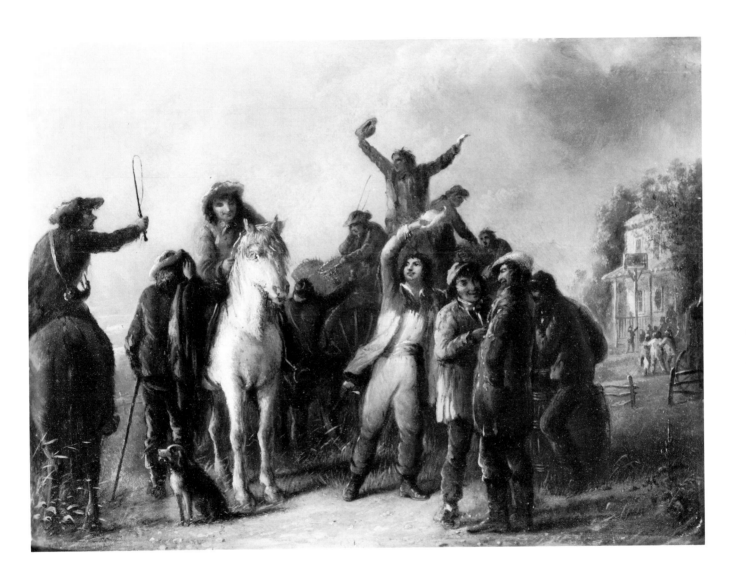

9 **James Walker** (1819–1889)
Review of Rhode Island and Maine Troops, 1861
Oil on academy board
16½ x 21⅝ in. (41.8 x 55 cm)

Inscribed lower left: *J. Walker, 1861*
Museum purchase 53.13

James Walker was a painter whose specialty was military subjects.[1] In 1861, at the outbreak of hostilities, he was in Washington working on a painting for the Capitol dealing with the Mexican War, *The Battle of Chapultepec.* Although Walker painted several large canvases depicting major battles of the Civil War, *Review of Rhode Island and Maine Troops* is typical of his regimental portraits. Dated 1861, the painting probably was executed in or near Washington during the late summer or early fall of that year.

The defeat of the Union forces at the first battle of Bull Run on July 21, 1861, made it clear that the war would not be of short duration and that the army, composed primarily of state militia and volunteer regiments, needed to be trained. The training lasted throughout 1861 and into 1862. Parades and reviews were part of the regime that turned green troops into a proud, disciplined military force. As one trooper noted in his diary:

The summer weeks wore on. By and by the effects of discipline became apparent. The candidates for glory, having had their rotund garments skillfully tailored, and their faces bronzed by sunshine and storm, began to look like soldiers. The companies march like squads of automatons. The buglers wind their horns more musically, and every call is obeyed promptly and without question. The drills and parades are splendid sights, crowding these fields and fences with spectators.[2]

The subject of this painting is a review by a brigadier general of a New England brigade composed of two infantry regiments on the right from Maine and Rhode Island as well as some regular light artillery. In the right foreground appears a *vivandière,* a woman who traveled with the troops, did the laundry, and performed other duties for volunteer regiments.[3] The state flags prominently displayed identify where the troops are from. The smart, even rows of soldiers attest to their being well disciplined. It was this quality that the volunteer regiments lacked at the outset of the war, and it is this quality, acquired only after months of rigorous training, that the artist has emphasized in his precise and crisply drawn painting.

EJN

1. For a list of Walker's known works see Marian R. McNaughton, "James Walker—Combat Artist of Two American Wars," *Military Collector and Historian,* 9 (Summer 1957): 35. Additional information on Walker as well as further works are cited or illustrated in Hermann Warner Williams, Jr., *The Civil War: The Artist's Record* (Washington, D.C.: Corcoran Gallery of Art, 1961).
2. George S. Fobes, *Leaves from a Trooper's Diary* (Philadelphia, 1869), p. 13, quoted in Williams, *Civil War,* p. 59.
3. I wish to thank Kim Holien, Historian, U.S. Army, Center of Military History, for bringing this information to my attention and for discussing various details of the painting with me.

10 **Emanuel Leutze** (?) (1816–1868)
New York—Street Scene, 1859–1868
Pencil, watercolor, and ink on paper
16⅞ x 20¾ in. (42.9 x 52.7 cm)

Gift of Rear Admiral E. H. C. Leutze
17.11

*N*ew York—Street Scene depicts a section of Broadway between Vesey and Fulton streets. The building to the right is St. Paul's Chapel; to the left is a horsecar marked Central Park and Third Avenue, a route which at this point turned from Broadway into Park Row and traveled ultimately to Harlem.[1] The location was infamous for its traffic jams and congestion. On any weekday during the 1850s it was estimated that 15,000 vehicles passed St. Paul's, and in 1866 a footbridge was built at Fulton Street to protect the safety of pedestrians.[2] Describing the "crush in Broadway," one British traveler wrote:

There are streams of scarlet and yellow omnibuses, racing in the more open parts, and locking each other's wheels in the narrower. . . . There are loaded stages hastening to and from the huge hotels . . . carts and wagons laden with merchandise, and 'Young America' driving fast-trotting horses, edging in and out among the crowd.[3]

This drawing satirizes the street's confusion: a plethora of vehicles converges upon the scene, knocking over frantic pedestrians; to the left a sign advertises the "Life and Limb Insurance Comp. only 1$." But the depiction may not be all that exaggerated. As one passerby said, "I merely think of getting across the street alive."[4]

The drawing was given to the Corcoran Gallery in 1917 by Rear Admiral E. H. C. Leutze, grandson of Emanuel Leutze, to whom it has been traditionally attributed. Recently this attribution has been questioned on the grounds that in subject matter and drawing style it bears little resemblance to Leutze's other work.[5] This author feels the issue is still unresolved. The complex arrangement of a large number of figures, the vigorous dramatic gestures, as well as the agitated drawing style used to create a sense of confusion are qualities found in Leutze's history paintings.[6] Furthermore, Leutze was not without a sense of humor, as is evident in his political cartoon concerning the Civil War.[7] *New York—Street Scene* perhaps is a humorous urban counterpart to the artist's famous mural painting *Westward the Course of Empire Takes Its Way* (1862).[8] Both works are comprised of a veritable chaos of vehicles and people built up into a pyramid and topped by a gesticulating figure: in *Westward* he waves his hat at seeing the other side of the Rocky Mountains; in *Street Scene* an angry coachman waves his fist at an offending driver. Leutze was in Germany—first as an art student and then as an artist—between 1840 and 1859, except for one brief visit to the United States in 1851. He would have therefore done this work (if indeed it is his) sometime between 1859 and his death in 1868, and it may reflect his reaction to a city that had grown enormously in his absence.

JRM

1. I would like to thank Reese J. Stone of the New York City Transit Authority, Steven Miller of the Museum of the City of New York, and Richard J. Koke of the New York Historical Society for helping me identify the site of this drawing.
2. Charles Lockwood, *Manhattan Moves Uptown* (Boston: Houghton Mifflin, 1976), pp. 129, 274.
3. *Ibid.,* p. 129.
4. *Ibid.,* p. 131.
5. The attribution was questioned by Barbara Groseclose, author of *Emanuel Leutze, 1816–1868: Freedom is the Only King* (Washington, D.C.: National Collection of Fine Arts with the Smithsonian Institution Press, 1975). I would like to thank Dr. Groseclose for discussing this drawing with me. Several pictures depicting New York's traffic jams exist, and it is possible that the creator of one of these images may also be responsible for *New York—Street Scene,* though no verifiable connection has as yet been made. See particularly *Sleighing in New York,* a chromolithograph by Thomas Benecke published in Harry T. Peters, *America on Stone* (n.p.: Doubleday, Doran, 1931), Plt. 12.
6. For example, these qualities can be seen in *Washington Rallying the Troops at Monmouth* (1854), in the collection of the University of California Art Museum, Berkeley, California.
7. *Cartoon—Civil War Period* (Acc. No. 17.20) in the collection of the Corcoran Gallery of Art.
8. In the United States Capitol.

47

**11 David Claypoole
Johnston** (1797–1865)
Slave Auction, 1863
Pencil on paper
3⅝ x 3⅝ in. (9.2 x 9.2 cm)

Inscribed verso center: *House that Jeff Built*
Museum purchase 52.1

Slave Auction is the final preparatory study for a scene that was published in 1863 as part of David Claypoole Johnston's broadside *The House that Jeff Built,* one of the last prints the artist executed.[1] The broadside consists of twelve scenes dealing with slavery. In *Slave Auction* an obese, bulbous-nosed slave trader talks with a gentleman who puts his hands on a black woman, perhaps his new purchase. Flanking this group are two men holding newspapers labeled in the print "Prime Lot of Slaves." The scene in the broadside is accompanied by the verse:

*These buy the slaves, both male and female
And sell their own souls to a boss with a tail
Who owns the small soul of that thing
 call'd a man
Whose trade is to sell all the chattels he can,
From yearlings to adults of life's longest
 span,
In and out of the house that Jeff built.*

The verse parodies the nursery rhyme "The House that Jack Built," with Jeff being Jefferson Davis, the President of the Confederate States of America. Understandably, the slavetrader was a particular target of anti-slavery polemics; *Slave Auction* perpetuates his stereotypical image as a "low boor, unaccepted socially by the [Southern] aristocrats."[2] In fact, some of the best Southern families made their wealth in the slave business.

Known in his day as the "American Cruikshank,"[3] Johnston is now considered to be "one of our foremost antebellum humorous draughtsman."[4]

Born in Philadelphia, the son of an actress and a printer, he spent most of his working career in Boston, the center of the abolitionist movement. The anti-slavery sentiments expressed in this broadside from the Civil War are evident throughout his career. In 1831, for example, he drew the first pictorial banner for *The Liberator,* the newspaper of abolitionist William Lloyd Garrison. Another of the anti-slavery prints is *The Early Development of Southern Chivalry* (1861), which shows white children whipping black dolls. Though his production declined during the 1850s when the slavery issue began to command much more attention among cartoonists, Johnston is significant as an early defender of blacks.

JRM

1. A copy of *The House that Jeff Built* is owned by Dartmouth College, Hanover, New Hampshire. Much of the information for this entry was provided by David Tatham of Syracuse University and Malcolm Johnson of Boston.
2. Sterling Brown, *The American Negro: His History and Literature,* (New York: Arno Press, 1969), p. 46.
3. Malcolm Johnson, *David Claypool Johnston: American Graphic Humorist, 1798–1865* (Lunenberg, Vermont: Stinehour Press, 1970), p. 9.
4. William Murrell, *A History of American Graphic Humor* (New York: Whitney Museum of American Art, 1933), p. 103.

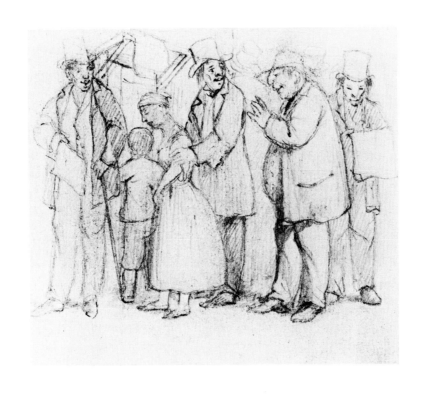

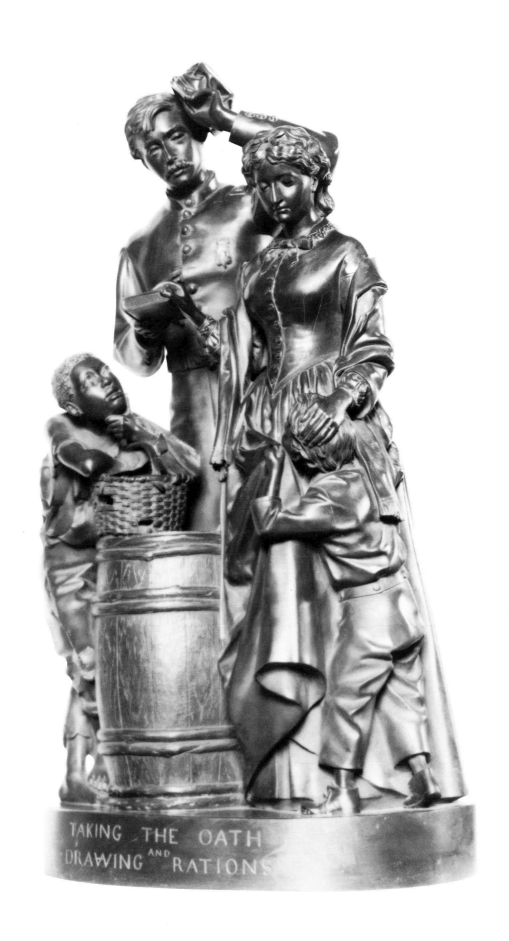

TAKING THE OATH
AND
DRAWING RATIONS

2 After **John Rogers** (1829–1904)
*Taking the Oath and Drawing
Rations,* 1866
Bronze
22¼ in. (55.9 cm)

Incised top of base: *JOHN ROGERS/
NEW YORK;* front of base: *TAKING
THE OATH/AND/DRAWING
RATIONS;* back of base: *PATENTED/
JAN 30 1866.*
Gift of Orme Wilson 61.32
See Color Plate

*T*aking the Oath and Drawing Rations
is considered to be one of John
Rogers' masterpieces.[1] The artist him-
self felt it contained some of the best
work of his life.[2] The sculpture, which
presents a moderate Northern position
on Southern Reconstruction, was
suggested by his wife's uncle, who had
witnessed a similar scene is Charleston.[3]
The piece, as was typical of Rogers'
groups, was cast in plaster for a general
audience. A limited bronze edition was
also made, but the number produced is
not known; the Corcoran's bronze is a
rare example.[4]

At the end of the Civil War the
pressing issue was the reintegration of
the Southern states into the Union. In
the early months of 1865 Congress
created the Bureau of Refugees,
Freedmen, and Abandoned Lands to
administer immediate relief to the
homeless poor. With President
Johnson's Proclamation of Amnesty in
May 1865, the means by which the
South could seek readmission and re-
gain suffrage were provided. Essential
to the process was the oath of al-
legiance. Rogers' group, in treating the
interrelated issues of oath and relief,
expresses a humane approach to Recon-
struction: a proud Confederate widow
swears allegiance to the Union, insuring

the South's future, which is symbolized
by her son and the Negro boy, probably
a former slave, who leans on the tat-
tered basket that will hold the family
ration of grain. The Union soldier tips
his hat respectfully as he administers the
oath.

Less than three years before Rogers
executed this work, he decided to pro-
duce in plaster inexpensive statuary for
the average household. These
groups—realistic genre scenes from
American life—established his reputa-
tion and elicited high praise from such
critics as James Jackson Jarves, who
remarked:

*We know no sculptor like John Rogers, of
New York, in the Old World, and he stands
alone in his chosen field, heretofore in all
ages appropriated by painting, a genuine
production of our soil, enlivening the fancy,
enkindling patriotism, and warming the
affections, by his lively, well-balanced
groups in plaster and bronze. Although
diminutive, they possess real elements of
greatness. In their execution there is no lit-
tleness, artifices, or affectation. The han-
dling is masterly, betraying a knowledge of
design and anatomy not common, and a
thoroughness of work refreshing to note.
His is not high art, but it is genuine art of
a high naturalistic order, based on true*

*feelings and a right appreciation of hu-
manity. It is healthful work, and endears
itself by its mute speech to all classes.*[4]

With this group Rogers captured the
hearts and minds of Americans, North
and South, recovering from the Civil
War. Historical events and the artist's
keen understanding of his public came
together in a work whose critical recep-
tion and popular appeal secured Rogers'
reputation.

EJN and ACW

1. David H. Wallace, *John Rogers: The People's
Sculptor* (Middletown, Conn.: Wesleyan Univer-
sity Press, 1968), p. 105.
2. Mr. and Mrs. Chetwood Smith, *Rogers' Groups*
(Boston: C. E. Goodspeed, 1934), p. 70.
3. Wallace, *Rogers,* p. 104.
4. *Ibid.,* p. 215, records one bronze (the Corco-
ran example, which in 1961 was at the Kennedy
Galleries, New York). The bronze master model
(reversed) is in the collection of the New York
Historical Society.
5. James Jackson Jarves, *The Art-Idea* (1864, re-
print Cambridge, Mass.: Harvard University
Press, 1960), pp. 220–221.

13 **Benjamin Franklin Reinhart**
(1829–1885)
An Evening Halt—Emigrants Moving to the West in 1840,[1] 1867
Oil on canvas
40 x 70 in. (101.6 x 177.8 cm)

Inscribed lower left: *B. F. Reinhart/ 1867*
Gift of Mr. and Mrs. Lansdell K. Christie
59.21

*A*n Evening Halt—Emigrants Moving to the West in 1840 is set during the earliest period of transcontinental migrations to California and Oregon, which—when they actually began in 1841—marked the inception of a period of expansionism in American history. The wagon train recurred repeatedly as a theme throughout the remainder of the century and became, particularly after its most famous incarnation in Leutze's *Westward the Course of Empire Takes Its Way,* a symbol for the fulfillment of America's "manifest destiny" to conquer and civilize the entire continent. Though recording a commonplace incident in the lives of the settlers, *An Evening Halt* in format resembles a historical epic. The covered wagons, dramatically silhouetted against the sky, form the apex of a grand triangular composition which organizes a large number of people and animals and focuses attention on the thoughtful figure of the pioneer mother. The focus is significant, because the family and particularly its women were seen as the means of civilizing the West. The painting's monumentality stresses the heroic nature of the journey.

Benjamin Franklin Reinhart's view of the emigrants' journey is idyllic in comparison with what is known about the actual hardships they endured. The trip to Oregon was different from that made by earlier westward-moving settlers. The distances covered were much greater, and often the poorly marked or barely passable route was through inhospitable terrain. The settlers took few horses and no sheep, as they were dif-

ficult to feed in the desert. However, in *An Evening Halt* there is a good road, an abundance of feed and water, and a plethora of horses and sheep. Another inaccuracy is the Conestoga-style wagons. Too awkward for the arduous passage, they were replaced by smaller, more flexible types of covered wagons.

This pastoral vision also differs from most pre–Civil War paintings of wagon trains, which stressed the dangers the emigrants faced. Two popular themes of this earlier era were the Indian attack and the prairie fire. In this respect *Evening Halt* undoubtedly reflects changing attitudes about the Great Plains: traditionally thought of as a desert, it came to be seen as a treeless but fertile garden as settlement there was encouraged. Moreover, though the 1860s and 1870s witnessed fierce Indian battles, post–Civil War images of wagon trains generally emphasized peaceful progress to the West. They express, as Dawn Glanz has pointed out, "the confident vision of westward emigration" that prevailed during the postwar period.[2]

The aesthetic behind *An Evening Halt* also effected the positive tone of the work. With its plump, rosy-cheeked figures and touching familial relations, the painting embodies the Victorian notion of sentiment. The image also has a high finish, is quite detailed, and contains a number of amusing vignettes such as the sheep watching the boy drawing water and the horse nipping the sheep in the background. This style is associated with Dusseldorf, a German center of history and genre painting

where a number of Americans, including Reinhart, trained. Sweet, anecdotal, and very realistic, works like *An Evening Halt* were frequently reproduced as lithographs and appealed to a large audience in mid-nineteenth century America.[3] *An Evening Halt* was not mass produced, but its sweetness as well as its patriotic ideas about civilizing the West would have made it a perfect living-room picture for any American home.

JRM

1. Since its acquisition by the gallery in 1959, this painting has been called the *Emigrant Train Bedding Down for the Night.* However, in 1868 Reinhart exhibited at the National Academy of Design *An Evening Halt—Emigrants Moving to the West in 1840,* which seems to correspond to this painting and thus would be the proper title.
2. Dawn Glanz, "The Iconography of Westward Expansion in American Art, 1820–1870: Selected Topics," Ph.D. dissertation, University of North Carolina at Chapel Hill, 1978, p. 147.
3. Peter Marzio, *The Democratic Art: Pictures for a Nineteenth-Century America* (Boston: David R. Godine, in association with the Amon Carter Museum of Western Art, Fort Worth, 1979), pp. 46–48, 123–125. A number of Reinhart's works were reproduced as chromolithographs, *The Morning Greeting* reportedly selling 200,000 copies. For this last statistic see George William Sheldon, *American Painters* (enlarged ed., New York: Appleton, 1881), p. 139.

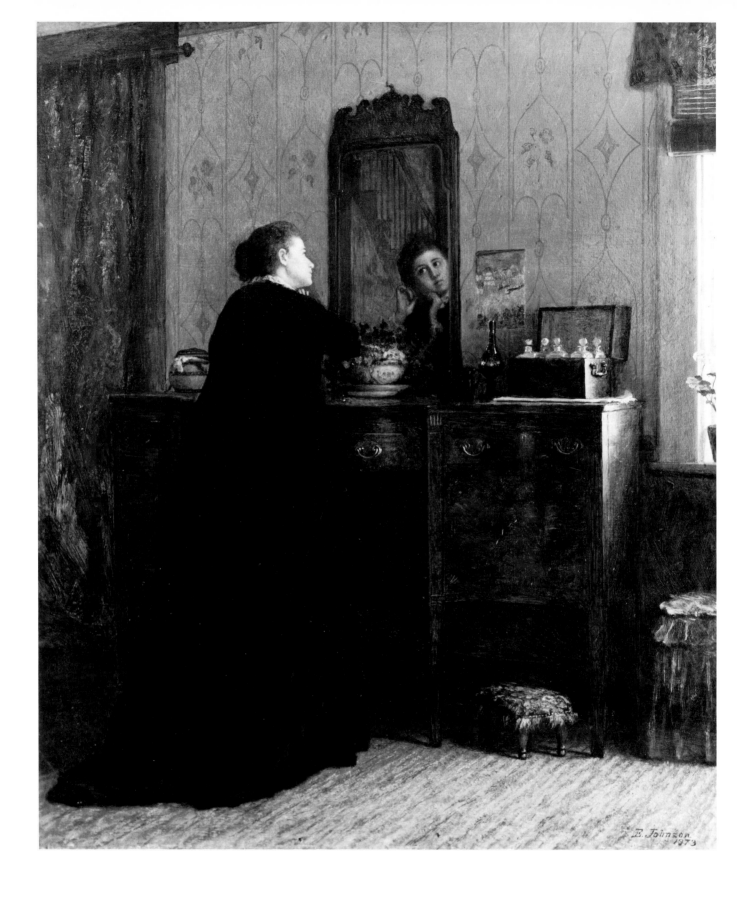

14 Eastman Johnson (1824–1906)
The Toilet,[1] 1873
Oil on academy board
26 x 22 in. (66 x 55.9 cm)

Inscribed lower right: *E. Johnson/1873*
Gift of Captain A. S. Hickey, U.S.N.
(ret.) in memory of his wife, Caryl
Crawford Hickey 57.21
See Color Plate

The Toilet was exhibited at the National Academy of Design, New York, in 1875. In a review of the exhibition Henry James praised Johnson's love for "the slow, caressing process of rendering an object" and delighted in his "coquetry of manipulation."[2] Although James was less enthusiastic about this particular work, his observations on Johnson's technique are telling. The artist's use of detail is exquisite, but the lively handling of pigment also gives this work the breadth and spontaneity of a sketch. His virtuosity, evident here in the differentiation in textures and surfaces, is without parallel in American art of the period. The thin, brushy strokes applied randomly over a light ground impart to the dressing gown an inner luminosity and outer sheen appropriate to the rich material. Johnson undoubtedly learned this technique from Rembrandt's works, which he studied during an extended stay in Holland in the early 1850s.

James was right on another point. Johnson is a painter of homely virtues. Like the Dutch and Flemish Masters he admired, he is not concerned with elegance, at least not with the fashionable elegance that occupied his European contemporaries such as Alfred Stevens, whose many canvases of contemplative ladies in chic interiors must have been known to him (see Fig. 5). Works like *The Toilet* speak of a different life style. The Queen Anne mirror from the mid-eighteenth century and the New York Federal sideboard (c. 1790), as handsome as they may be, are decidedly unfashionable. They give the interior an unpretentious, conservative air. The woman, too, though attractively attired, is restrained in dress and appearance.

With the adjustment of an earring, the woman finishes her personal grooming, presumably before beginning domestic chores on a beautiful spring day. The allusion to Venus at her toilet was undoubtedly intentional. The specific time of day is denoted by the woman's dress and by the low-raking light that comes in the window; the time of year (and perhaps the lady's time of life) is suggested by the geraniums on the window sill.

In the 1870s domestic interiors recur repeatedly in Johnson's oeuvre. The artist had married in 1869 and a daughter was born the following year. In 1872 the family moved into a house on West 55th Street in New York, the interior of which may be the setting for this painting. The extraordinarily intimate scenes from this period often include a woman or a child or both. Occasionally even the same furniture appears.[3] In the case of *The Toilet,* the allusion to the goddess of love in the guise of a young matron seems too pointed a reference to the artist's marital state to be coincidental. And the old furnishings project wholesome values as well as a sense of tradition as America approached its centennial year.

EJN

1. The painting has been frequently published as *The Earring.* However, Patricia Hills in her dissertation on Johnson (*Genre Painting of Eastman Johnson,* New York: Garland, 1977, p. 141) identifies it as the work exhibited as *The Toilet* at the National Academy of Design in 1875, No. 174, when the painting was owned by James Sloan. Contemporary reviews, including that of Henry James cited below, support this identification.
2. Henry James, "On Some Pictures Lately Exhibited," *The Galaxy,* 20 (July 1875); quoted in John W. McCoubrey, ed., *American Art 1700–1960* (Englewood Cliffs, N.J.: Prentice-Hall, 1965), pp. 164–165.
3. See, for example, the mirror and sideboard in *After the Feast* (1872), illustrated in *American Art Review,* 3 (July–August 1976): 19.

15 **Enoch Wood Perry, Jr.** (1831–1915)
Seated Young Lady, Writing, c. 1870[1]
Pencil and charcoal heightened with
Chinese white on grey paper
14 x 10 in. (35.6 x 25.4 cm)

Gift of J. William Middendorf, II
1977.53.77

When this sketch was executed, Perry ranked with Eastman Johnson and Winslow Homer (see Cat. Nos. 14, 18) among the leading genre painters of the day. Like those artists, he depicted typically American scenes. Perry specialized in domestic subjects, frequently of a rustic nature, that tended to be quiet and gentle in mood and subject matter. Such is the case with this drawing, whose simple image of a young married woman sitting in a field writing a letter projects the "delicacy of expression" for which the artist was generally admired by his contemporaries.[2]

Like many artists of his generation, Perry went to Europe to obtain the kind of academic training, particularly in figure drawing, unavailable in America at the time. In fact, his career closely parallels that of Eastman Johnson. They studied in Dusseldorf within a few years of each other, and both worked under the famous French academician Thomas Couture in Paris. It is not surprising, therefore, that their art frequently displays stylistic and thematic kinships. The figure in this particular piece, for example, is a type encountered in the work of Johnson.

Today Perry's oeuvre is not as well known as that of Homer or Johnson. While his paintings occasionally appear labored in execution, his drawings exhibit a technical virtuosity that suggests that he was responsive more to the pencil than to the brush. Certainly in works such as this he seems the effortless draftsman. His confident handling of line and bold use of chiaroscuro create a sense of form and light essential to its peaceful air.

EJN

1. I wish to thank Linda Mary Jones Gibbs for sharing her views on this work and its date with me. She has recently completed her master's thesis on Perry at the University of Utah: "Enoch Wood Perry, Jr.: A Biography and Analysis of his Thematic and Stylistic Development."
2. See, for example, "American Painters. E. Wood Perry," *The Art Journal,* 1 (1875): 216.

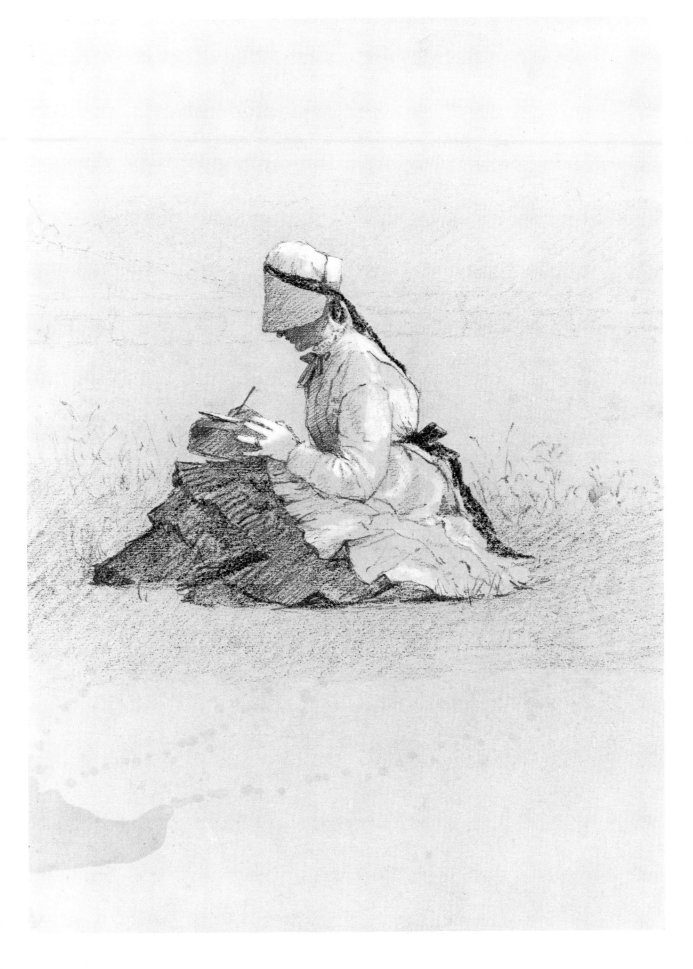

16 **James Wells Champney** (1843–1903)
Customs Shed, 1875–1876
Ink and wash on paper
9⅛ x 12⅞ in. (23.1 x 32.7 cm)

Inscribed lower left: *Champ*
Museum purchase 63.3

Customs Shed was published in 1876 in the French periodical *L'Illustra-tion* as part of an article, "Notes sur les Etats-Unis," which detailed in serial installments the American visit of Le Capitaine Bérard, probably a fictitious character invented by the anonymous author. James Wells Champney had studied in Paris and was there when he received this and a number of other commissions for the series. *Customs Shed* illustrates Bérard's following remarks:

Do you want to be expedited still more promptly? Make a little gift to the man who visits your bags and all will go well. He hints at it himself while speaking to you softly and pretending to open your trunk. Slip 20 francs into his hand, do not be ashamed. . . . In New York, the corrupt administration, graced by a sort of conni-vance of all the advisors of General Grant and, is it necessary to say, perhaps also graced by the indifference . . . of the Presi-dent himself, this corruption has passed beyond all limits. It is time to clean the Augean stables.[1]

In the center of the picture a gentleman slips a coin into the hand of a clerk, while a porter lifts up the apparently unopened trunk. To the right another official opens a trunk while the owner sits down to wait out the inspection.

The New York Customs House, as collector of two-thirds of all tariff reve-nue, was one of the largest federal in-stitutions outside Washington. During the Grant administration it was rife with corruption; scandals concerning it broke in 1871, 1874, and in the spring of 1876 just prior to the publication of the Bérard article. The bribing of cus-toms agents by tourists was merely a mild example of more serious malfea-sance which riddled the agency. Moreover, the customs house scandals were just one of the many occurring during the Grant administration. The incident depicted in *Customs Shed,* though minor, serves effectively as a symbol for corrupt politics and business during that era.

Though best known for his paintings and pastel "translations" of Old Master works, Champney also worked exten-sively as an illustrator. In addition to "Notes sur les Etats-Unis" he illustrated two travel series, "The Great South" and "Brazil: The Amazon and the Coast," for the popular magazine *Scribner's Monthly.*

JRM

1. "Notes sur les Etats-Unis," *L'Illustration,* 67 (April 22, 1876): 261. Author's translation.

7 Horace Bonham (1835–1892)
Nearing the Issue at the Cockpit,
1878[1]
Oil on canvas
20 x 27 in. (50.8 x 68.6 cm)

Inscribed upper right: *Horace Bonham/—*; on verso before relining: *Painted by // Horace Bonham, // York Pa. // 1879*[2]
Museum purchase 99.6
See Color Plate

Ostensibly, *Nearing the Issue at the Cockpit* depicts a diverse group of spectators at a cockfight. Elements of the painting suggest, however, that the picture is less a portrayal of a sporting scene than a commentary on American life and politics.

Notorious for the extravagant wagers it inspired, cockfighting was a popular form of entertainment in the early nineteenth century. Because of the cruelty of the sport, it was outlawed in Bonham's home state, Pennsylvania, in 1830, and throughout the country by the end of the century; however, it continued as a covert amusement in many areas. Early depictions of cockfighting generally focus on the contest or the contestants.[3] Bonham departs from this practice by portraying only the audience.

Sporting events provided rare opportunities for members of different classes to mingle together. It seems unlikely, however, that the artist would have presented such a sympathetic view of the spectators of an illegal sport simply to enumerate the various social and ethnic types of men attracted to the spectacle. It is also possible that the motley group collectively represents the enfranchised adult male population of the United States and reflects the immigration policies of the country. In 1870 the fifteenth amendment was ratified, guaranteeing that no adult male resident would be denied the right to vote "on account of race, color, or previous condition of servitude"; two years before, a treaty with China opened the way for increased immigration from the Orient. Representatives of the newly enfranchised are prominent in Bonham's composition.

The cockpit was widely used at the time among journalists and caricaturists as a metaphor for the political arena.

Bonham, who had edited two newspapers in York, Pennsylvania, in the early 1860s, would have been conversant with this imagery. The presidential election of 1876 had been very close and was ultimately given to Rutherford B. Hayes by one vote of a congressional commission, although Samuel J. Tilden had won a majority of the popular vote. The spectators, therefore, could well be America's voters observing a political battle that was more intriguing and bloody than any cockfight. While this interpretation is admittedly speculative, the unusual subject and diverse types when considered in light of contemporary political events encourage conjecture.

EJN and ACW

1. The inscribed date has been read as 1870 and so published in a number of places, including *A Catalogue of the Collection of American Paintings in the Corcoran Gallery of Art* (Washington, D.C.: Corcoran Gallery of Art, 1966), Vol. I, p. 132. However, close examination reveals the date to be 1878. The painting was exhibited at the National Academy of Design, New York, in 1879 (No. 104).
2. A photograph of this verso inscription, hereto unrecorded, is in the object file, Corcoran Gallery of Art. It was probably added on the occasion of Bonham's submitting the work to the National Academy's spring exhibition.
3. Cockfights and famous fighting cocks were depicted in British sporting art of the eighteenth and early nineteenth centuries; see, for example, Henry Alken's compositions published in *The National Sports of Great Britain* (London, 1821).

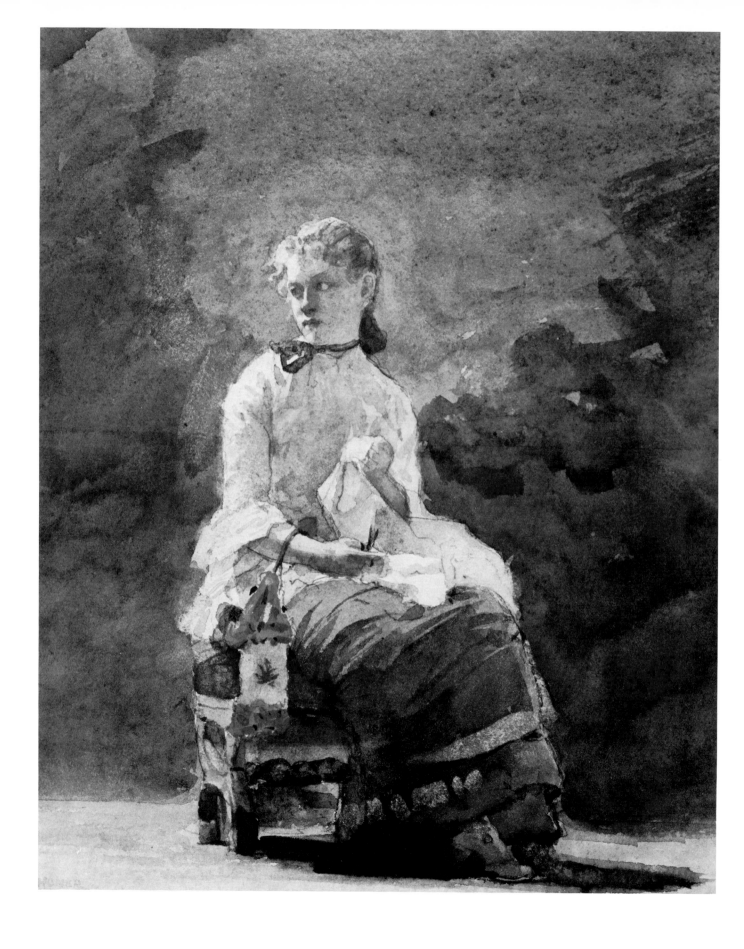

Winslow Homer (1836–1910)
Woman Sewing, 1878–1879 [1]
Watercolor over pencil on paper
9¾ x 7⅞ in. (24.8 x 20 cm)

Inscribed lower left: *Homer*
Bequest of James Parmelee 41.15
See Color Plate

Woman Sewing is one of a number of variations on the theme of a woman engaged in everyday activities created by Homer in the 1870s, a period bracketed by a trip to Paris in 1867 and a sojourn in Tynemouth, England, in 1881–1882. Frequently she was portrayed alone in a landscape or an interior that emphasized her gentleness. This work is unusual, although not unique, in its depiction of a young lady in an undifferentiated space. Its date is suggested by a watercolor from 1879, *Girl with a Letter,* which is similar in composition, style, and mood; in fact, the subject may be the same model. [2]

Images of women reading, writing, sewing, musing are ubiquitous in American art of the late nineteenth century (see, for example, Cat. No. 15). Like paintings of carefree children, these pictures of young women on the threshold of life offer visions of an innocent world far removed from the masculine realm of business and industry. The subject was not, of course, an American preserve. The same theme recurs repeatedly in the European art and Japanese prints that Homer probably saw in Paris. Although one or both of these influences can be detected in many of Homer's works of the 1870s,

Woman Sewing does not seem to be indebted to those sources. Rather, the almost candid and spare composition, with its isolated figure modeled by a strong light, is more suggestive of a photograph than of any European or Oriental prototype. And this photographic quality is reinforced by the unidealized features of the woman's face. The simplified background contains no compositional interest; it acts merely as a foil for a study in mood and character.

Homer's contemporaries admired his naturalism and his effective use of chiaroscuro, particularly in his sketches. [3] These qualities are central to the aesthetic of this modest work, whose quiet intensity gradually engages the viewer's attention. G. W. Sheldon's observations concerning a group of watercolors exhibited in Boston in 1878 could well be applied to *Woman Sewing:*

In composition they were not remarkable—few of Mr. Homer's productions are noteworthy in that respect; he does not seem to care greatly for it; but, in their ability to make the spectator feel their subjects at once, they were very strong. . . . The handling of the figures was easy and decisive; you said to yourself that the pictures had been made quickly and without effort, and you felt in most instances, at least, they were true to Nature. [4]

EJN

1. I wish to thank Helen Cooper, Yale University Art Gallery, who is doing her dissertation on Homer's watercolors, for discussing this work and its date with me. The title was given to the piece by Lloyd Goodrich in 1948. When it was on the New York market in 1920 it was called *Woman Seated.* Homer's original title is not presently known.
2. *Girl with a Letter* is illustrated as Fig. 31 in Lloyd Goodrich, *Winslow Homer* (New York: Braziller, 1959). Although there are certain similarities in facial features and dress, there are sufficient differences to make a positive identification impossible. Mrs. Cooper suggests that the same figure appears in a watercolor of the same period, *Woman with a Rose* (San Diego Museum of Art), and that the model may be a German girl named Kashi. Mrs. Cooper also brought to my attention the presence of a similiar bench in *Woman Peeling a Lemon* (Sterling and Francine Clark Art Institute) of 1876, which also has an undefined setting.
3. See, for example, S. N. Carter, "The Water-Colour Exhibition," *The Art Journal,* 5 (1879): 93–94.
4. George William Sheldon, *American Painters* (New York: Appleton, 1879), p. 25.

19 **John George Brown** (1831–1913)
The Longshoremen's Noon, 1879
Oil on canvas
33¼ x 50¼ in. (84.4 x 127.6 cm)

Inscribed lower left: *J. G. Brown
N.A./N.Y. 1879*
Museum purchase 00.4

Best known for sentimental scenes of bootblacks, newsboys, and urchins, John George Brown painted *The Longshoremen's Noon* at the end of a very creative decade marked by an exploration of a variety of subject matter and the establishment of an international reputation. Although children appear in the painting, attention focuses on the dockworkers taking their noontime rest. At the center, one worker, presumably having just put aside a newspaper, seems to expound on an issue of the day to his half-interested captive audience. The subject of the man's remarks is neither specified nor implied by the details with which Brown fills his composition. But the specificity of the scene arouses the viewer's curiosity and makes the painting appear to be a faithful record of an actual event.

The artist, who compared his approach to a subject with that of a "good newspaper reporter,"[1] teases his audience with the crumpled *Sun,* whose date and headline cannot be read. At the same time, he gives prominence to the name of the boat and thereby establishes the scene's historical legitimacy. The *J. R. Baldwin,* an unrigged barge registered in Albany, shuttled material and goods up and down the Hudson, one of the busiest rivers in America at the time.[2] The cotton bales on which the men lounge are presumably in the process of being loaded for shipment upriver to some manufacturer. These details reflect Brown's conviction, reported in a book published in the year this work was executed, that art "should express contemporaneous truth, which will be of interest to posterity."[3] The artist went on to voice his hope that viewers of his paintings a hundred years later would know from his work what people of that period looked like. The documentary value of this particular

work exists in the variety of physical types and costumes, rendered with the photographic accuracy for which Brown was admired, as well as in the detail of the scene itself. The painting was undoubtedly created in the artist's studio with models, but the composition is full of what one commentary called "local interest"[4] and a note of on-the-spot immediacy is struck by both the newspaper and the barge.

Although urban subjects are not infrequent in American art of the late nineteenth century, rural scenes with their nostalgic allusions to a disappearing way of life predominated. *The Longshoremen's Noon* is an unusual naturalistic representation of city laborers, albeit at rest, at a time when such a theme could be misinterpreted as social criticism or considered vulgar. Brown avoids this problem. Although he presents an accurate view of a part of New York, his well-groomed and clean workmen project respectability while the children add a picturesque flavor to the scene. These laborers present no threat to society or, by extension, to the artist's patrons.

EJN

1. G. W. Sheldon, *American Painters* (New York: Appleton, 1879), p. 141.
2. I wish to thank Robert Scheina, Historian, U.S. Coast Guard, for providing me with information on the *J. R. Baldwin,* and Robert Post, Curator, National Museum of American History, Smithsonian Institution, for discussing this work with me.
3. Sheldon, *American Painters,* p. 141.
4. See *William T. Evans Sale,* American Art Association, February 1, 1900, n.p., No. 175.

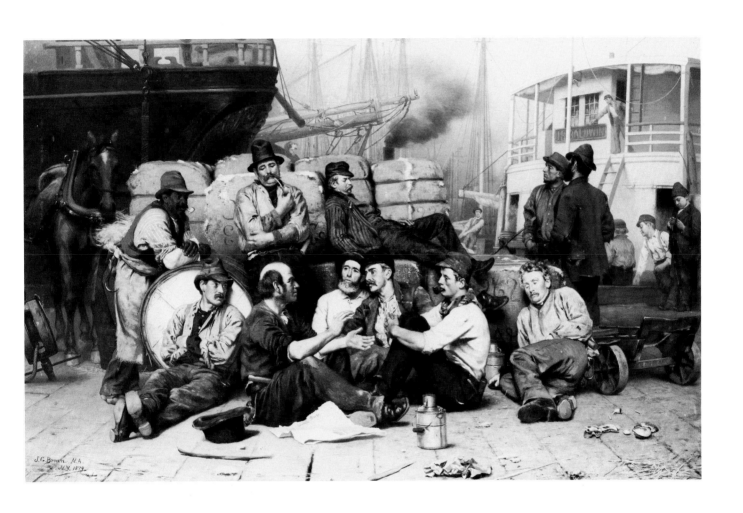

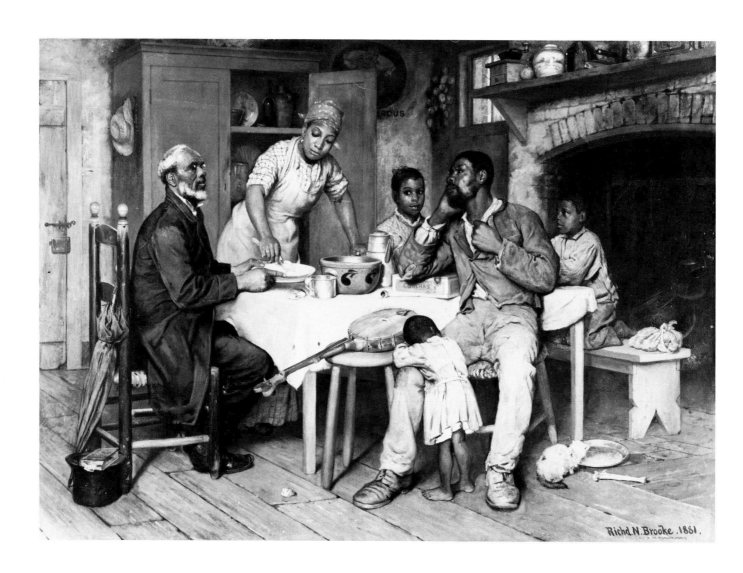

Richard Norris Brooke (1847–1920)
A Pastoral Visit, Virginia, 1881
Oil on canvas
47¾ x 65¾ in. (121.3 x 167 cm)

Inscribed lower right: *Richd. N. Brooke.*
1881./(ELEVE DE BONNAT-PARIS)
Museum purchase 81.8

A Pastoral Visit, painted in Richard Norris Brooke's hometown of Warrenton, Virginia, used local people as models—"old" George Washington, Daniel Brown, and Georgianna Weeks.[1] The inscription "Eleve [pupil] de Bonnat" indicates Brooke's pride in his Parisian training under Léon Bonnat, one of France's leading academicians. Brooke was also greatly influenced by contemporary European painters of peasants. About *A Pastoral Visit* he wrote in 1881 that it had been his "aim, while recognizing in proper measure the humorous features of my subject to elevate it to that plane of sober and truthful treatment which dignified the peasant subjects of Jules Breton."[2] Like Breton, Brooke portrayed his people as being humble and sincerely religious, the subject, perhaps, of Christ's promise that the meek will inherit the earth. The family's lowly status is emphasized by their environment—a rough kitchen filled with hand-me-down furniture and dishes—as well as by their worn and patched clothes. But the viewer primarily feels the love shared by the family and their simple respect for a man of God.

In 1914 Brooke further described *A Pastoral Visit* as "a sincere reproduction of a phase of pastoral life familiar to every American. But the war changed everything. The romance, the essential pastoral quality of Negro life was undermined. I had caught the last flashes of a fast changing social order."[3] The tendency evident in this passage to see Southern Negro life as a tranquil pastorale had a long history in nineteenth-century America. Though the reasons for the development of this view are complex, the pastoral ideal that it represents—and which is also embodied in European peasant painting—manifested itself in nineteenth-century art in part as a reaction against life in an urban and industrialized society. In creating this traditional image of Negro life, Brooke as a Southerner may also have been influenced by the trend among contemporary Southern writers and politicians to idealize black life under slavery, a trend that was motivated, perhaps subconsciously, by a desire to re-establish the former dominant/dependent relationship between whites and blacks.

In view of Brooke's background and artistic intentions, it is not surprising that *A Pastoral Visit* presents a number of stereotypes: the strong and loving Negro woman; the kindly and humble pastor; the happy and perhaps footloose Negro father. Moreover, the inclusion of the banjo, with the implication that the instrument has just been put down, certainly reflects the view of blacks as a carefree people always dancing and making music. Even the emphasis on religion is stereotypical in that blacks, ever since the abolitionist writers of the 1840s, were regarded as "natural Christians." Despite these stereotypes, *A Pastoral Visit* remains a moving and powerful image, perhaps in large measure because the people are specific individuals rather than generalized types.

JRM

1. *A Catalogue of the Collection of American Paintings in the Corcoran Gallery of Art* (Washington, D.C.: Corcoran Gallery of Art, 1966), p. 156, states that the pastor was Daniel Brown. However, Brooke's manuscript, *Record of Work,* a copy of which is preserved in the library of the National Museum of American Art, states that "old" George Washington was the pastor and Daniel Brown was the host.
2. Letter from Brooke to the director of the Corcoran Gallery, dated April 18, 1881, in the possession of the Corcoran Gallery of Art.
3. Clipping from the *Washington Times,* June 9, 1914, in the vertical file of the Corcoran Gallery.

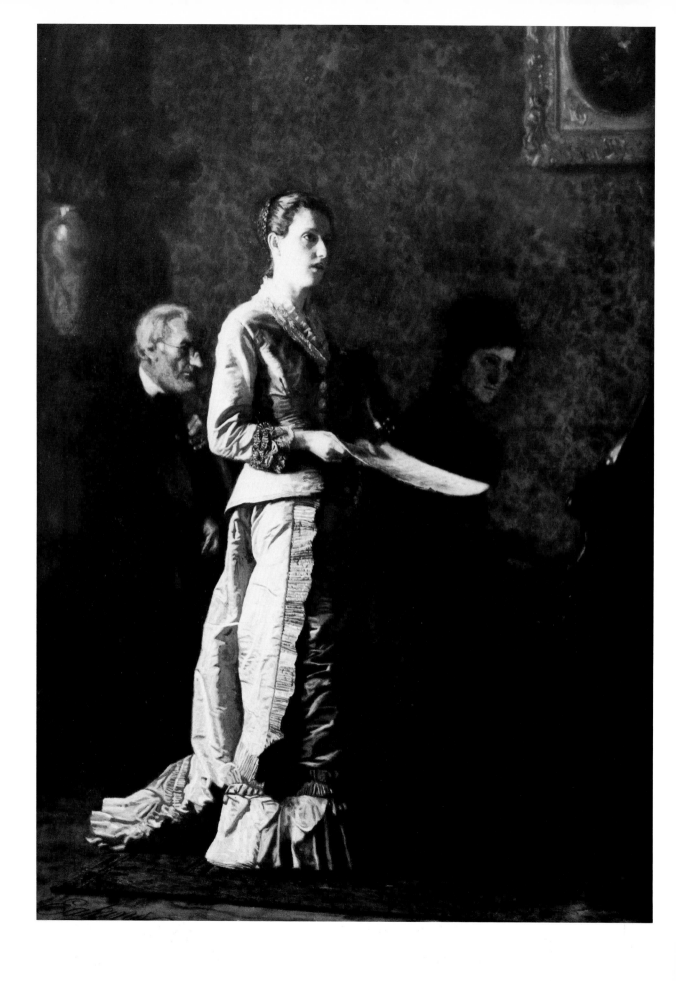

Thomas Eakins (1844–1916)
The Pathetic Song,[1] 1881
Oil on canvas
45 x 32½ in. (114.3 x 82.6 cm)

Inscribed lower left: *Eakins./1881*
Museum purchase 19.26
See Color Plate

The Pathetic Song is one of those rare paintings that defy classification. A fusion of portraiture, genre, and history painting, it transcends the limitations of each. As a realistic portrayal of three musicians at a seemingly specific entertainment in a Philadelphia house,[2] the picture combines elements of an informal group portrait with ingredients of a genre painting while in the transfixed gaze of the singer there is a visual reference to representations of the ecstasy of St. Cecilia, patron saint of music. Thus, *The Pathetic Song* is far more than a faithful and sensitive transcription of a contemporary scene; it also alludes to the role of the artist as divine instrument or intermediary between the real and spiritual worlds. When the painting was shown in New York and Philadelphia, it was well received: one critic remarked, *"Lady Singing a Pathetic Song* ranks him among the foremost painters of his day."[3]

Starting with his first major composition, *Street Scene in Seville* of 1870,[4] Eakins displayed a thematic interest in musical subject matter. Throughout his life he executed genre portraits, such as *The Pathetic Song,* of professional and amateur musicians at work, intimate portraits of female members of his family at the piano, and straight portraits of musicians and critics. This painting represents a culmination of Eakins' involvement with this theme after a decade of treating similar subjects. The work expresses the artist's deep personal reaction to music and his close association with the social and cultural life of Philadelphia, of which such informal musical performances were an integral part.[5] Its mournful air may also reflect Eakins' sorrow following the death of his fiancée, Katherine Crowell, in 1879.

By modelling the singer with a strong, raking light, Eakins physically isolated her from the rest of the scene and placed her in a luminous spiritual realm. Her fixed stare suggests she is experiencing a kind of divine ecstasy that psychologically separates her from her two colleagues and the implied spectators in front of the picture plane. At the same time that Eakins injects this almost mystical quality into the picture, he does not idealize: the singer's ill-fitting bodice reinforces the painting's unremitting reality. In this depiction of a sustained climactic moment in a performance, Eakins captured the intense emotional impact of music, its transient poignancy and transcendent nature.

EJN

1. For various titles under which the painting was exhibited, see a letter from Gordon Hendricks, dated February 25, 1966, to James Harithas, in the accession file for the painting at the Corcoran. The letter also contains contemporary references to the painting. Additional information on this work can be found in Joan Lemp, "Thomas Eakins: An Evaluation of the Influence of Music on his Paintings," an unpublished paper in the file.
2. The singer is Margaret A. Harrison; the pianist is Susan Hannah Macdowell, who studied with Eakins and married him in 1884; and the cellist is Mr. Stolte, a member of the Philadelphia Philharmonic Orchestra.
3. *New York Times,* April 15, 1881; quoted in the Hendricks letter noted above.
4. Illustrated in Sylvan Schendler, *Eakins* (Boston: Little, Brown, 1967).
5. It has been suggested by Lemp that the setting is the living room of Eakins' house. While the piano is similar to one Eakins depicted in other paintings (*Frances Eakins,* Nelson Gallery, Atkins Museum; *At the Piano,* University Art Museum, University of Texas; *Home Scene,* Brooklyn Museum; and *Elizabeth at the Piano,* Addison Gallery of American Art, Phillips Academy) there is no indication that the settings are the same. See Margaret McHenry, *Thomas Eakins Who Painted* (published privately, 1946), p. 121, for reference to Eakins' presence at Saturday afternoon performances at a slightly later date.

22　**Charles Frederic Ulrich**
(1858–1908)
*In the Land of Promise—Castle
Garden,* 1884
Oil on panel
28⅜ x 35¾ in. (70.9 x 89.3 cm)

Inscribed lower left: *Copyright by
Charles F. Ulrich ANA/1884.*
Museum purchase　00.3
See Color Plate

In the Land of Promise enjoyed critical acclaim when it was exhibited at the National Academy of Design in 1884.[1] The setting is a stark waiting room at Castle Garden, the immigration center of the port of New York located in the Battery at the southern tip of Manhattan. Charles Frederic Ulrich has filled his composition with representatives of many nationalities and ethnic groups: Swedes, Russians, Germans, Irish, Jews. By stressing the different types of people coming to America at a time when a liberal policy was attracting immigrants from many parts of Europe, the artist created an image of the United States as a melting pot, a nation of nations.[2] It is, however, the young madonna-like Swedish mother nursing her child who embodies the view of America as the biblical and bountiful land of promise.

Castle Garden went through several transformations before it officially opened its doors as an immigration center on August 1, 1855. Constructed as a fort in the early nineteenth century, it became a pleasure garden with a luxurious auditorium in the 1840s. It was here, in 1850, that Jenny Lind, the Swedish Nightingale, began her triumphant tour of America. Ulrich's young Swedish woman, about to begin her life in America, surely was intended as an allusion and a contrast to her glamorous compatriot.

During Castle Garden's thirty-five years as an immigration center (it was closed in 1890), nearly eight million people landed there. This sum represents almost seventy percent of the total immigrants to America from 1855 to 1890. In both 1881 and 1882 close to half a million poured through its gates. The center may have had special meaning for Ulrich, who was born of German parents in New York in 1858, only

three years after Castle Garden began operations.

A student at the National Academy of Design in New York, Ulrich went to Munich for additional study at the end of the 1870s. His meticulous attention to detail and solid, well-drawn forms provide evidence of the type of training he obtained there.[3] Despite the recognition Ulrich received for this and other works, he eventually returned to Europe, where he died in 1908. It is ironic that he, like many of his contemporaries,[4] sought his artistic land of promise abroad.

EJN and ACW

1. See, for example, Robert Jarvis, "The National Academy Exhibition," *The Art Amateur,* 10 (May 1884): 126. The painting was awarded the Thomas B. Clarke Prize; it also received an honorable mention when it was shown at the Paris Exposition in 1889.
2. This theme is also reflected in the works by John G. Brown and Horace Bonham in this exhibition (Cat. Nos. 19 and 17).
3. For a discussion of the Munich style toward the end of the 1870s when Ulrich was there, see Michael Quick's essay in *Munich and American Realism in the 19th Century* (Sacramento, Calif.: E.B. Crocker Art Gallery, 1978), p. 32.
4. For a study of expatriate artists, see Michael Quick, *American Expatriate Painters of the Late Nineteenth Century* (Dayton, Ohio: Dayton Art Institute, 1976).

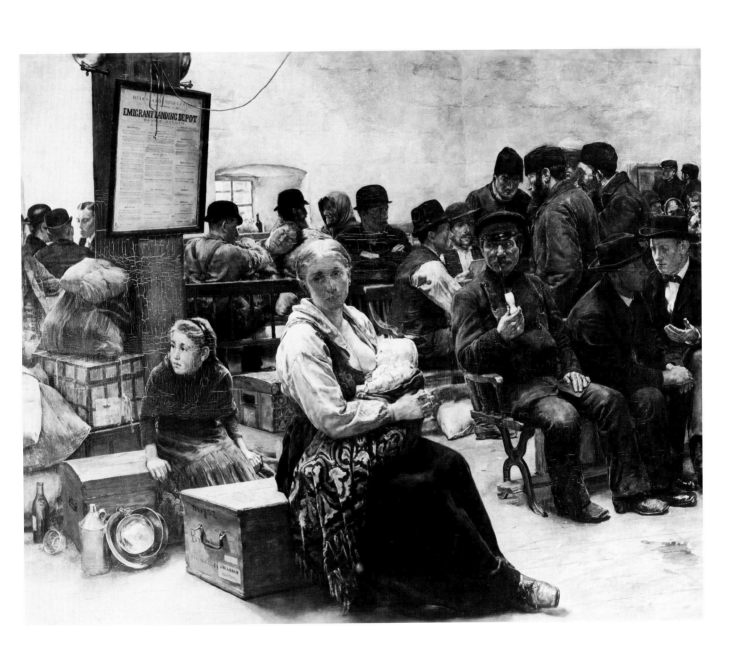

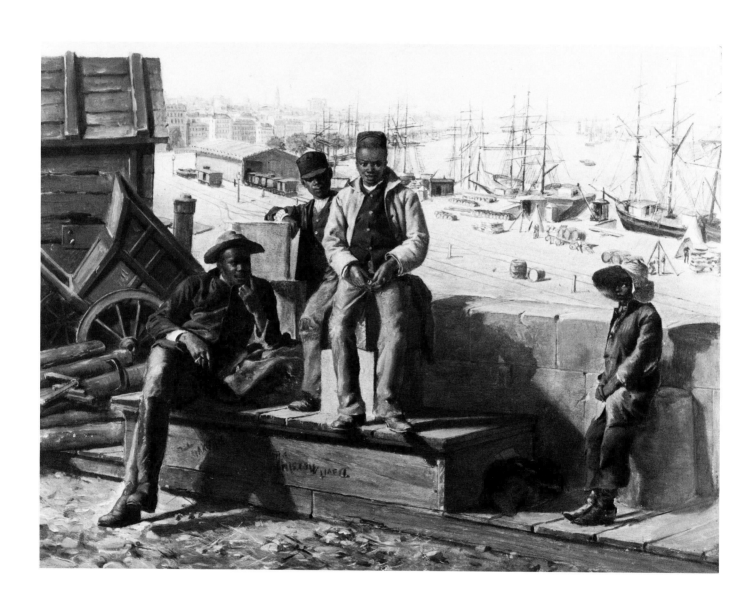

23 **David Norslup** (?)
Negro Boys on the Quayside, 1880s
Oil on panel
15⅞ x 19½ in. (40.3 x 49.5 cm)

Inscribed lower center: *Davi[d]*
[No]rslu[p]
Museum purchase (Gallery Fund and
William A. Clark Fund) 60.38

Negro Boys on the Quayside is signed
upside-down with a name variously
interpreted as Norslup, Merslup, or
Marslur. Unfortunately, no such artist
has as yet been identified. The picture's
setting has been equally difficult to de-
termine, the best choice being New
Orleans. Though far from exact in all
details, the general shape of the harbor,
the appearance of the buildings along
the waterfront including the distinctive
steeple of St. Louis Cathedral, and the
arrangement of the railroad tracks along
the quay all suggest that city; however,
no rise of land like the one on which the
boys are standing exists above New
Orleans harbor. Thus, the painting does
not represent any exact locale but uses a
panoramic view of the city as backdrop
for the foreground incident. If the set-
ting is New Orleans, the painting can be
dated to the 1880s when the railroad
was extended as far upriver as it is
shown here.[1]

The subject of *Negro Boys on the
Quayside* is unclear. The central figure
holds a coin in a sexually suggestive
manner. He stares directly out of the
canvas as if to confront the viewer, his
intense gaze and arched eyebrows giv-
ing him a threatening and malevolent
appearance. His street-wise buddies
glance sideways at him, bemused by his
audacity; the seated one raises a finger
to his eye employing an old rhetorical
gesture which means "look out" or
"beware." Meanwhile, the young
Negro boy just in from the country—a
bag lies at his feet and he wears a straw
hat—looks on fearfully, his hands cov-

ering himself in embarrassment. What-
ever the painting's exact meaning, it has
a sinister air and projects a negative
view of blacks. This interpretation,
speculative though it may be, is consis-
tent with a prevalent contemporary
white Southern opinion of blacks as
promiscuous and lustful. Further, a dis-
tinction was made between the good,
subservient Negro (the boy on the
right) who remained on the farm, and
the Negro who deserted his master:
most white Southerners found it impos-
sible to see anything good in a black in-
dependent of white domination. The
painting's apparent anti-black bias may
help explain why the artist's identity has
escaped detection, for the signature
may be fictitious. Although uncom-
plimentary images of blacks, for the
most part of a humorous nature, were
quite common in the popular arts in the
1880s and 1890s, in the fine arts Neg-
roes were sympathetically, if condes-
cendingly, portrayed, as in Brooke's *A
Pastoral Visit* (see Cat. No. 20). If this
interpretation is correct, *Negro Boys on
the Quayside* is a rare document of late-
nineteenth-century racial paranoia.

JRM

1. Information provided by John Mahe of the
Historic New Orleans Collection. I would also
like to thank Dode Platou of that institution and
J. B. Harter of the Louisiana State Museum for
sharing their thoughts on this work.

24 **Louis Charles Moeller** (1855–1930)
Disagreement, c. 1890
Oil on canvas
24⅜ x 34½ in. (61.9 x 87 cm)

Inscribed lower right: *Louis Moeller*
Museum purchase 99.10

*D*isagreement was one of twelve paintings by Louis Moeller owned by Thomas B. Clarke, an important late-nineteenth-century collector of American art.[1] Although the exact year of execution has not been established, a date around 1890 for the painting seems reasonable in view of the furnishings and subject. It may have been among the unfinished works Clarke purchased as a group from Moeller in 1891, which the artist offered to complete.[2]

Trained in Munich, Moeller began specializing in small interior scenes, usually involving elderly men, upon his return to America around 1884. He quickly came to be regarded as a very promising painter of genre scenes. His works were admired for their meticulous detail. One writer, perhaps in an attempt to counter adverse criticism of Moeller's photographic style, remarked that the artist's "methods do not permit him to make use of the camera. Every bit of still-life in the picture, as well as the figure of the sitter, is a piece of free-hand drawing, and not tracing on a photograph."[3] Moeller's attention to detail is amply displayed in *Disagreement.*

Although Moeller's minutely rendered realistic images richly document the manners and pastimes of elderly American men at the end of the nineteenth century, the artist's purpose was not merely to reproduce the minutiae of libraries and clubs for their own sake. Nor was it simply to immortalize the typical Yankee senior, although the figure recurs repeatedly in his paintings. Such details and characters become devices for enticing the viewer. Moeller further engages his audience by presenting an ambiguous but volatile situation, which requires him to depict a variety of reactions to a single incident. The observer searches the profusion of seemingly significant details in vain for an explanation of why the people are responding so strongly. It is the type of painting that tricks the wit as well as the eye of the beholder. Details and incidents serve as foils for Moeller's true interest revealed in titles such as *Disagreement, Puzzled, Gratitude, Amazement*—the portrayal of human emotions and states of mind—an interest which reflected perhaps current theories of physiological psychology. The details, because they are so accurate, add to the veracity of the artist's psychological observations. That these qualities were recognized by his contemporaries is evident from the comment on *Disagreement* published in the auction catalogue for the Clarke Collection in 1899:

It should be noted that this composition, worthy to rank with the works of the Dutch genre painters of three centuries ago, is executed with a high degree of finish which is in no respect wanting, and as a study of character, life and manners, it has not been surpassed by any work of its kind.[4]

EJN

1. See *The Thomas B. Clarke Collection Sale,* American Art Association, February 14–18, 1899.
2. Letter from Louis Moeller to Thomas B. Clarke, dated December 31, 1981; Charles Henry Hart Autograph Collection, Archives of American Art (D 5). In the letter, Moeller agreed to "finish such works as Mr. Clarke requests" but no work is specifically identified.
3. George W. Sheldon, *Recent Ideals of American Art* (New York: Appleton, 1888), p. 18.
4. *Clarke Sale,* n.p., No. 362.

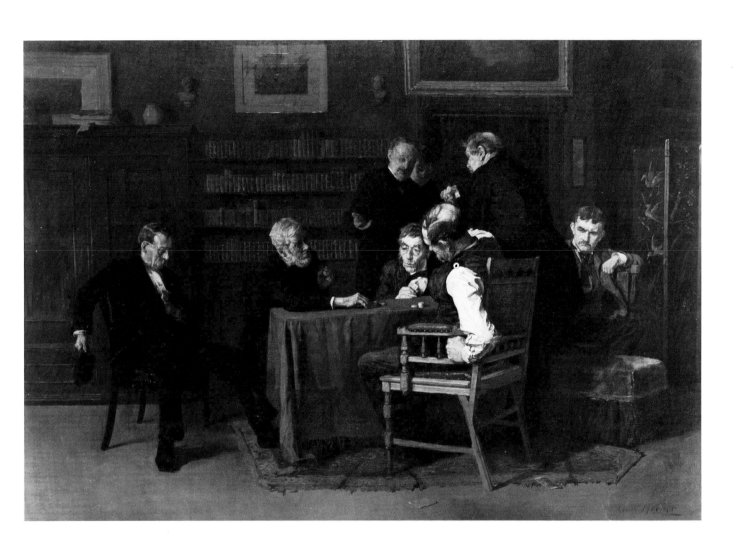

25 **Bessie Potter Vonnoh** (1872–1955)
Day Dreams, 1903
Bronze
10½ in. (26.7 cm)

Inscribed back left: *Bessie Potter Vonnoh
no. 1 copyright 1903*
Foundry mark back right: Roman
Bronze Work, N.Y.
Museum purchase 10.4

Day Dreams represents two young women lost in reverie, the dreamy mood conveyed in part by the indefinite modeling of their faces. The upright figure seems to have been reading to the reclining figure from a book open in her lap, and it is perhaps this book that has prompted the women to muse. Women meditating on a work of art is a frequent theme of turn-of-the-century American artists, particularly Thomas Dewing and John White Alexander. The theme had its origins in the work of James McNeill Whistler and Albert Moore, two artists associated with the English Aesthetic Movement. The artists and writers of this group—among them Walter Pater, Algernon Swinburne, and Oscar Wilde—despised the reality of the industrialized nineteenth century and sought, through art, an alternative in the world of imagination.

The artists of the Aesthetic Movement often turned to "the antique" for inspiration. In creating images of poetic reverie, they frequently dressed their models in classical or noncontemporary dress. The women in *Day Dreams* wear long flowing gowns, which are reminiscent of classical garb and add to the suggestive tone of the work. The composition of one girl reclining against another strongly recalls the two seated goddesses on the Parthenon's east pediment. Moreover, Vonnoh's small bronze statuettes recall the small Hellenistic figures called tanagras, named after the town on the Greek island of Boeotia where they were first discovered in the early 1870s. Some tanagras, in fact, show draped women reclining on couches.[1] The collecting of these Greek statuettes was quite fashionable at the end of the nineteenth century. There are, for example, paintings by Thomas Anshutz and Childe Hassam which show elegantly dressed women looking at tanagra figures.[2] Implicit in these works is the comparison between contemporary and classical female beauty. Vonnoh's small statues would have had for collectors the same appeal as the Greek figures on which they were probably modeled.

Despite the allusions to classical antiquity, *Day Dreams* does portray a contemporary scene. The women lie on an American Empire-style sofa (c. 1820s), which, lavishly draped, conveys an atmosphere of luxury. The sofa also refers to the fashion for collecting antique furniture, particularly American after the Centennial, as well as objets d'art such as tanagras. By acquiring antiques and thus bringing into their homes the most beautiful objects from all ages, American collectors may have been aspiring to the aesthetic life prescribed by Pater, Swinburne, and Wilde, who were widely read in this country. In a discussion of Dewing's paintings critic Sadakichi Hartmann described his subjects as women who "transform their boudoirs into sanctuaries devoted to the worship of their individual tastes; they read Swinburne, and are fond of orchids and lying around on divans in their large solitary parlors."[4] This description is particularly relevant to *Day Dreams* with its reference to the ability of art to move the soul, and its illustration of the aesthetic life style.

JRM

1. Marcus B. Huish, "Tanagra Terra-Cottas," *International Studio,* 5 (1898): 97–104.
2. Thomas Anshutz, *The Tanagra,* 1911 (Pennsylvania Academy of Fine Arts); Childe Hassam, *Tanagra* (National Museum of American Art).
3. Sadakichi Hartmann, "Thomas W. Dewing," *The Art Critic,* 1 (1894): 35. I would like to thank Susan Hobbs for pointing out this source to me.

Inscribed middle right: *Frederic Remington;* bottom right: *Copyright 1903 by/Frederic Remington*
Foundry mark: Roman Bronze Works
Museum purchase 05.8

In 1904 Frederic Remington said that he intended *Mountain Man* to represent "one of those old Iriquois trappers who followed the Fur Companies in the Rocky Mountains in the '30 and 40'-ties."[2] The Iroquois, once a powerful Indian confederation in New York, had by this time been dispersed, some into Canada, and Remington's remark probably refers to a French-Canadian half-breed of which there were many among the trappers of the Rocky Mountains. The bone structure of his face indicates his Indian heritage, and his fur hat is characteristic of French-Canadian trappers (the Americans commonly wore brimmed felt hats; see Cat. No. 7).[3] His gear is typical of the Rocky Mountain trapper. Wearing a buckskin suit, he carries beaver traps, a half-stock Plains flintlock, a Plains Indian knife sheath, and a powder horn and bag. He rides a mule, the appropriate animal for the mountains, and sits on an Indian-style saddle covered with a piece of buffalo hide for increased comfort.[4] Like many of Remington's sculptures, *Mountain Man* combines a man and his mount in a highly dramatic composition.

It is curious that Remington depicted a French-Canadian half-breed trapper, for during the early part of the nineteenth century French-Canadian trappers were considered inferior to American mountain men. The distinction was perhaps forgotten by the artist's time, or else Remington was indifferent to the traditional model of mountain men as nation builders (see Cat. No. 7). His oeuvre, which consists for the most part of cowboys, Indians, and military men, is conspicuously lacking in images of women or settlers, the stereotypical agents of civilization. Remington abhorred the taming of the West—the coming, as he put it, of "brick building, derby hats and blue overhauls"[5]—and reveled in the virile rough-and-tumble life of the frontier.

Remington thought of his art as documentary: he wanted to capture the vanishing West. And although he did not take up sculpture until mid-career, it became for him the perfect medium to achieve this end. "I propose," he wrote in 1896, "to do some more sculptures to put the wild life of our West into something that burglars won't have, moth's eat or time blacken."[6] The Rocky Mountain trapper properly belongs in his gallery of Wild West types because he was, as Remington's friend Theodore Roosevelt, put it:

The arch-type of freedom. His well-being rests on no man's hand but his own. . . . The mountain men are frank and bold. . . . They fear neither men, brutes nor elements. . . . They stand loyally by their friends and pursue their enemies with a bitter and vindictive hatred.[7]

Mountain Man embodies these qualities; with stoic endurance he is calm in the face of danger.

Remington's interest in the West and his emphasis on tough masculinity were deeply ingrained in his personality. As a boy he loved sports, outdoor activities, horses, Western and Civil War stories. In his youthful sketching he preferred not "women and dudes" but "Indians, cowboys, villians and toughs."[8] Never a good student, he dropped out of Yale after two years, had a string of office jobs which he bitterly hated, and then in 1880 went West, where he found the adventure he had been looking for. Remington was not alone in his rejection of the financial or cultural pursuits thought appropriate for a young man of his upper-class origins. Of a generation profoundly affected by Darwin and his theory of the survival of the fittest, he was, in his stress on physical toughness, an important exponent of Roosevelt's cult of strenuosity.

JRM

1. *Mountain Man* was created in 1903, but this cast (No. 7) was not produced until 1904. According to Michael Shapiro, about seventy-four casts of this sculpture are known to exist (*Cast and Recast: The Sculpture of Frederic Remington,* Washington: Smithsonian Institution Press, 1981, in press, Ch. 3). I would like to thank George Guerney of the National Museum of American Art, Smithsonian Institution, for talking with me about this piece.
2. Letter from Remington to director of the Corcoran F. B. McGuire, January 29, 1904, in the possession of the Corcoran Gallery.
3. Dawn Glanz, *The Iconography of Westward Expansion in American Art, 1820–1870: Selected Topics* (Ann Arbor: University Microfilms, 1978), pp. 103–104.
4. Paul A. Rossi and David C. Hunt, *Art of the Old West from the Collection of the Gilcrease Institute* (New York: Knopf, 1971), pp. 102–103.
5. Peter Hassrick, *Frederic Remington: Paintings, Drawings and Sculpture in the Amon Carter Museum and the Sid W. Richardson Foundation Collection* (New York: Harry N. Abrams, 1973), p. 39.
6. Maria Naylor, "Frederic Remington, Part II: The Bronzes," *Connoisseur,* 185 (February 1974): 138–141.
7. Theodore Roosevelt, "Frontier Types," *Century Magazine,* 36 (October 1888): 831–835.
8. Harold McCracken, *Frederic Remington: Artist of the Old West* (New York: Lippincott, 1947), p. 28.

27 **Gilbert Gaul** (1855–1919)
Picking Cotton, after 1904
Oil on academy board
13¼ x 18¼ in. (33.7 x 46.4 cm)

Inscribed lower right: *G. Gaul*
Museum purchase (Josephine B. Crane
Fund) 57.6

Picking Cotton was undoubtedly done from life during one of Gilbert Gaul's many trips to the South. Though born in Jersey City, Gaul inherited a family farm in Van Buren County, Tennessee, where he lived from 1881 to 1884 and again around 1904–1905. *Picking Cotton* may have been done during the second residency, from which there are several similar landscapes, or even as late as 1910, the date of another black subject, *Tennessee Cabin.*[1] Gaul is said to have had a "long love affair with the people and places of Tennessee,"[2] a fact borne out by the number of Tennessee themes in his oeuvre.

Using pure intense colors, Gaul has successfully conveyed the scintillating effect of light on a Southern landscape by contrasting the dappled spots of white cotton with the dark faces. The artist was probably attracted to this subject because it was picturesque and full of local color. From his extensive travels in the West, where he studied the Indians, and in Mexico, Central America, and the Caribbean came numerous reportorial sketches similar to *Picking Cotton* which would sometimes be used as the basis for magazine illustrations or paintings. Like *Picking Cotton* these small works tend to be quiet, nondramatic renderings of people in their usual environments. Their naturalness contrasts sharply with the exaggerated facial expressions and gestures of Gaul's larger anecdotal works.

In *Picking Cotton* the black women have a dignified bearing which differs from the extremely negative stereotypes of blacks common around the turn of the century. However, Gaul did not frequently portray Negroes, nor does this painting demonstrate any awareness of their exploitation in the sharecropping system, under which these women are probably working.

JRM

1. In the Vanderbilt University Collection of Fine Arts.
2. James F. Reeves, *Gilbert Gaul* (Huntsville, Ala.: Huntsville Museum of Art, 1975), p. 10.

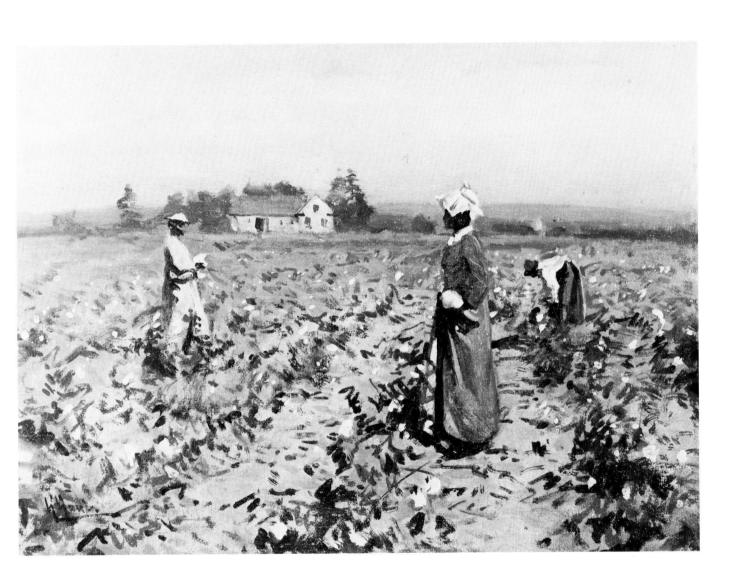

28 **Charles Dana Gibson** (1867–1944)
The New Hat, 1905
Ink on cardboard
20¾ x 27⅞ in. (51.8 x 70.8 cm)

Inscribed lower left: *C. D. Gibson*
Gift of Orme Wilson 65.28.3

The New Hat was published in May 1905 in *Life,*[1] the humor magazine which was Charles Dana Gibson's principal outlet for his illustrations and cartoons for nearly fifty years. The title refers to the polo-turban hat which became *the* hat to wear in the spring and summer of that year. The polo turban was much smaller than other hats and was thought to be "a trifle startling to conservative ideas about headwear."[2] In order to produce a comic effect, Gibson made his turbans even smaller than they actually were. Furthermore, he satirized the authoritarian grip of fashion by having every woman wear the same type of hat.

The central figure in the drawing is the famous Gibson Girl, who began to appear in the artist's work about 1890. Beautiful and exquisitely groomed, the Gibson Girl was self-assured yet always modest, agreeable, and morally without blemish. Gibson satirized her, but he also clearly adored her, and so did the public. She was so extraordinarily popular that she not only became the staple of Gibson's oeuvre, but decorated countless manufactured goods and appeared repeatedly as a character in popular songs and plays. Her popularity may well have reflected a need among America's newly rich for appropriate models of behavior. Between the Civil War and World War I rapid industrialization led to an accumulation of vast wealth in America. The moneyed yet socially inexperienced class found in the Gibson Girl and her counterpart, the Gibson Man, types to admire and emulate.

The New Hat is also noteworthy for its depiction of members of the working class and blacks. Gibson's interest in people other than the socially elite, though never a dominant concern, began to emerge around 1903 and was possibly due to his connection with the progressive journal *Collier's.* The humorous contrast between the fresh Gibson Girl and the exhausted working girl—while calculated to make the former more appealing—also suggests the overworked and underpaid status of most working women of that day.

JRM

1. *Life,* 45 (May 18, 1905): 578–579.
2. "Spring and Summer Millinery," *Vogue,* 25 (April 13, 1905): 579.

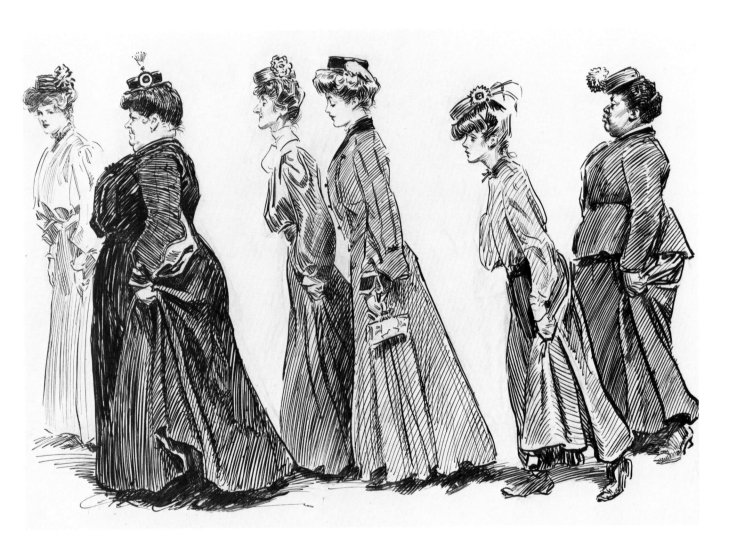

84

9 John Sloan (1871–1951)
Fifth Avenue Critics, 1905
Etching
4⅞ x 6⅞ in. (12.3 x 17.6 cm)

Inscribed lower left: (in plate)
1905/John/Sloan; lower right: *John
Sloan;* lower center: *Fifth Avenue Critics;*
lower left: *100 Proofs*
Museum purchase (Mary E. Maxwell
Fund) 33.10

Fifth Avenue Critics was the second print in John Sloan's *New York City Life Series* (1905–1906), a suite of ten etchings created shortly after he moved to that city from Philadelphia in 1904. The theme of the series was to have been the connoisseur, with each print satirizing the pretensions of the upper class (this etching was originally titled *Connoisseurs of Virtue*). Sloan, in envisioning his series, was undoubtedly aware of the long tradition in the graphic arts of the satiric treatment of the connoisseur. For example, it was a theme that Daumier—a favorite of the artist—had explored.

Sloan claimed he encountered the subject for this print while walking down Fifth Avenue, known at that time for its lavish mansions. These women, he remarked, "were typical of the fashionable ladies who used to drive up and down the Avenue about four o'clock of an afternoon, showing themselves and criticizing others." [1] Sloan did not reproduce the scene exactly but purposely heightened the satiric element by the use of exaggerated gestures and features. The women are essentially archetypes: the demure young beauty; the knowing, self-satisfied middle-aged woman; the self-righteous old battle-axe.

Sloan's harsh treatment of the wealthy in *Fifth Avenue Critics* contrasts strongly with his sympathetic treatment of the working class in his other works. Yet his vision of wealthy New York is not particularly fresh or scathing. It depends too heavily on eighteenth- and nineteenth-century European caricature, a source he had consistently tapped in his previous work as an illustrator. One feels, in fact, that Sloan's satire of the upper class grew less out of an intent to ridicule the wealthy than out of a desire to create a successful and humorous suite of prints. It was to be, as it were, his debut in the New York art scene.

Sloan quickly found the connoisseur theme too confining as he became increasingly caught up in the vibrant life of New York City, and he abandoned it after the third print. The remaining works of the series are slice-of-life depictions of the working class, much like *Sunday, Drying Their Hair* (Cat. No. 41).

JRM

1. *John Sloan: Paintings and Prints* (Hanover,
N.H.: Dartmouth College Art Gallery, 1946), p.35.

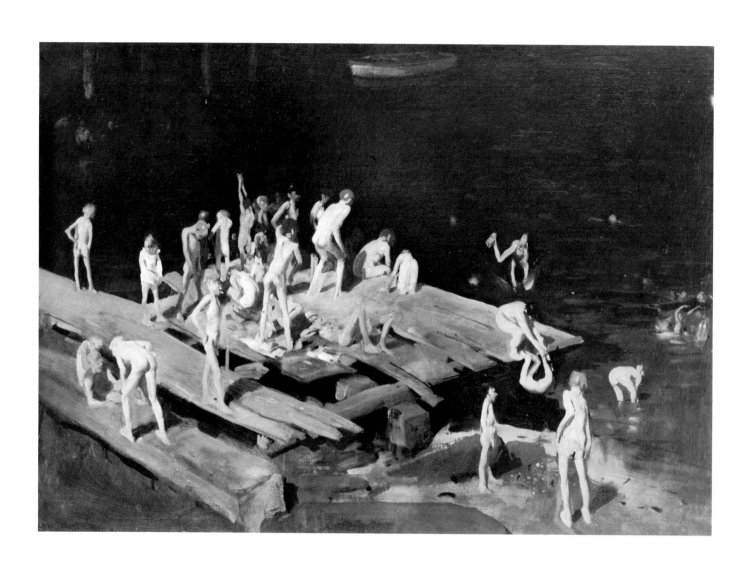

George Bellows (1882–1925)
Forty-two Kids, 1907
Oil on canvas
42⅜ x 60¼ in. (107.6 x 153 cm)

Inscribed lower left: *Geo Bellows*
Museum purchase (William A. Clark
Fund) 31.12
See Color Plate

*F*orty-two Kids represents a gang of slum children swimming off a dilapidated pier on Manhattan's East River. The bold strokes used to model the figures and the dramatic contrast between white bodies and murky water create an animated picture which communicates both the restless tempo of the city's slum sections and the ceaseless energy of youth. While the vitality of the slums is reflected, there is nothing to suggest their dreadful aspects; in fact, the boys seem transported to some water wonderland. The fantasy-like quality of the image and the dynamic composition create an air of positive exuberance which, while at odds with reality, was in keeping with the prevalent optimism in America just prior to World War I.

Executed while Bellows was still a student of Robert Henri, *Forty-two Kids* reflects his teacher's pictorial interest in the poor because of their uninhibited responsiveness to live. This attitude undoubtedly was a factor in Bellows' decision to depict the carefree play of slum children rather than their sordid living conditions. His stress on the boys' lack of inhibitions—some even urinate—corresponds to the delight of John Sloan, another member of Henri's circle, in the natural sexuality of

working-class women (Cat. No. 41). Both men found the justification for their works in the philosophy of Walt Whitman channelled through Henri. As Sloan said, "I got my Whitman through him. Whitman's love for all men, his beautiful attitude toward the physical, the absence of prudishness."[1] Both works convey the idea that the poor find real pleasure in the simple act of living.

Bellows painted the subject of boys swimming a number of times throughout his career.[2] A semi-professional baseball and basketball player, he probably was drawn to the subject because of his own passion for sports,[3] which he loved not only for the competition but for the male companionship and the playful give and take evident in this painting. While *Forty-two Kids* is certainly a tribute to the exuberance of youth and to the pleasures of physical activity, it is more than this. On one level, the theme seems a nostalgic reference to the artist's own Midwestern childhood. On another, it reveals Bellows' social concerns and his philosophical debt to Henri. Finally, with its depiction of the progressive positions of one swimmer as he prepares to dive, dives, and returns to land, *Forty-two Kids* seems to be paying hom-

age to *The Swimming Hole* of Thomas Eakins, an artist admired by the Henri circle who shared Bellows' enthusiasm for physical exercise.[4]

JRM

1. Sloan quoted in Joseph J. Kwiat, "Robert Henri and the Emerson-Whitman Tradition," *PMLA,* 71 (September 1956): 620.
2. Including *River Rats,* 1906 (Collection of Everett D. Reese, Columbus, Ohio); *Summer City,* 1908 (Knoedler & Co., New York, in 1942); *River Front, No. 1,* 1915 (Columbus Museum of Art).
3. Bellows did a number of boxing, basketball, and baseball subjects at this time, including *Club Night,* 1907 (Collection of Mr. and Mrs. John Hay Whitney), as well as two drawings, *Take Him Out!,* 1906 (Greenville County Museum of Art, South Carolina) and *Basketball,* 1906 (Peter H. Davidson and Co., New York).
4. In 1907 *The Swimming Hole,* now owned by the Fort Worth Art Center, was still in the possession of Eakins. It may have been known by Bellows through Henri.

31 Abastenia St. Leger Eberle
(1878–1942)
Girls Dancing, 1907
Bronze
11½ in. (29.2 cm)

Inscribed top of base: *A St. L Eberle 07*
Foundry mark left side of base:
B. Zoppo/Foundry N.Y.
Bequest of the artist 68.28.4

In *Girls Dancing* Abastenia St. Leger Eberle's subject was two children dancing in the streets of Manhattan's Lower East Side, a section of New York City inhabited by a large population of poor Russian Jewish immigrants (see Cat. No. 45). *Girls Dancing* and *Roller Skates* (1906)[1] were Eberle's first depictions of the Lower East Side. She had begun exploring that area some years earlier during her student days, drawn by her "strong taste for life." "In those early years in New York," she wrote, "I would often stroll around the lower parts of Manhattan losing my loneliness in the consciousness of all the pulsing, throbbing life around me."[2]

Like John Sloan, Eberle was attracted to the tenement dwellers not because they were poor but because she found them "human beings through whom I get at the living spirit of humanity more vitally than elsewhere."[3] In her view the immigrants, unlike the bourgeoisie, expressed their emotions unreservedly. About the children of the Lower East Side she wrote:

[They] *play without restraint, their griefs and their joys are expressed with absolute abandon . . . and their natural emotions are not restrained by the pretty curtseys taught by governesses. . . . They laugh loudly. They shout. They race on roller skates and dance unrestrainedly. . . . They express life.*[4]

Eberle's sculptures are, however, rarely about the griefs of the poor. Children are her most frequent subject, and she shows them joyously at play. As an advocate of the Progressive Movement and a disciple of Jane Addams, founder of the first settlement house in the United States, Eberle believed that the lives of the poor were improving: "In all the history of mankind, there was never so much thought given to the cruelty of social conditions as today. . . . The humanitarian spirit is strong."[5] *Girls Dancing,* with its swinging arms, legs, skirts, and hair, expresses both the vitality she felt in the youthful immigrants and her optimism about their future.

JRM

1. A cast of *Roller Skates* is in the collection of the Rhode Island School of Design and is illustrated in Louise R. Noun, *Abastenia St. Leger Eberle, Sculptor (1878–1942)* (Des Moines: Des Moines Art Center, 1980), Plt. 8.
2. Undated letter to R. G. McIntyre, Macbeth Gallery Papers, Archives of American Art, Smithsonian Institution (Gift of the Robert McIntyre Estate), roll NMc44, frames 256–257.
3. "Which Is True Art?" *Washington Post,* February 6, 1916, p. 4.
4. *Ibid.*
5. *Ibid.,* p. 5.

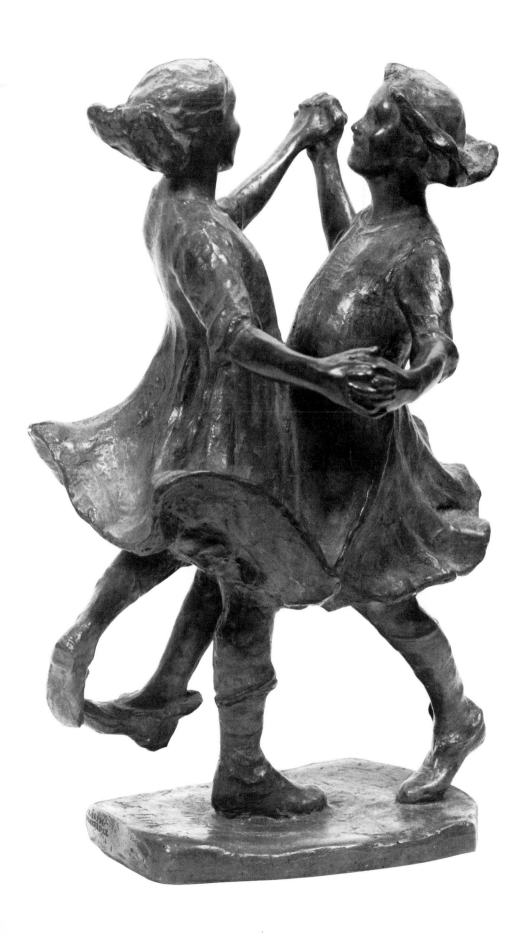

32 **Edmund Charles Tarbell**
(1862–1938)
Josephine and Mercie, 1908
Oil on canvas
28¼ x 32¼ in. (71.8 x 81.9 cm)

Inscribed lower right: *Tarbell.*
Museum purchase 19.2

Josephine and Mercie portrays two of the artist's daughters in the family's summer home in New Castle, New Hampshire. Such domestic interiors comprise a major part of Edmund Charles Tarbell's oeuvre and were a common theme of the period, especially with the Boston School, which included William Paxton (Cat. No. 34), Frank Benson, and Philip Hale, as well as Tarbell. This work seems to present the artist's idea of the perfect home life: his house is shown as a sunny, peaceful place, quietly intimate and inhabited by pretty young women. Tarbell's family had lived in Massachusetts since 1638, and he was one of Boston's old guard. Deprived of political power by the Irish and appalled by America's feverish industrial expansion, these Boston Brahmins at the end of the nineteenth century feared they were a "dying race," as Van Wyck Brooks so melodramatically put it.[1] Comfortable, civilized, bookish, and filled with the accumulations of generations, Tarbell's quiet interiors reflect the enduring values of this increasingly conservative class.

The artist's daughters embody the contemporary ideal of young womanhood. The American Girl, as she was repeatedly called, figured greatly in art and was the subject of much discussion around the turn of the century.[2] Existing in many variations, her image was that of a pretty, wholesome, and unaffected young lady who was also intelligent and enjoyed a great deal of per-

sonal freedom. Untouched by the murky ethics of politics and business—man's domain—she was the best America had to offer. As artist Will Low put it, "It is the young girl who fills such a large part of our [America's] experiment who is really to the fore. It is Smith and Wellesley who row with the young girl enthroned."[3] *Josephine and Mercie* is not quite so adulatory, nor is it clear whether the girl to the left is studying Latin or filling in her date book, but dressed in pure white, she symbolizes the naturalness and innocence of the perfect American girl.

Tarbell's aesthetic, like that of the other Boston School artists, combined visual verisimilitude with an interest in "decorative design and color harmonies."[4] The artists' emphasis on the abstract qualities of painting was derived from Whistler, although they rejected his lack of realism and looked instead to the Dutch artist Jan Vermeer as their mentor. Tarbell was also greatly influenced by Japanese prints and by Degas. The impact of these various sources is apparent in *Josephine and Mercie.* For example, the device of cropping the image to flatten the picture space is found in Degas' works and in Japanese prints. As in Vermeer's paintings, the pictures, windows, and furniture in the room form a strong grid of horizontals and verticals. Superimposed upon this grid is a rhythmic and decorative arrangement of dark and light masses which undoubtedly was

done in imitation of the *notan*—that is, "the agreeable, well-planned distribution and balance of the lights and darks"[5]—of Japanese prints. The palette is limited, a harmonious combination of brown, yellow, and white enlivened by touches of purple and green. While *Josephine and Mercie* presents an image of intimate home life, it is also an abstract arrangement of colors and shapes intended to be appreciated on purely visual terms.

JRM

1. Bernice Leader, "The Boston Lady as a Work of Art: Paintings by the Boston School at the Turn of the Century" (Ph.D. dissertation, Columbia University, 1980), p. 69. The Boston context of Tarbell's work is discussed at length.
2. For example, illustrator Howard Chandler Christy wrote a book called *The American Girl* (New York, 1906) and Charles Dana Gibson became famous drawing her. The figure is also frequently encountered in American literature of the period, most notably in the works of Henry James.
3. Brooklyn Institute of Arts and Sciences, *The American Renaissance, 1876–1917* (Brooklyn: The Brooklyn Museum, 1979), p. 51.
4. Leader, "The Boston Lady," pp. 274–275.
5. Philip Hale, *Vermeer* (Boston: Hale, Cushman and Flint, 1937), p. 83.

33 **Lewis Hine** (1874–1940)
*"Bologna," Hartford, Connecticut,
March, 1909,* 1909
Photograph
4⅞ x 6⅞ in. (11.1 x 17.5 cm)

Gift of Harry Lunn, Jr. 1977.54.3

*"*B*ologna," Hartford, Connecticut,
March, 1909,* is one of the hundreds of photographs from all over the country that Hine shot for the National Child Labor Committee between 1906 and 1918. The photograph was taken at 9:00 p.m. on, in Hine's words, "a bitter cold and blizzardy" night.[1] Hine's notes on the boy nicknamed "Bologna" read as follows:

Tony Casale, 11 years old, been selling 4 years. Sells until 10 PM sometimes. His paper boss tole [sic] *me the boy had shown him the marks on his arm where his father had bitten him for not selling more papers. He (the boy) said, "Drunken men say bad words to us."* [2]

The National Child Labor Committee (NCLC) was one of the many reform organizations that sprang up during the period of progressivism prior to World War I. The NCLC's purpose was twofold: to document the child labor system and to promote legislation for eliminating the evils of this system. Photographs were particularly effective in achieving both these goals. As Hine said in 1910, "The child labor photos have already set the authorities to work to see if such things [the appalling conditions] are possible. They try to get around them by crying 'Fake' but therein lies the value of the data and a witness."[3] Hine's photographs were used in scholarly articles published by

the NCLC, for publicity, and as stereopticon slides to illustrate lectures. Deeply devoted to the reform movement, Hine himself wrote many articles, gave lectures, and organized exhibitions of his pictures. His widely known photographs were extremely influential in the passage of child labor legislation in this country.

"Bologna" was, it seems, shot in preparation for an article, "Street Trades in Hartford," though it has not been established that this article or the picture was ever published.[4] The evils of the street trades, which included newspaper sales, shoeshining, peddling, and making deliveries, were the same as those of child labor in general. They robbed a youngster of childhood, health, and education, ruining any chance of earning a decent wage. Newsies, as the boys and girls who sold newspapers were called, were also exposed to vice at a young age and often turned to smoking, drinking, gambling, and theft. Reform of this occupation proved to be extremely difficult because of the popular conception of the newsie as a young Horatio Alger. Not surprisingly, Hine's boy differs markedly from Bellows' boisterous slum children (see Cat. No. 30). He is also unlike the charming, lovable newsboys found in the paintings of J. G. Brown from the same period (Cat. No. 19), although Hine's compositions—fre-

quently figures lined up against a wall—do resemble Brown's. Hine's photographs tend to be posed, but *"Bologna"* is a candid shot and captures the almost pathetic look of the young boy forced to sell newspapers on a cold winter night.

JRM

1. Caption #600, file of captions for Hine's NCLC photographs preserved in the Library of Congress, Prints and Photographs Division. I would like to thank Patricia Thompson for doing the preliminary research for this entry.
2. Caption #655, Hine caption file. The caption for this photograph is #660; it refers the reader to #600 and #655, captions for other photographs of Tony Casale.
3. Alan Trachtenberg. "Ever the Human Document," in *America and Lewis Hine: Photographs 1904–1940* (New York: Aperture, 1971), pp. 127–128.
4. Manuscript in the National Child Labor Committee Papers in the Library of Congress, Manuscript Division. No published version of this article or photograph was found among NCLC publications in the Library of Congress.

34 **William McGregor Paxton**
(1869–1941)
The House Maid, 1910
Oil on canvas
30¼ x 25⅛ in. (76.8 x 63.8 cm)

Inscribed upper left: *Paxton/1910*
Museum purchase 16.9

William Paxton, like Edmund Tarbell (see Cat. No. 32) and the other Boston School artists, was greatly influenced by the work of Jan Vermeer and to a lesser degree by the Belgian artist Alfred Stevens, who also painted leisure-class women in elegant interiors. Spurred by Impressionist theories of light and color, the Boston artists had developed during the 1890s an aesthetic of "making it like" which demanded the exact transcription, tone by tone, of nature to canvas. Dissatisfied by Impressionism's lack of form, they turned about 1904 to Vermeer's art because of its visual veracity and concern with abstract design and color harmony—concerns they shared with James McNeill Whistler.[1] About Vermeer, but nicely summing up the philosophy of the group, Philip Hale wrote that the Dutch artist "chose an arrangement that appealed to him and painted it as it appeared to him." [2]

The House Maid exemplifies this aesthetic. It has a simple yet elegant triangular composition—a staggered line of objects, left, balanced by the maid and ginger jar, right—and a limited and carefully orchestrated color scheme of blue, brown-black, white, cream, and a hint of red. Moreover, the texture of each object is precisely rendered: the reflective translucency of the marble, the metallic sheen of the bronze, the smooth purity of the porcelain pieces, the porcelain-like skin of the girl. Paxton reportedly was a painstaking worker. He spent weeks selecting objects of the right color and shape and perfecting their arrangement,

then months meticulously studying and exactly reproducing their colors and values.[3]

Paxton was the only member of the Boston School who frequently used servants as subjects. His choice of model may have been suggested by Vermeer's *Maidservant Pouring Milk,*[4] to which *The House Maid* is similar in the placement of the figure behind a table and the use of a bare wall as a backdrop. These devices create a psychological barrier between the viewer and the girl and a sense of an undefined environment; both contribute to the serenity and reserve of the piece. The essentially nondramatic nature of the event, the placing of the woman's face in shadow, and the cool tonality of the painting's color are also reminiscent of Vermeer's work.[5]

Oriental art also had an impact on Paxton's oeuvre. He was interested in Japanese prints, and this painting's essential flatness as well as its limited palette are perhaps attributable to that source. The still life is comprised mainly of Oriental objects: from the right, a late Ch'ing dynasty blue and white porcelain jar, a contemporary Japanese porcelain figurine, a nineteenth-century Japanese bronze, and a Chinese-style jar.[6] Oriental art was extremely popular in turn-of-the-century Boston. Prominent Bostonians traveled to Japan and amassed large collections; small objects like these which appear repeatedly in Paxton's work were a feature of many a tastefully decorated home. These precious *objets de virtu* lend *The House Maid* an atmosphere of culture and refine-

ment. By grouping them with a piquantly pretty woman in an environment of softly diffused light, Paxton has created a beautiful yet highly restrained work of art.

JRM

1. Vermeer's work had been rediscovered in the 1860s and would have been known by Paxton as a student in Paris (1889–1893). However, his influence does not become apparent until after 1904, the year of publication in Boston of an illustrated book on Vermeer, edited by Philip Hale, which seems to have kindled the Boston artists' enthusiasm for the Dutchman. See Bernice Leader, "The Boston School and Vermeer," *Arts,* 55 (November 1980): 174.
2. Philip L. Hale, *Vermeer* (Boston: Hale, Cushman and Flint, 1937), p. 88. The ideas for this book were developed by both Hale and Paxton, according to Ives Gammell, who knew both men well. See *William McGregor Paxton, N.A., 1869–1941* (Indianapolis: Indianapolis Museum of Art, 1978), p. 60.
3. For Paxton's method see *Paxton* (Indianapolis Museum), pp. 57-60.
4. Then and now in the Frick Collection in New York.
5. For formal similarities between Paxton and Vermeer, see Leader, "The Boston School and Vermeer," pp. 172–176.
6. Information provided by Ann Yonemura, assistant curator of Japanese art, Freer Gallery, Washington, D.C.

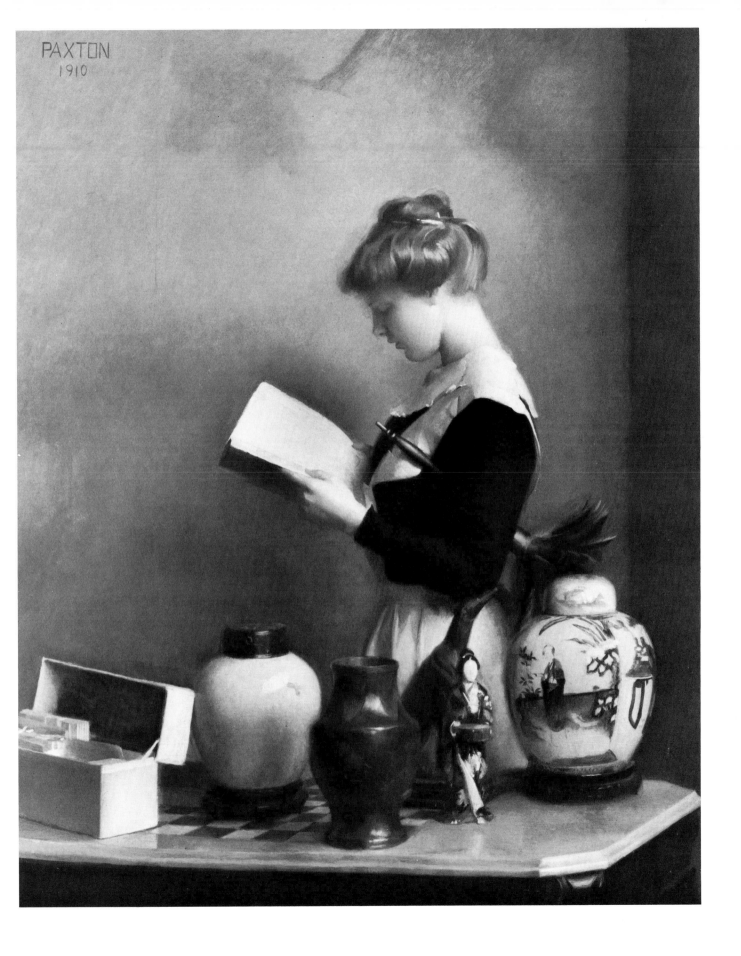

PAXTON
1910

95

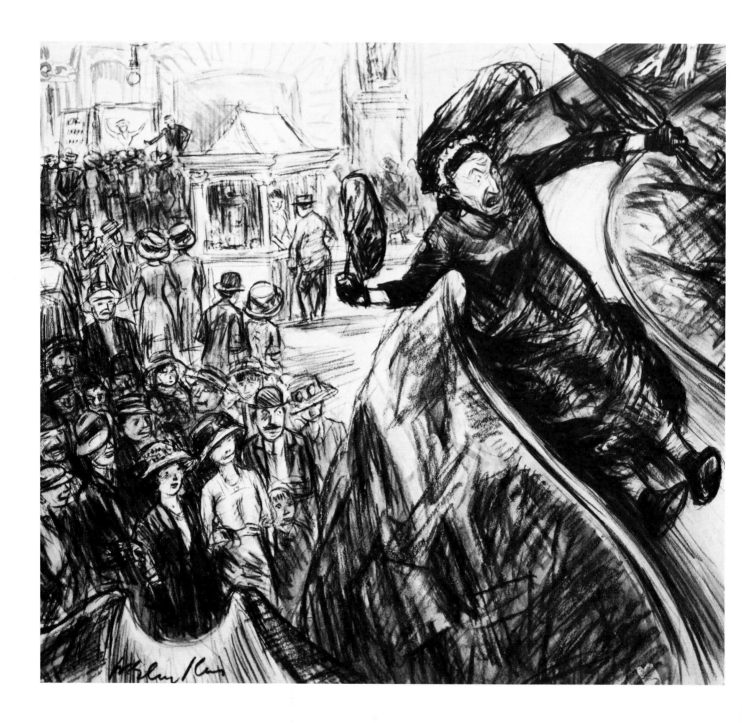

5 William Glackens (1870–1938)
I Went Down that there Slide Faster than the Empire State Express,
1910–1913
Conte crayon with Chinese white on paper
12 x 14½ in. (30.5 x 36.8 cm)

Inscribed lower left: *W. Glackens*; verso: *I Went Down that there Slide Faster than the Empire State Express*
Gift of Mrs. William J. Glackens 43.16

I Went Down that there Slide Faster than the Empire State Express was undoubtedly created to illustrate a short story in one of the popular magazines of the day such as *Collier's, McClure's,* or the *Saturday Evening Post.* It was customary to select a significant sentence—such as this one—as the basis for an illustration. However, where or even if the drawing was published is not known.

Prior to 1900 magazine fiction had been dominated by tales of romance, history, and fantasy and was illustrated by such men as Howard Pyle, C. D. Gibson, Frederic Remington, and Maxfield Parrish. However, around 1900 the trend toward literary realism set up a demand for illustrations dealing with contemporary life. As newspaper illustrators experienced in picturing the contemporary scene, William Glackens and his friends John Sloan, George Luks, and Everett Shinn were perfectly suited to cater to this new taste, and they, together with other young illustrators, initiated a new realistic style in magazine illustration. Glackens, who moved from Philadelphia to New York in 1896 and began working for magazines in 1897, was frequently assigned Lower East Side subjects (Cat. Nos. 31, 45), a newly popular theme in fiction. Though his work was in great demand, he did not like illustration, and once it was no longer a financial necessity—around 1915—he devoted himself exclusively to painting.

This relatively late illustration portrays middle-class people at an amusement park, the type of theme Glackens favored in his paintings. Although his magazine work included nonfiction and serious fiction pieces, many of his illustrations are humorous. His sensitivity to the humor inherent in daily life was undoubtedly sharpened by his interest in such English and French illustrators as John Leech, Alfred du Maurier, Honoré Daumier, J. L. Forain, and Théophile Steinlen. Like any cartoonist, he exaggerated for comic effect, as in this portrayal of an elderly woman whose face is contorted into a look of sheer fright. But this bit of caricature is not the image's only delight. Glackens was a keen observer of humanity and his illustrations and paintings are animated by charming vignettes from daily life. In this work, for example, a man in the second row glances affectionately at the child on his shoulder and farther back another man tips his hat to two approaching ladies. One of Glackens' specialities as an illustrator was crowds, which he frequently enlivened with small sketches such as these. Glackens was, in the words of Everett Shinn, "perennially happy," and he loved to portray life's sunny side, what Guy Pène du Bois called "the picnic spirit," a spirit surely evident in this drawing.

JRM

1. *City Life Illustrated, 1890–1940* (Wilmington: Delaware Art Museum, 1980), p. 18.
2. Everett Shinn, "William Glackens as an Illustrator," *American Artist,* 9 (November 1945): 23.
3. Guy Pène du Bois, *William J. Glackens* (New York: Whitney Museum of American Art, 1931), p. 13.

36 Alexander Phimister Proctor
(1862–1950)
Indian Pursuing Buffalo, 1917
Bronze
18⅛ in. (46 cm)

Inscribed right top of base: *A PHIMISTER PROCTOR SCULPTOR*;
left top of base: © *1917*
Museum purchase 18.2

Indian themes, which had been popular in American art prior to the Civil War, enjoyed a revival near the end of the nineteenth century and into the early decades of the twentieth. This was in part the result of an upsurge of interest in the West in general: with the passing of the frontier, declared officially closed in 1890, Americans began to look nostalgically on Western life as a distinctive yet vanishing aspect of America's heritage. Artistic fascination with the Indian was probably also due to his final capitulation to the white man. Images of Indians are unusual in the 1860s and 1870s during the period of protracted conflicts; however, as these subsided, it again became possible to romanticize native Americans.

In *Indian Pursuing Buffalo,* A. Phimister Proctor created a heroic image of the Plains Indian hunter. The buffalo hunt was an important theme in pre–Civil War Indian iconography and is frequently reinterpreted in the later period. It was a perfect vehicle for demonstrating the qualities stereotypically associated with the Indian: his physical prowess, instinctual understanding of animals and nature, great daring and bravery, and unbridled ferocity—qualities all evident in this work. Proctor does not present a contemporary event (the Western herds of buffalo had

been exterminated by the 1880s) nor is he working as an ethnologist. Uninterested in Indian customs, he focused in his Indian sculptures on the hunter and warrior, and in so doing romantically idealized heroic Indians of the past.

Unlike the majority of Western artists, Proctor grew up in the West and even as a boy was caught up in its developing mythology. Living in Denver when it was still very much the frontier, he could recall the neighboring and usually friendly Ute Indians riding into town with scalps on their belts. As a youth he wanted to be a great hunter and spent much time in the wilds hunting and associating with a rough crowd of frontiersmen, prospectors, and ranchers. After training in Paris and New York, he resided periodically in the West, hunting, following roundups, and studying Indians. He loved to listen to old Indians describing buffalo hunts and past victories. Proctor rarely pictured people and events out of his own experience (the modern reservation Indian held no appeal for him) but sought more monumental themes that epitomized the West. In addition to Indian subjects he created such heroic figures as *The Pioneer Mother* and *The Circuit Rider.*[1] The majority of his works are of animals, however.

Proctor's aesthetic called for the faithful representation of nature. A persistent student of human and animal anatomy, he meticulously detailed in his sculptures each muscle and joint of his models. The animal in *Indian Pursuing Buffalo* was a bison owned by the Roundup Association of Pendleton, Oregon; the Indian was Jackson Sundown, nephew of the Indian warrior Chief Joseph of the Nez Perce.[2] Through dramatic poses and the precise depiction of musculature, Proctor has successfully conveyed the passion of the hunt, the headlong charge of the buffalo, and the tense straining power of the horse and man.

JRM

1. To be found respectively in Penn Valley Park, Kansas City, Missouri; State Capitol Grounds, Salem, Oregon.
2. A. Phimister Proctor, *Sculptor in Buckskin* (Norman: University of Oklahoma Press, 1971), pp. 148, 168–170. Chief Joseph led the Nez Perce on a retreat from the American military which became famous for its brilliant strategy and tactics. Unfortunately, the tribe was overtaken and forced to surrender just before it reached the Canadian border.

37 **Charles Demuth** (1883–1935)
In Vaudeville: Bicycle Rider, 1919
Watercolor and pencil on paper
11 x 8⅝ in. (28 x 22 cm)

Inscribed lower right: *C. Demuth 1919*
Bequest of Mr. and Mrs. Francis Biddle
57.30

In Vaudeville: Bicycle Rider is one of a large number of works dealing with vaudeville that Charles Demuth created between 1915 and 1920. Demuth's frequent renderings of vaudeville and cafe scenes reflect his association during the 1910s with the artistic Bohemias of New York and Paris, where popular entertainments, drinking, partying, and sexual experimentation were standard fare. But the circus, music halls, and cafes had also been popular subjects in European art from the 1880s, and Demuth seems to have been especially influenced by Toulouse-Lautrec's treatment of similar themes.

Vaudeville was not simply a frivolous pastime for Demuth. A true aficionado, he made regular weekly visits to the Colonial, a vaudeville house in his home town, Lancaster, Pennsylvania. Like his friend Marsden Hartley, he felt that vaudeville was a form of art; he painted it because he found it visually interesting. Demuth's vaudeville pieces depict specific acts, and in each he tried to convey the essence of the act, whether it was the springiness of tumblers or the razzle-dazzle energy of a dance team. *Bicycle Rider* conveys a sense of precarious balance and masculine grace. Disregarding realism, the artist has manipulated each element—the buoyant globes of light, the gracefully curved and balanced parts of the bicycle, the juxtaposed figure and spotlights—to express these qualities.

Demuth's fascination with vaudeville was also part of a widespread rejection of academic art. From 1875 to 1925 vaudeville was America's favorite form of entertainment, with 25,000 artists working in 4000 theatres throughout the country. Demuth felt that vaudeville, as well as Negro music, ragtime, and jazz, was the most genuine form of American art. His interest in these indigenous, popular arts, as opposed to the fine arts and the legitimate theatre, corresponded to current artistic interest in primitive art and the untutored art of children and the insane—art that was considered fresh and vital because it was free of the restrictions and pretensions of academic art.

Some scholars who are aware of Demuth's homosexuality have seen phallic symbolism and other sexual meanings in his pictures of acrobats.[1] During this decade he did paint many works focusing on the male body, some overtly sexual, others not. Whatever possible sexual meaning this work may have had for Demuth, the viewer senses only a general appreciation of the male figure and a personal delight in the configuration of forms and movement of line.

JRM

1. Kermit Champa, "Charlie Was Like That," *Artforum,* 12 (March 1974): 54–59.

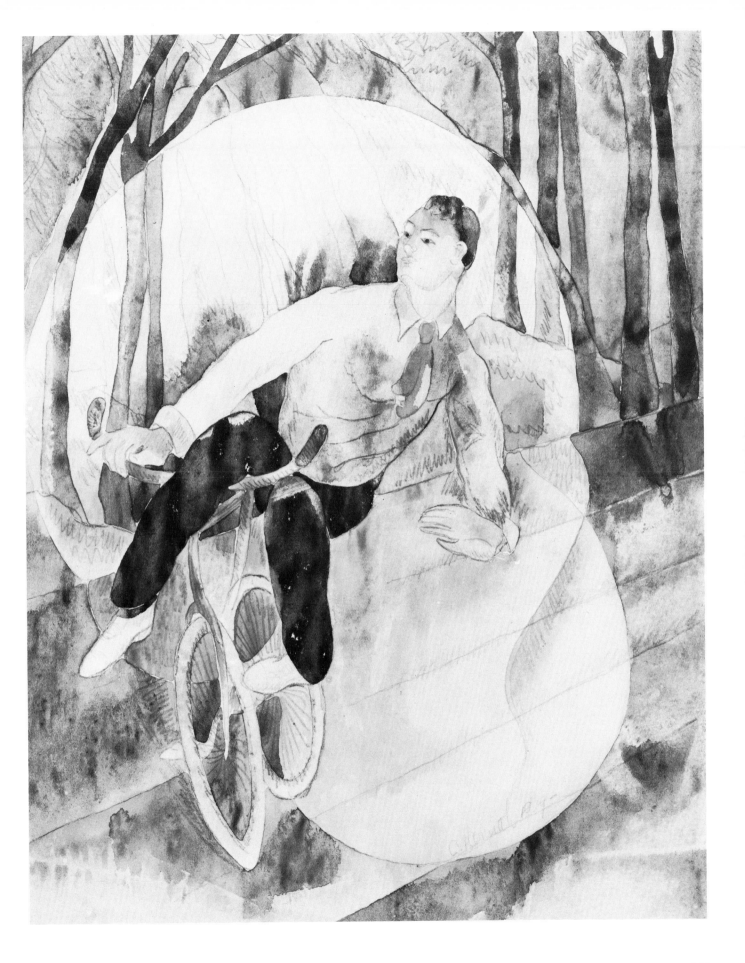

101

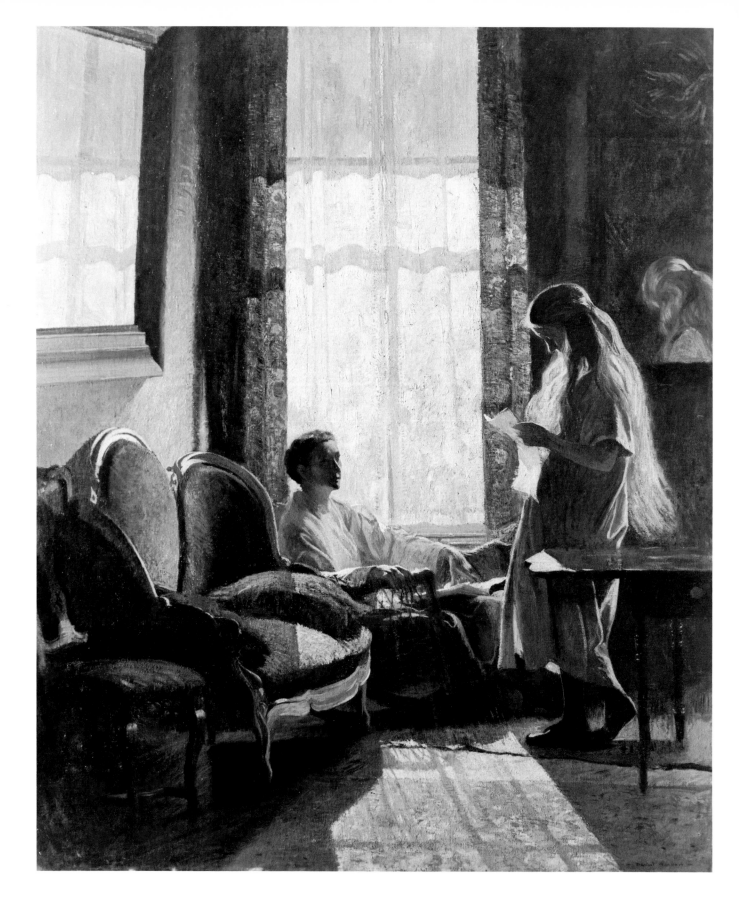

38 **Daniel Garber** (1880–1958)
South Room—Green Street, 1921
Oil on canvas
51⅛ x 42⅜ in. (129.9 x 107.6 cm)

Inscribed lower right:
—*Daniel Garber*—
Museum purchase 21.6
See Color Plate

Although Daniel Garber is best known as a landscape painter, he did occasionally create figurative subjects like *South Room—Green Street,* which portrays the artist's wife and daughter in their Philadelphia home. Garber greatly admired the Boston School artists (see Cat. Nos. 32,34), and his genre pieces share with theirs an interest in women involved in domestic activities. Indeed, the reading of a letter was a popular theme among Boston artists. Like Tarbell's *Josephine and Mercie* (Cat. No. 32), *South Room—Green Street* projects an air of familial intimacy; but Garber's room, with its motley collection of furniture and faded rugs, is more homey than Tarbell's genteel interior.

Garber was one of the leading Impressionists of the Pennsylvania School. His early figurative works, done between 1908 and 1920, show people bathed in full sunlight, but with *South Room—Green Street* he began a series of pictures concerned with the problem of light falling into a darkened room. Intent on representing the properties of light as precisely as possible, he carefully depicted light reflected from mirrors, light reflected off the settee and onto the dark side of the mother's face, and light pouring through his daughter's hair and clothes. Even a small detail like the lacy wicker of the mother's chair is accurately repeated in its shadow on the floor. According to the artist's daughter, her pose reading a letter was only "an excuse to be standing in the light." [1]

Although Garber was interested in the objective qualities of light, he also responded to it emotionally. Concerning *South Room* he wrote: "As the light

came through the heavy cretonne curtains, it made them seem almost like stained glass, and you felt the wonder and charm of its passage. When you feel those things, it seems to me they are really worth recording." [2] The bright light of the window and mirror and the illumination of the girl's hair creates a radiance that verges on the religious, and Garber's reference to stained glass focuses our attention on the room's hushed, cathedral-like mood. Dusky and filled with cool light, it is a silent sheltered place. Not a conventionally religious person, Garber was deeply moved by nature and especially by light. The tranquil tone of *South Room* is typical of his works. As one early critic put it: "This search for the restful and beautiful within the plain facts of his own life motivated all of Garber's best work and transformed it into something serene and golden." [3]

JRM

1. Letter to author dated December 31, 1980, in the possession of the Corcoran Gallery. I would like to thank Tanis Page for freely discussing her father with me.
2. Dorothy Grafly, "Form is the Philosophy of Art, as Color is its Drama," *The Monitor* (September 2, 1922): n. p. Clipping in the vertical file of the library of the National Museum of American Art.
3. Kathleen A. Foster, *Daniel Garber, 1880–1958* (Philadelphia: Pennsylvania Academy of Fine Arts, 1980), pp. 30–31. Quoted from the *Brooklyn Daily Eagle,* April 15, 1925.

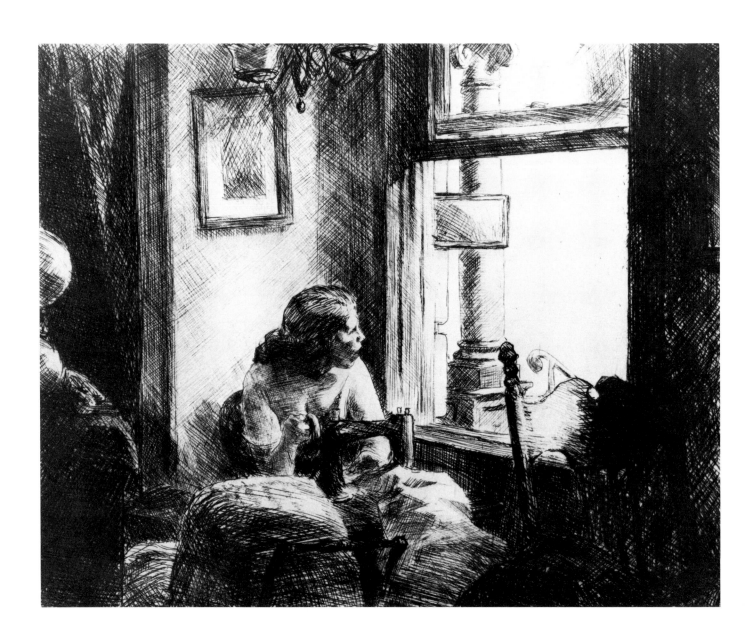

39 Edward Hopper (1882–1967)
East Side Interior, 1922
Etching
7⅞ x 9⅞ in. (28 x 25.1 cm)

Inscribed lower right: *Edward Hopper*
Museum purchase (Mary E. Maxwell
Fund) 54.18

*E*ast Side Interior is set in the slums of the Lower East Side, also the locale of Myers' *Life on the East Side* and Eberle's *Girls Dancing* (Cat. Nos. 45,31). Unlike Myers, Eberle, and also John Sloan, Hopper was not interested in the poor as such. A political conservative, he wrote in 1956 of *East Side Interior:* "No implication was intended with any ideology concerning the poor and oppressed. The interior itself was my main interest, simply a piece of New York, the city that interests me so much."[1]

Hopper in his etched work, done principally between 1915 and 1923, was greatly influenced by Sloan's etchings. He probably adopted from Sloan the subject of the solitary woman in a room, a theme that was to be extremely important in his mature period beginning in 1925. However, the figure in *East Side Interior,* though dressed only in a slip, lacks the lusty, slightly vulgar quality of Sloan's women.

Hopper's etchings are often mistakenly judged in light of his later work, which tends to be quite static. They actually have, as Ian Jeffrey has pointed out, the "same scudding vigor" of the Mohegan Island landscapes of 1916–1917.[2] Far from static, *East Side Interior* records a fleeting moment as the woman, distracted by something outside, looks up from her sewing. The composition adds to the lively spirit of the scene. Unlike *Ground Swell* (Cat. No. 54), the picture is not spare but filled with objects—chandelier, Ionic capital, stair rail, baby carriage, and lamp. In describing Sloan's design, Hopper once wrote: "It attempts tenaciously . . . the surprise and unbalance of nature, as did Degas," whom Hopper also greatly admired.[3] The many diagonals give this composition a visual instability, reminiscent of Sloan's work,

while the cropping of the objects on the edges to create a haphazard look is a technique adapted from Degas.

The woman's expression has been described as "wistful" or "extremely melancholic,"[4] but startled seems more to the point. The tone of the work is not wistful but rich, warm, and almost joyous. Warmth is conveyed by the womanly softness of the figure as well as by the rich softness of the chiaroscuro. Hopper, who particularly admired Rembrandt, avidly searched for stark white papers and very black inks that would give him "the contrast and brilliance" that he wanted.[5] The chiaroscuro is even more important in creating the impression of strong sunlight, a quality Hopper strongly responded to all his life.[6] In his mature works his figures tend to be oblivious to the magnificent light that often fills the settings; but in *East Side Interior* the woman seems surprised by the beauty of the sunlight pouring in on her.

JRM

1. Gail Levin, *Edward Hopper: The Complete Prints* (New York: W.W. Norton and Whitney Museum of American Art, 1979), p. 30.
2. *Edward Hopper, 1882–1967* (London: Arts Council of Great Britain, 1980), p. 8.
3. Levin, *Hopper,* p. 8.
4. *Ibid.,* p. 20, and Nancy Heller and Julia Williams, *The Regionalists* (New York: Watson-Guptill, 1976), p. 131.
5. Levin, *Hopper,* p. 11.
6. In Hopper's obituary in the *Washington Post* (May 18, 1967, p. B9) Hopper is quoted as having said: "As a child I felt the light on the upper part of the house was different than that on the lower. There is a sort of elation about sunlight on the upper part of a house."

40 John Grabach (b. 1886)
Waterfront–New York, c. 1923
Oil on canvas
36 x 42 in. (91.4 x 101.7 cm)

Inscribed lower left: *John R. Grabach*;
on stretcher: *Waterfront—New York*
Museum purchase (William A.
Clark Fund) 41.88

Waterfront—New York depicts a section of the docks along the Manhattan side of New York's East River.[1] In the foreground are dockworkers and horses; in the background, the Brooklyn Bridge. The painting is typical of John Grabach's work of the 1920s. Originally a painter of impressionist landscapes and figure subjects, he turned to city themes because "the rhythm of city life impelled me to interpret it on canvas."[2] In creating his urban work, Grabach seems to have been strongly influenced by the Ash Can School, particularly by the work of John Sloan and George Bellows. Many of his subjects had been treated earlier by them; for example, Bellows' *Men of the Docks* (1912) and *Snow Dumpers* (1911) prefigure *Waterfront—New York.*

Grabach's emphatic treatment of the Brooklyn Bridge also allies him intellectually with a number of modernist artists who painted the city during the 1910s and 1920s.[3] A popular symbol of American progress and know-how since its completion in 1883, the Brooklyn Bridge became part of the iconography used by the modernist painters to glorify the American city and modern industrialism. In their paintings reverence previously accorded God and nature accrued to man and technology. Even the title of one of Grabach's bridge pictures, *The Steel Rainbow,* shows how appreciation for nature was transferred to engineering. In *Waterfront* the gleaming white bridge, silhouetted against a black sky, towers majestically over the mundane dock activities below.

The modernist artists who glorified the city frequently created pictures without people, treating the urban environment with all the impersonality of a machine. Grabach shared their admiration for American technological progress, but, grounded in the tradition of Sloan and Bellows, he did so without minimizing the contribution people make to the dynamism of the city.

JRM

1. I wish to thank Mr. Grabach for confirming that this was the Manhattan side and for generally discussing this work with me.
2. *Newark Sunday Call,* September 3, 1939; clipping file, National Museum of American Art Library.
3. Virginia Mecklenburg suggests this connection in her *John R. Grabach: Seventy Years an Artist* (Washington, D.C.: Smithsonian Institution Press, 1980), p. 15.

41 **John Sloan** (1871–1951)
Sunday, Drying Their Hair, 1923
Lithograph
7⅜ x 9⅛ in. (18.8 x 23.1 cm)

Inscribed in plate at lower right: *John Sloan '23;* in pencil at lower right: *John Sloan;* lower left: *25 proofs;* lower center: *Sunday Drying Their Hair*
Museum purchase (Mary E. Maxwell Fund) 51.33

Sunday, Drying Their Hair, a variation in reverse of Sloan's painting *Sunday, Girls Drying Their Hair* of about ten years earlier,[1] was commissioned by *Century Magazine* as part of a picture essay on Sloan's lithography.[2] The incident depicted reportedly took place on the roof of the tenement building adjacent to Sloan's loft studio in Greenwich Village,[3] at that time a predominantly Irish and Italian working-class neighborhood. Here space was at a premium: large families, sometimes with additional lodgers, frequently crowded into small three-room flats. The roof offered an escape from these living conditions and in good weather was the scene of much of the social life of the tenement.

Sloan began treating working-class subjects in his *New York City Life Series* (Cat. No. 29). His interest in the working class was partly the result of the intellectual climate of the Progressive Era, the twenty-five years prior to World War I. During the 1890s the deplorable circumstances of the lives of the poor and their exploitation by industry became of increasing concern to many Americans. Consequently there were a number of important social innovations, such as the settlement house movement, that attempted to alleviate these conditions. By the turn of the century, city slum life was visible and very topical. It is against this backdrop that Sloan—spurred by Robert Henri's philosophy that everyday life should be the artist's inspiration—turned to working-class subjects.

Unlike social reformers, Sloan did not expose the sordid aspects of slum life. His work has more to do with the then important issue of assimilating into American life the post-1880 influx of Southern and Eastern European immigrants. Sloan's most frequent subject was the young working-class girl, whom he consistently depicts as robust and full of life. His notebooks of this period are peppered with references to such girls, often including comments about their sexuality. Sloan seems to have perceived the natural, healthy sensuality of the immigrant girl as a welcome antidote to the over-refined bloodlessness of middle- and upper-class American women such as those depicted in *Fifth Avenue Critics* (Cat. No. 29). He was not alone in this position: a number of intellectuals of his day felt that the new waves of immigrants could bring variety and vitality to American culture.

JRM

1. Now in the Addison Gallery of American Art, Andover, Massachusetts.
2. John Sloan, "Among the Four Million," *Century Magazine,* 106 (August 1923): 569.
3. John Sloan, *Gist of Art* (New York: American Artists Group, 1939), p. 233.

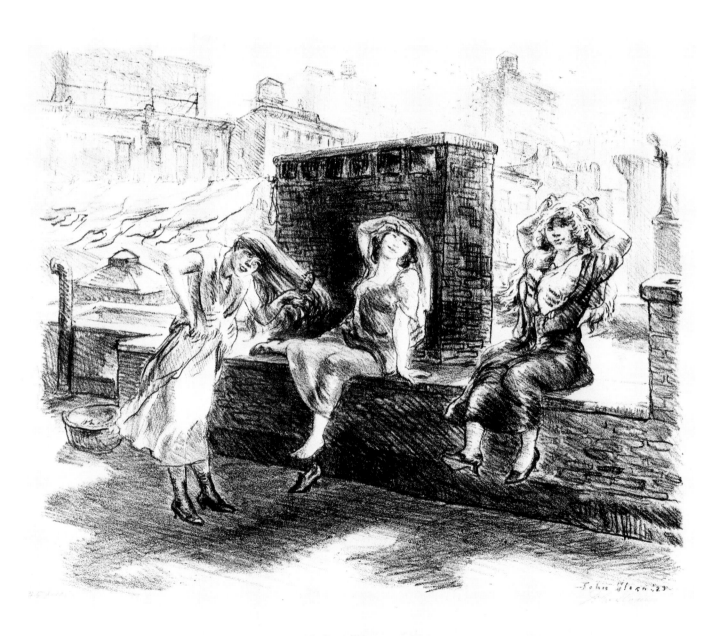

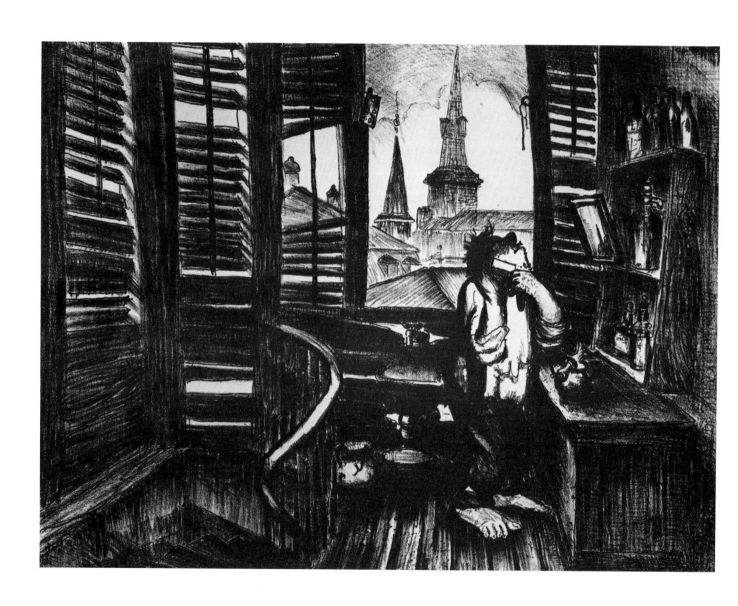

110

George Overbury "Pop" Hart
(1868–1933)
Springtime in New Orleans, 1925
Lithograph
9½ x 12½ in. (24 x 31.8 cm)

Inscribed lower center right: *Pop Hart*
Bequest of George Biddle 1974.23

"Pop" Hart, so called because of his unruly beard, was one of the more unorthodox American artists of his time. Caring little for money, fame, or respectability, he only wanted to do two things: travel and draw. And travel he did. Born in Cairo, Illinois, he left home as a young man and spent twenty-five years visiting London and Paris along with Italy, Tahiti, the West Indies, South America, Egypt, and Iceland.

Hart had almost no formal training as an artist. A sign and scenery painter by trade, he did not devote himself to art fulltime until after 1921, when he took up printmaking and began to produce images based on drawings done in his years of wandering. *Springtime in New Orleans* is a case in point; it was done in 1925 from a drawing made in 1917.

A born raconteur, Hart loved to tell funny stories about things that happened to him on the road. Not surprisingly, his approach to art was also comic and anecdotal. In *Springtime in New Orleans,* which shows the rooming house where Hart lived,[1] he has clearly exaggerated the dilapidated condition of the room and its disheveled inhabitant in order to produce a comic effect. This lithograph also satirizes the picturesque views of cities popular with artists and tourists since the time of Canaletto. In the background is the Cathedral of St. Louis, one of the most famous landmarks in the French Quarter, the Vieux Carré. Hart has cunningly juxtaposed this view and the seedy rooming house as if to compare the real New Orleans with the tourist's romantic view.

The title itself has an appropriately humorous origin. In New Orleans Hart lived with the artist Jules Pascin. George Biddle, a mutual friend of Hart and Pascin, subsequently recorded how the print was named:

On the original proof "Pop" in bold architectural lettering had the words "Veau Carre." Pascin had corrected his orthography. Then it became "The Early Morning Razor." But had razor one or two s's? "Oh, hell," said "Pop," "call it Springtime in New Orleans."[2]

JRM

1. George Biddle Papers, "Diary, Feb. 1933–Sept. 1935," Archives of American Art, Smithsonian Institution, roll D-127, frames 206–207. (Lent by George Biddle, 1963.)
2. *Ibid.*

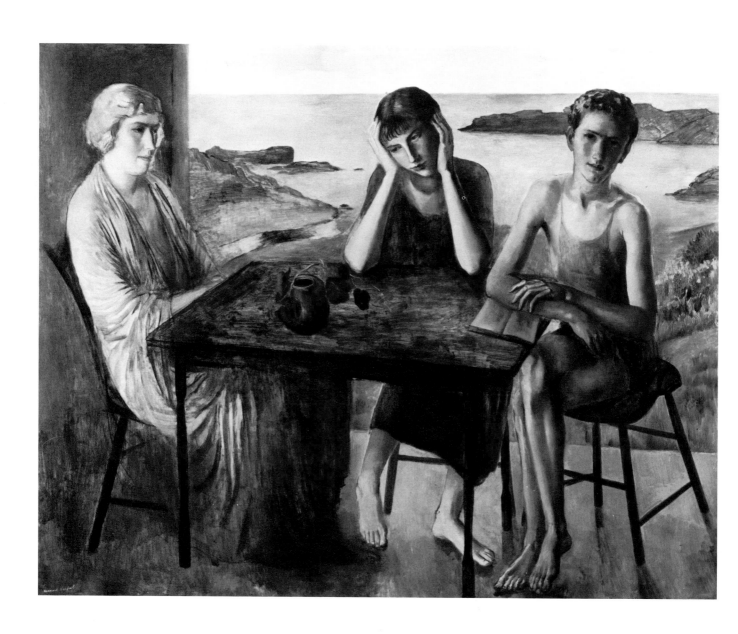

43 **Bernard Karfiol** (1886–1952)
Summer, 1927
 Oil on canvas
46⅜ x 60⅜ in. (117.8 x 153.4 cm)

Inscribed lower left: *Bernard Karfiol*
Museum purchase (William A. Clark
Fund) 28.6

Bernard Karfiol frequently used members of his family as models. In *Summer* he depicted his wife and two children in their summer home at Ogunquit, in southwest Maine. The view seen through the window appears repeatedly as the background in his paintings.[1]

Because of improved rail transportation during the last third of the nineteenth century, Maine became a favorite place for middle-class Easterners to spend the summer. Artists quickly followed. By the second decade of the twentieth century, Ogunquit had a sizable art colony: Hamilton Field, an early promoter of modernism, held his summer school there; Yasuo Kuniyoshi and Abraham Walkowitz, among others, were frequent visitors. Karfiol was introduced to Maine in 1914 by Field, and he vacationed there for the rest of his life.

Stylistically *Summer,* like much of Karfiol's work of the mid-1920s, has its roots in the work of Picasso and in Archaic Greek art. Karfiol lived in Paris from 1901 to 1906 and was one of the first Americans to join Gertrude Stein's circle. There he met Rousseau, Matisse, and Picasso, among others. In *Summer* the elongated and slightly awkward forms, the mannered yet expressive hands, and the placement of the figures behind a table are reminiscent of certain early works of Picasso. Karfiol's interest in Archaic Greek art[2] is seen in the mother's drapery and the stylized features of the faces.

Summer communicates a sense of calm and timelessness. Karfiol was unusual among his contemporaries in trying to evoke these qualities. He found them in Greek art—and also in Ogunquit. In a letter to the artist Max Weber, dated August 1927 and possibly written while working on this painting, Karfiol wrote:

But when you get away from the city you forget your troubles. . . . Ah! to sit under a great pine tree, as I am doing at this moment and to see as far as I can see . . . wonderfully colored cliffs, great rock formations, also old farms and the great peace of loneliness which everyone who thinks finds necessary at times.[3]

In *Summer,* Karfiol's family sits together, yet each person is isolated. Deep in separate musings, they seem at peace with the loneliness that was for Karfiol such an important part of Maine.

JRM

1. There is a photograph of the same scene among his papers in the Archives of American Art. Bernard Karfiol Papers, Archives of American Art, Smithsonian Institution, roll NKa 1, frame 389.
2. John Shapley, ed., *The Index of Twentieth-Century Artsists, 1933–1937* (New York: Arno Press, 1970), p. 130.
3. Max Weber Papers, Archives of American Art, Smithsonian Institution, roll N69-83, frames 508–509.

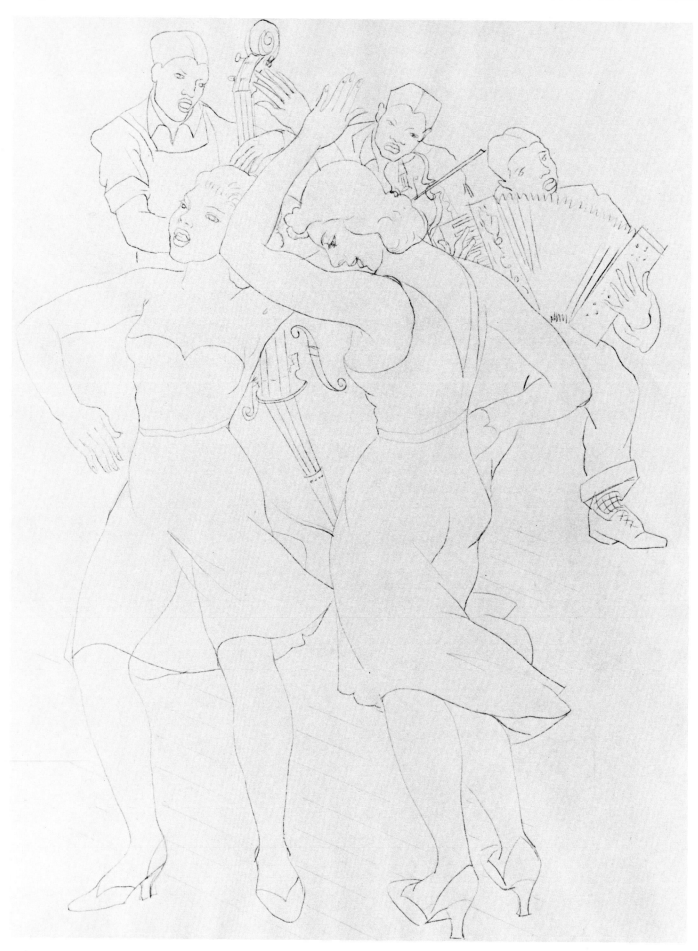

44 **William L'Engle** (1885–1957)
Girls Dancing, Harlem, 1930
Pencil on paper
20½ x 15⅞ in. (52.1 x 40.3 cm)

Inscribed lower left: *Harlem 1930;*
lower right: *W L'E 1930*
Gift of Lucy L'Engle 58.14

Girls Dancing, Harlem, one of a number of Harlem scenes by William L'Engle, represents a dance team in a nightclub in New York's black ghetto. Harlem's nightclubs and speakeasies enjoyed a burst of popularity during the 1920s when they attracted whites going "slumming." This popularity reflected a widespread fascination with things Negro, especially among artists and sophisticates who found the middle-class values of white America hypocritical, puritanical, and boring.[1]

L'Engle was among those artists who saw in black art an alternative to the artificiality of established modes of artistic expression. Jazz and the new dance forms created by blacks were particularly admired, and L'Engle chose these as the theme for his drawing. In tight clothes, very sexy, and moving to a rhythmic beat, his dancers epitomize the then current view of blacks as primitive, exotic, and highly sensual. As one critic of a Harlem revue wrote, "You will not enjoy it if you blush at dancing that suggests the end to which dancing was originally dedicated."[2]

L'Engle considered himself a modernist artist. He studied in Paris before World War I and championed the modernist faction at the Provincetown Art Association, where he was an active member for over fifty years. His emphasis on simplified linear definition of form was common to a number of American artists such as Charles Demuth and Bernard Karfiol (Cat. Nos. 37, 43). Like Demuth, L'Engle frequently took his subjects from the world of entertainment: dancers and acrobats, wrestlers and baseball players appear repeatedly in his work. He was greatly interested in the body in motion and in representing it solely by means of line. In *Girls Dancing* he achieved this end by using supple wavy lines and patterned repetition of shapes to create a sense of undulating, rhythmic motion.

JRM

1. Gilbert Osofsky, *Harlem: The Making of a Ghetto* (New York: Harper and Row, 1963), pp. 181–187.
2. Allon Schoener, ed., *Harlem on My Mind; Cultural Capital of Black New York, 1900–1968* (New York: Random House, 1968), p. 82.

Jerome Myers (1867–1940)
Life on the East Side, 1931
Oil on canvas
30¼ x 40¼ in. (76.8 x 102.2 cm)

Inscribed lower right: *Jerome Myers/N.Y. 1931*
Museum purchase 32.11

Manhattan's Lower East Side, an area east of the Bowery, was the home of most of the more than two million Eastern European Jews who poured into the United States between 1870 and 1914. Dire poverty and extreme crowding made this one of New York City's worst slums.

Jerome Myers was one of the first American artists to paint scenes of city slums. His sympathy for the slum dweller seems to have grown out of his own deprived background. As his friend Harry Wickey has pointed out, Myers was "one with them [the poor] from the beginning and enjoyed nothing so much as being in their midst."[1] Despite this empathy, the artist chose not to record realistically the squalor and despair of the slums. Rather he took an idealistic view that focused on the importance of the family, the community, and religious tradition in the lives of the Jewish immigrants.

Life on the East Side is a typical example. In the center is an old bearded Jew, a familiar type who, having come to America as an adult, tried to maintain his life as it was in the old country. Around him are heavy-set Jewish housewives accompanied by their children. As they buy their daily supplies, they familiarly pass the time of day with their neighbors. These are the types of people one sees repeatedly in Myers' paintings. Rarely does he depict, for example, active young men and women.

By the date of this painting (1931) Myers' view of the Lower East Side was anachronistic as well as romanticized. In the twenties the population declined as families moved to more comfortable parts of town, perhaps symbolized by the skyscrapers in the background. Myers never relinquished his ideal view, though he did realize times were changing. Shortly before his death in 1940 he commented, "Something is gone. Something is missing. I say to myself, 'It is the warmth of human contact; that's what it is. It is gone. Men and women and children hide behind the walls of their homes.' New Yorkers no longer live in the open."[2] This painting is thus more a nostalgic comment on immigrant life in the opening decades of this century than it is an accurate recording of the Lower East Side in 1931.

JRM

1. *Jerome Myers Memorial Exhibition,* intro. by Harry Wickey (New York: Whitney Museum of American Art, 1941), p. 5.
2. Grant Holcomb, "The Forgotten Legacy of Jerome Myers (1867–1940): Painter of New York," *American Art Journal,* 9 (May 1977): 91.

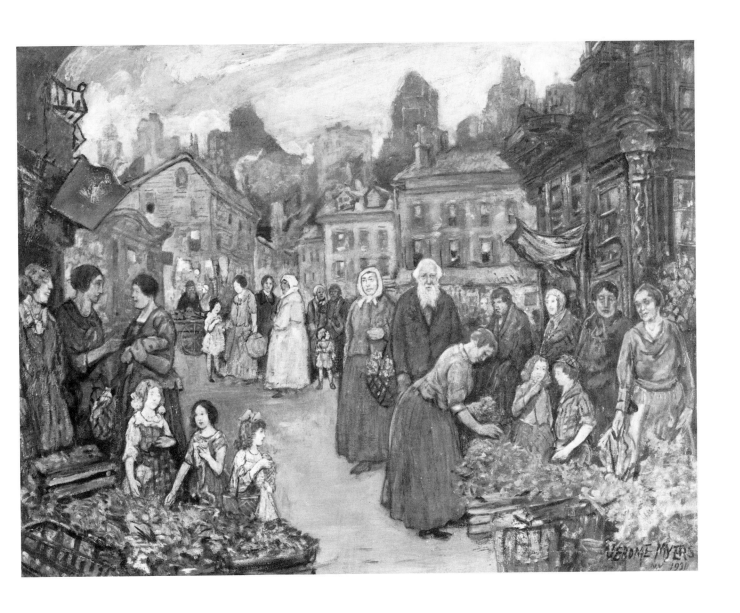

46 **George Benjamin Luks** (1867–1933)
Woman with Black Cat, 1932
Oil on canvas
30⅜ x 25⅜ in. (77.2 x 64.5 cm)

Inscribed lower left: *George Luks*
Museum purchase 32.13

W*oman with Black Cat,* which was begun in 1923 and completed in 1932,[1] is a portrait of an old beggar woman whom Luks saw on a New York street and asked to pose. (The newspapers reported that she was an ex-chorus girl reduced to selling pencils.[2]) The artist has taken a rather sentimental view of his subject: she is less a beggar than a kindly grandmother type. The stray and hungry cat she feeds perhaps serves as a metaphor for the woman herself, while her ridiculous hat adds a hint of humor to the scene.

Luks' interest in lower-class subjects can be traced back to his days as an illustrator for newspapers in Philadelphia, where his assignments brought him into contact with the realities of contemporary urban existence. Moreover, as a member of Robert Henri's circle, he embraced the philosophy that depicting life—not self-consciously creating art—should be the artist's goal. His approach to subject matter was more personal and less optimistic than that of Jerome Myers or John Sloan (Cat. Nos. 45, 41), who dealt with similar themes. Interested in character rather than incident, he frequently painted the more vulnerable members of society—old women and children were among his favorites. His works often exhibit a tenderness and pathos at odds with his image as hard-drinking and boisterous. Mahonri Young has suggested that Luks "understood his battered sitters because he was battered himself."[3]

The Dutch master Frans Hals had a great influence on Luks. In fact, Luks once said that he and Hals were the world's two greatest painters.[4] *Woman with Black Cat* looks very much like a Hals painting. In addition to the obvious similarities—the painterly technique, the dark background, and the half-length format—Hals' influence is also evident in the choice of the low-life subject and in the inclusion of objects—the bowl and the cat—which give a narrative dimension to what is essentially a portrait.

JRM

1. Letter from Luks to Edward W. Root, March 21, 1932, now in the possession of the Munson-Williams-Proctor Institute, Utica, New York (copy at the Corcoran).
2. "One of Luks' Best Paintings in Gallery Here," *Washington Post,* October 30, 1933.
3. Mahonri Sharp Young, *The Eight: The Realist Revolt in American Painting* (New York: Watson-Guptill, 1973), p. 122.
4. *Ibid.,* p. 112.

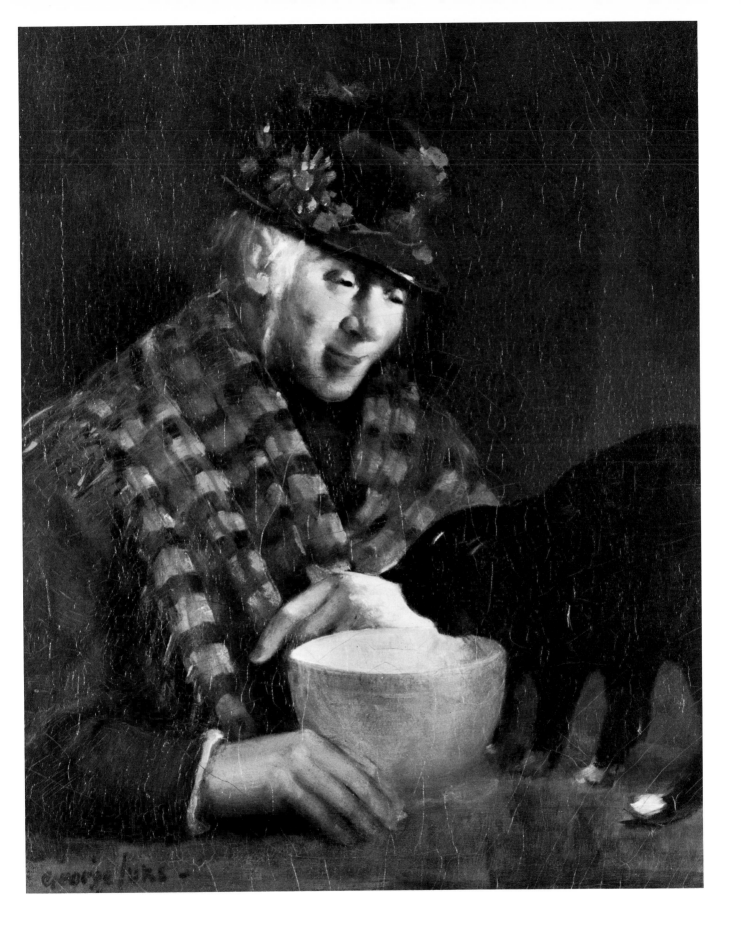

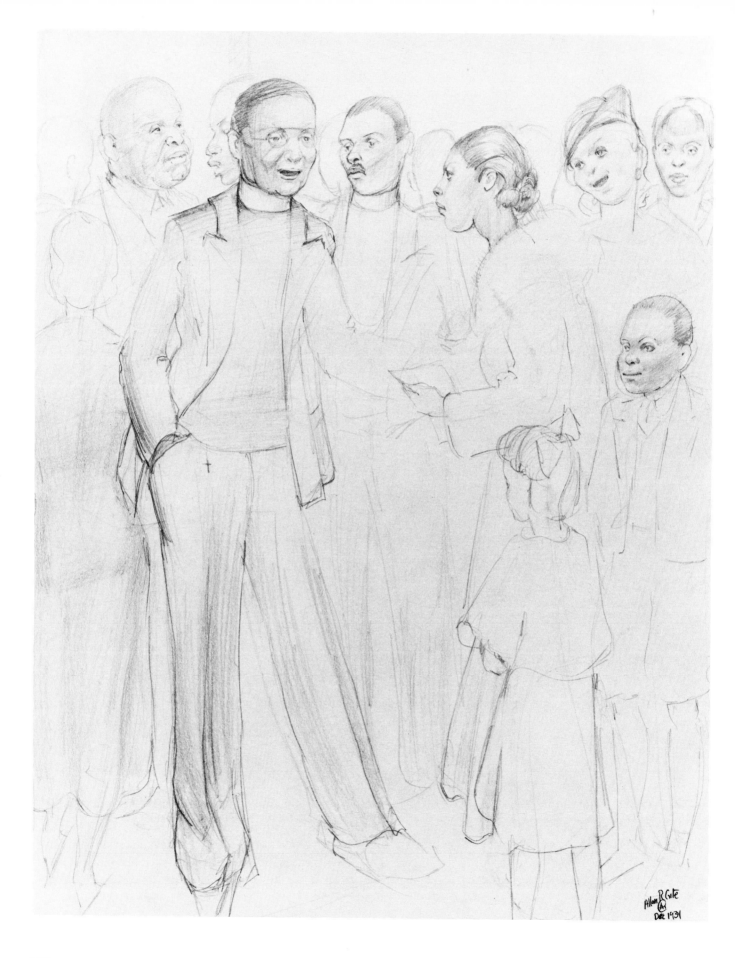

47 **Allan Rohan Crite** (b. 1910)
At a Church Fair, 1934
Pencil on paper
18 x 12 in. (45.7 x 30.5 cm)

Inscribed lower right: *Allan R. Crite/A/Dec 1934;* lower center: *At a Church Fair*
Museum purchase through a gift of Dr. and Mrs. William Chase 1981.32

At a Church Fair is set in a black Episcopal church in Boston's South End. The drawing, depicting a conversation between the priest and a female parishioner, captures the self-assurance of the minister and the respectful demeanor of the woman. A delineator of individual physiognomies and facial expressions, Allan Rohan Crite did not usually sketch from life but kept what he called a "mental file cabinet" of faces from which he could choose when he began to draw.[1]

Crite, who studied at the Boston Museum School from 1929 to 1936, has lived in the South End for over fifty years. During the 1930s it was a poor immigrant section with a few pockets of Negroes. Much of the life of the area, like that of any tenement district (see Cat. No. 45), was on the street. In the 1930s Crite created many drawings of the daily life of his neighborhood, focusing generally on the relationships that make a neighborhood a home. He pictured the streets, the barbershops, and the parks and showed people of all ages coming together in friendly inter-course. *At a Church Fair* is typical in its emphasis on communal relations. The church traditionally has played a prominent role in the social life of the black community, and black ministers have often been important community leaders. A church fair in the 1930s, according to the artist, who remains active in his church, was a fund raiser to which local merchants would donate goods for sale.

Crite's blacks contrast sharply with the wild dancers of L'Engle's Harlem (Cat. No. 44). His people are ordinary Americans, not exotic or primitive creatures. His vision of Negro life was a fundamentally positive one. Crite was aware of the hardships the Depression created among blacks, but he preferred to focus on the warmth of the family and the community.

JRM

1. I would like to thank Mr. Crite and his dealer, Angus Whyte, for discussing his work and this drawing with me.

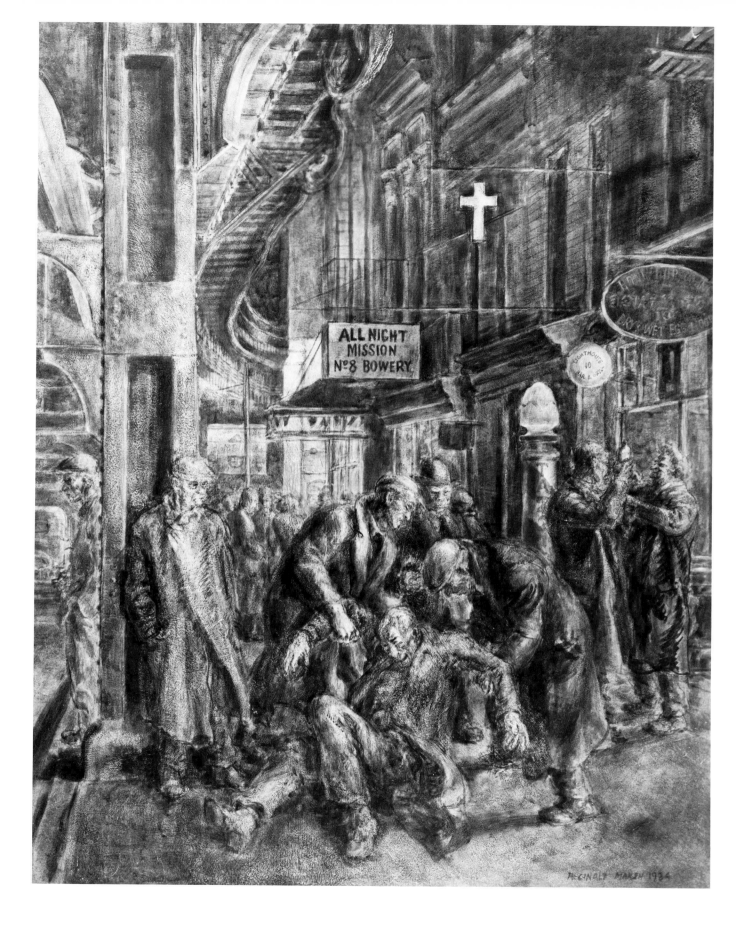

48 **Reginald Marsh** (1898–1954)
Smoke Hounds, 1934
Egg tempera on masonite
36 x 30 in. (91.4 x 76.2 cm)

Inscribed lower right: *Reginald Marsh, 1934*
Gift of Felicia Meyer Marsh 58.26

Reginald Marsh once remarked that he would "rather paint an old suit of clothes than a new one because an old one has character, reality is exposed not disguised. People of wealth spend money to disguise themselves." [1] *Smoke Hounds* reflects this aesthetic in its depiction of a squalid scene in the Bowery, a section of lower Manhattan that was, and still is, the home of a large population of derelicts. Its numerous missions, such as the All Night Mission seen in *Smoke Hounds,* provided the bums with food and shelter in exchange for a chance to save their souls. This minimal living was all the stereotypical Boweryman desired—nothing more than to live undisturbed by hope or ambition and be consoled by the rot-gut whiskey called smoke.

Only a few blocks from Marsh's studio on Fourteenth Street, the Bowery, along with Times Square and Coney Island, provided a major source of imagery for the artist throughout his career. His Bowery paintings of the 1930s were surely affected by the Depression and by the swarms of unemployed that poured into the area, but his fascination with tramps can be traced back to his childhood. He began treating them in his art in the 1920s. He depicted Bowery themes as a magazine illustrator in the late 1920s, drew tramps when in Paris in 1925–1926, and made his first print of a Bowery subject in 1928. Although Marsh sometimes painted the unemployed of the Depression, his primary concern was not with them but with the permanent outcasts of society. In *Smoke Hounds* the grotesque, even animalistic faces express the degradation of these broken men. The dark, murky color and the scratchy handling contribute to this impression.

A major motivating force behind Marsh's work seems to have been his rejection of the genteel and affluent milieu in which he had been raised. Marsh's father, the son of a wealthy Chicago pork packer, did not work for a living, and both he and his wife dabbled in painting. According to Lloyd Goodrich, a lifelong friend, Marsh as a youth "always did his best to seem . . . a completely normal boy, interested in sports, fights and outdoor life. All of which was doubtless a rebellion against the artistic atmosphere of home." [2] This rebellion continued into his maturity. Marsh painted ruined men, sexy burlesque queens and their admirers, and the hordes of Coney Island; his themes of failure and sensuality were offensive to proper society. Whether he was reveling in the vulgar excitement of Times Square or looking, as in *Smoke Hounds,* at New York's underside, his message was always the same: this, not refined manners or cultural pursuits, is what is real.

JRM

1. Lloyd Goodrich, *Reginald Marsh* (New York: Harry N. Abrams, 1972), p. 35.
2. *Ibid.,* p. 18.

49 **Walker Evans** (1903–1975)
 Sidewalk in Vicksburg, Mississippi
 1936
 Photograph
 8 x 9⅞ in. (20.3 x 25.1 cm)

Gift of Mr. and Mrs. Murray Bring
1980.156.1

Sidewalk in Vicksburg, Mississippi, comes from a series shot in the black sections of Southern towns as part of the photographic section of the Farm Security Administration, an agency of the New Deal. The project's goal was to document everyday life in America with particular emphasis on the country's farmers, who had been victims of both Depression and drought. Its intent was humanitarian—to lead to the correction of social ills. Walker Evans worked intermittently for the project between the summers of 1935 and 1938. It was a time of immense creativity for the artist, a time when he produced some of the most significant work of his career.

Evans was committed to an uncompromisingly objective treatment of his subjects. In forming this aesthetic he rejected two of the most important photographers of the day—Alfred Stieglitz, whose "artiness" [1] he disliked, and Edward Steichen, whose work he thought too commercial. Evans was also greatly influenced by the French realist writers of the nineteenth century, particularly Flaubert. He hated the contemporary materialism of American life and wanted to photograph a country not touched with "the hardness and superficiality of America's latter day." [2] But his works are not nostalgic; nor are they "part of the social protest of the time or intended to be heart-wringing. They are a record of what's what." [3]

Evans had the ability to pick subjects that revealed the whole tenor of the lives of the people portrayed. In *Sidewalk in Vicksburg* the composition makes the viewer aware of the weathered, crumbling building. Everything looks as if it had been there forever. The image also communicates the lethargic, enervating, unchanging pace of small Southern towns, where there is little to do and little to talk about. Yet a sense of personal pride remains, as is evident in the man who passes the time in a suit and tie.

His objectivity resulted in an exceptionally lucid, crisp style. Shot in bright sunlight and sharply focused, this photograph is rigidly symmetrical and was taken directly in front of the subject. The artist's detachment allows his subjects to speak for themselves. But his style does have a bias. Its restraint imparts to the subject a monumentality and dignity that commands respect. "Transcendence" is what Evans called the quality that distinguishes his pictures from ordinary documentation: "Unless I feel the product is a transcendence of the thing, of the moment in reality then I haven't anything and throw it away." [4] American poet William Carlos Williams perhaps best described Evans' photography when he wrote, "It is ourselves we see, ourselves lifted from a parochial setting. We see what we have not heretofore realized— ourselves made worthy in our anonymity." [5]

JRM

1. Isabelle Storey and Alan Trachtenberg, *The Presence of Walker Evans* (Boston: Institute of Contemporary Art, 1978), p. 20.
2. *Ibid.*
3. Evans quoted in *Walker Evans, Photographs* (London: Arts Council of Great Britain, 1976), n.p.
4. Storey and Trachtenberg, *Presence of Walker Evans,* p. 16.
5. John Szarkowski, *Walker Evans* (New York: Museum of Modern Art, 1971), p. 16.

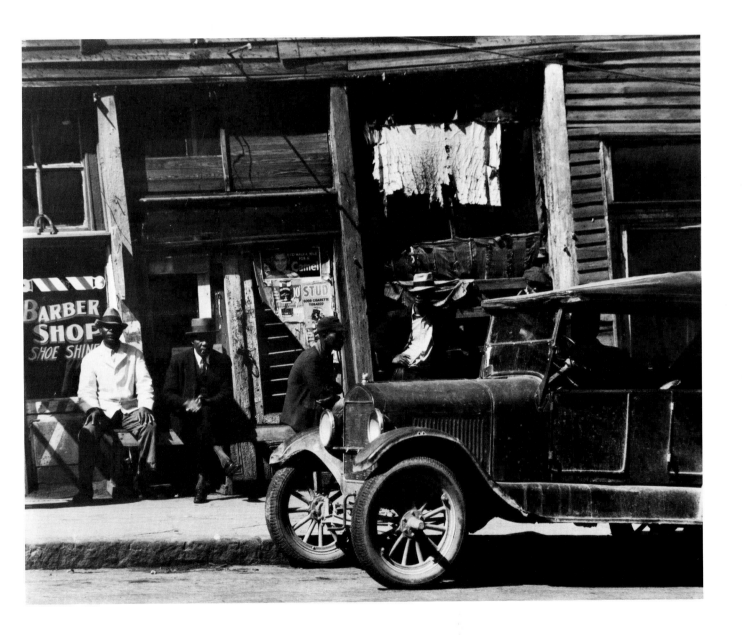

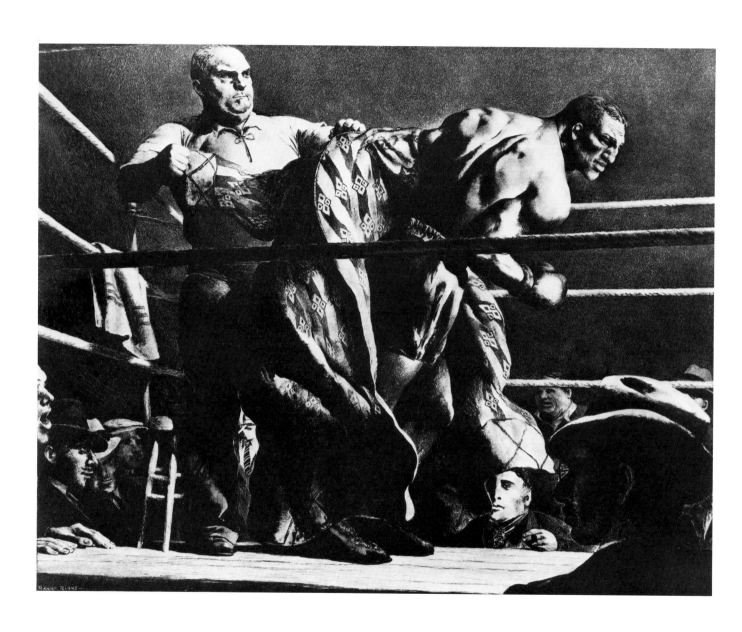

50 **Robert Riggs** (1896–1970)
Club Fighter, 1936–1939
Lithograph
14 x 18⅛ in. (35.6 x 46 cm)

Inscribed in plate lower left: *Robert Riggs*; inscribed lower left: *Club Fighter*; lower right: *Robert Riggs*
Bequest of Frank B. Bristow
68.26.550

Club Fighter was based on observations Robert Riggs made at the Broadway Athletic Club in South Philadelphia.[1] The designation "club fighter" indicates that the boxer was not nationally known but fought in local clubs. Riggs' fighter is Italian. One of the recent immigrant groups at this time, Italians were beginning to dominate a sport which had previously been the preserve of the Irish.

Riggs took up boxing subjects during the Depression after he turned his back on the modernist European art that had so strongly influenced his early career. His choice of subject is not surprising: it had already been treated by such major realists as Thomas Eakins and George Bellows. More important, it was a popular sport in this country during the 1930s, and Riggs was determined to focus on American themes. As he wrote in 1932: "There is no such thing that rises above national frontiers; you can't be born in Decatur, Illinois, and think in terms of Constantinople."[2] In addition, Riggs' fascination with the cultures of Africa and with the North American Indian made him particularly receptive to the primitive, ritualistic quality of boxing and of the circus, his other favorite theme.

Riggs' print presents a stereotypical image of the boxer as a kind of cult hero of the period. Boxing was a recurring theme in American films of the 1930s, with the standard plot involving the struggle between a pure, noble fighter and the corrupt gangsters who are trying to use him. *Club Fighter* follows the same pattern. Riggs' strong, dignified fighter contrasts sharply with the sleazy types that surround the ring; he seems simultaneously above them and a victim of the system. It is tempting to find in this bold image an expression of individual worth within a corrupt society. In any case, Riggs' view captures the dilemma of a decade in which the common man was at the mercy of social and economic forces beyond his control.

JRM

1. John Warren Papas, "Robert Riggs: His Life, His Lithographs, and Related Works," master's thesis, Temple University, 1967, p. 15. I wish to thank David Schwarz, of the National Portrait Gallery, and Phillip Desind, of the Capricorn Gallery, for bringing this source to my attention.
2. *Ibid.*

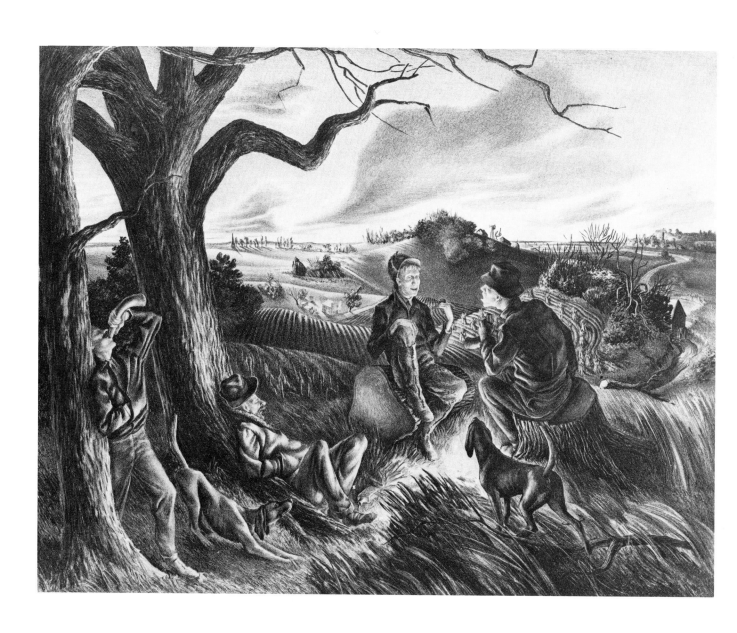

128

1 **John Stockton de Martelly**
(1903–1979)
Blue Valley Fox Hunt, 1937–1938
Lithograph
12⅛ x 16½ in. (30.8 x 41.8 cm)

Inscribed lower right: *John S. de Martelly*
Bequest of Frank B. Bristow
68.26.433

*B*lue Valley Fox Hunt is set in the valley of the Blue River, which flows from southern Nebraska into northern Kansas not far from John de Martelly's adopted home town, Kansas City. Fox hunting took several forms in the United States, including stalking the fox on foot as well as the customary British hunt on horseback. This print shows a more unusual but very old practice in which the hunters neither chase nor kill the fox, and probably do not even see it. Men go out into the country with their trained foxhounds, which are let loose to stalk the prey. The pleasure of the "hunt" comes from sitting up all night "jawing" with friends and listening to the dogs pursue the fox. In the morning the "hunters" round up the dogs and return home. *Blue Valley Fox Hunt* shows men sitting around a fire just as the sun is beginning to come up. One man sleeps off the liquor from the bottle tossed to the right of his foot, another leisurely smokes a pipe, and two others call in the dogs.

De Martelly's career provides an excellent example of the trend toward nationalism in American art in the 1930s. During the Depression years there was a great reaction against what was perceived as the sophisticated cosmopolitanism of the 1920s and a drive to get back to the basic—meaning rural—American values. In art these ideas were embodied in the work of the American Scene, or Regionalist, movement headed by Thomas Hart Benton, who greatly influenced his friend de Martelly. *Blue Valley Fox Hunt,* one of de Martelly's most popular prints,[1] epitomizes his allegiance to Benton's view of rural America. The fox hunters are "just plain folk" enjoying male camaraderie. De Martelly is also stylistically indebted to Benton, frequently adopting his mentor's compositional practices and his habit of distorting shapes in order to produce rhythmic patterns.

JRM

1. It was published in *Fine Prints of the Year* for 1938 (Malcolm Charles Salaman, ed., London: Halton and T. Smith, Vol. 16, Plt. 68.) and was chosen to represent the artist in the Associated American Artists Tenth Annual Exhibition (*Studio,* 129, June 1945, p. 198).

52 **Peter Hurd** (b. 1904)
Sermon from Revelations, 1938
Lithograph
10 x 13½ in. (25.4 x 34.3 cm)

Inscribed lower left: *Sermon From "Revelations";* lower right: *Peter Hurd*
Bequest of Frank B. Bristow
68.26.306

Sermon from Revelations, one of approximately fifty lithographs Peter Hurd executed during the 1930s and 1940s, represents a religious gathering observed by the artist on the outskirts of his hometown—Roswell, New Mexico. The subject is "an itinerant preacher from some Pentecostal sect calling down the terror of the Apocalypse on all the unrepentant."[1] Pentecostalism differs from other Protestant denominations in its belief that "speaking in tongues"—glossolalia—is the only acceptable proof that the baptism of the Holy Spirit has taken place. This creed is based on the biblical description of the day of Pentecost (Acts 2:4) in which it is said that the apostles, when filled with the Holy Spirit, began to speak in other languages. The Pentecostals also believe in the imminent Second Coming of Christ and in faith healing.

The print is a veritable handbook of Pentecostal doctrine. The standing figure with arms raised is perhaps speaking in tongues. The evangelist, using a text from Revelations (the last book of the Bible, in which the end of the world is described), exhorts the audience to repent, for the day of reckoning is near. A crippled man to the left waits to be healed. The bright explosion of lantern light in the dark sky as well as the dramatic gestures of the preacher and the standing man give the print the excitement and revelatory quality that the evangelist is trying to achieve in his sermon.

The Pentecostal movement found its adherents almost exclusively among the lower class and had its stongest support in the rural South, Midwest, and Far West. It was, like its predecessor the post–Civil War Holiness movement, a reaction against the increasingly anti-revivalist and middle-class orientation of the traditional Protestant denominations. Founded in 1906, Pentecostalism grew rapidly during the next few decades. Its growth in the 1930s was probably a result of the economic dislocations of the Depression.

Peter Hurd's respect for the values and folkways of rural America marks him as a Regionalist. Throughout his career, his principal subject matter has been the land and people of his beloved New Mexico. His interest in revivalist religion goes back to his childhood, when he watched highly emotional tent meetings and baptisms with a fascination that was probably heightened by his restrained Anglican upbringing.[2] He continued to follow religious gatherings after he returned to New Mexico in 1935 following school in the East. He did one other lithograph of rural religion, *The Baptism at Three Wells.* Both works might also have been inspired by the treatment of similar themes by such Regionalists as Thomas Hart Benton and John Steuart Curry.

JRM

1. John Meigs, ed., *Peter Hurd: The Lithographs* (Lubbock, Texas: Baker Gallery Press, 1969), Plt. 48. In this book the print is titled *Sermon from Revelations No. 2* to distinguish it from an earlier version which is essentially the same except that it shows a smaller congregation and a younger preacher.
2. Information provided by Walt Robinson, Mr. Hurd's secretary.

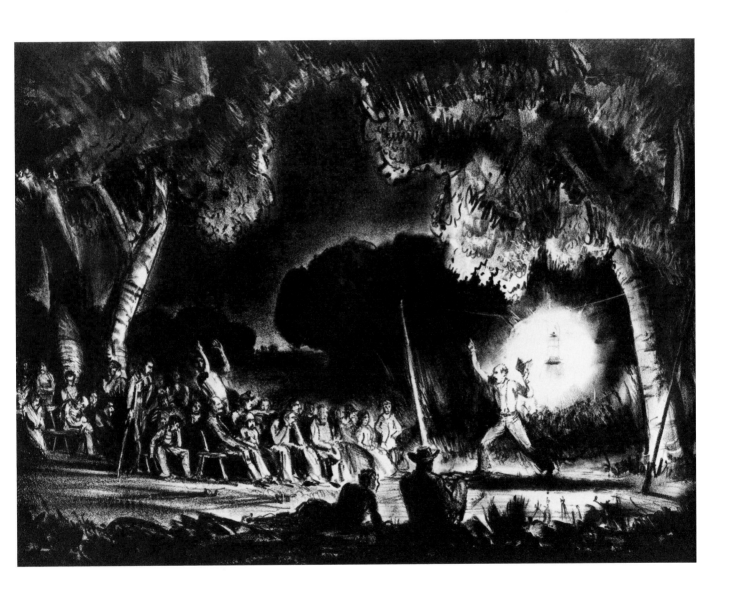

53 **Paul A. Hesse** (1895–1973)
Studebaker Car Advertisement, 1938
Color photograph
11¾ x 16¾ in. (29.8 x 42.5 cm)

Museum purchase with funds from the
Polaroid Corporation 1978.55

This photograph, as its title indicates, was taken in 1938 as an advertisement for Studebaker automobiles.[1] Paul A. Hesse, a commercial artist who turned to photography during World War I, handled Studebaker's advertising photography from shortly after the war until the mid-1950s, when the company went out of business. Hesse's other clients included TWA, Chesterfield cigarettes, Rheingold beer, Lux soap, and Jergens hand lotion. During the 1920s Hesse was one of the first to use color photographs in advertisements. This image was produced by carbro printing, a process little used today in which three very thin pigment layers of the same image are joined in register to form one color picture. Hesse, who was quite well known in his field, began his career in New York but in 1940 moved his studio to Los Angeles, where he had perhaps the largest commercial photography studio in Southern California.[2]

Almost since its invention, the automobile has been an important, if not the most important, status symbol in American life. How successful a man was, how far along he was in attaining the good life, could be measured by what kind of car he could afford. In a sense car manufacturers created the prestige value of the automobile in advertisements by presenting their cars in contexts reflecting the material aspirations of their markets. Studebaker, for example, was a mid-market car, a cut above Ford and Chevrolet, a cut below Cadillac and Lincoln. Although an automobile for the middle class, the Studebaker in the advertisement is placed in an upper-class setting—large home with a black servant carrying golf clubs. The potential buyer of a Studebaker could afford the automobile but probably not the house.

JRM

1. I would like to thank Robert Post of the National Museum of American History, Smithsonian Institution, for identifying the year of the car.
2. "A Belated Thanks," *Petersen's Photography Magazine,* 3 (July 1974): 2. I would also like to thank Don Hesse of Pacific Palisades, California, for providing information about his father.

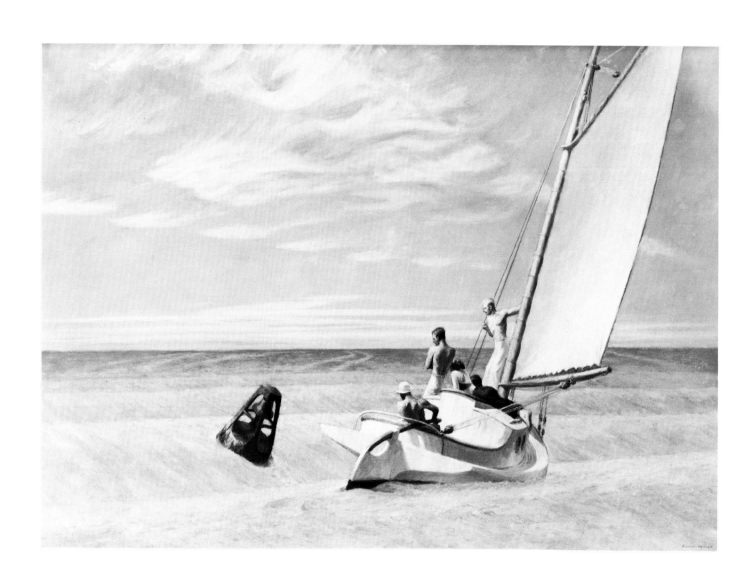

134

54 **Edward Hopper** (1882–1967)
Ground Swell, 1939
Oil on canvas
36½ x 50¼ in. (92.7 x 127.7 cm)

Inscribed lower right: *Edward Hopper*
Museum purchase (William A. Clark
Fund) 43.6
See Color Plate

Edward Hopper's inspiration for *Ground Swell* was sailing at Wellfleet Harbor near his home in Truro, Massachusetts. Marine themes are common in Hopper's oeuvre. Growing up in Nyack, New York, a thriving port on the Hudson, he was fascinated by boats, built his own sailboat, and at one time considered becoming a naval architect. Sailing was the only sport that interested him. He seems to have loved the strong light and sense of physical isolation one experiences on the sea, an isolation that reflected his own taciturn nature. Sailing pictures are scattered throughout his oeuvre, but between 1935, when he was fifty-three, and 1944 he painted four major sailing subjects, including this one which depicts young people in a Cape Cod catboat. His wife, Jo, did not like Hopper to sail: she felt "he was too good a man to lose that way," [1] and he eventually gave up sailing entirely. *Ground Swell* might be the work of an older man looking back at the sport of his youth.

A ground swell is defined as "a violent swelling or rolling of the ocean caused by a distant storm or earthquake." [2] The painting does seem to capture a tense moment as the sailors try to avoid having the bell buoy dashed into them by the large swell. The painting is oddly static, considering the nature of the scene; but the static compo-

sition, as well as the firmness of the horizon, the rigid repetition of the swells, and the solidity of the water, all contribute to the impression of the vast, unyielding power of the sea.

Richard Lahey recorded Hopper's comments about the creation of *Ground Swell:*

I made studies in pencil then took the canvas . . . out to the landscape when the light and the time of day were about the same. I worked from nature and then painted back in the studio from memory—changing, organizing. . . . I remember how I would say to myself when I was working in the studio and going a little stale—"How wonderful it would be to go back to nature again with the big canvas and get the fresh suggestion of nature" and then after a few days working directly would declare—"the accidents of nature are getting in my way—I want to get back to the studio again"—so it went back and forth. [3]

This working method, first with nature and then in the studio, indicates the two-sided nature of Hopper's aesthetic. In 1933 he wrote, "My aim in painting has always been the most exact transcription possible of my most intimate impressions of nature." [4] At the same time he felt that "Great art is the outward expression of an inner life in the artist, and this inner life will result in his

personal vision of the world." [5] Hopper's personal vision was dependent on his ascetic personality: hating decoration and foregoing luxury, he led an austere life. He was extremely reserved; his detachment has been described by Alfred Kazin as "the taut surface of some deeply engrained solitude." [6] Both aspects of this aesthetic are evident in *Ground Swell,* the severity of the scene reflecting both nature's power and Hopper's personality.

JRM

1. Gail Levin, *Edward Hopper: The Art and the Artist* (New York: W. W. Norton in association with the Whitney Museum of American Art, 1980), p. 152.
2. *Webster's New Twentieth Century Dictionary of the English Language: Unabridged* (Collins World, 1976).
3. Richard Lahey Papers, Archives of American Art, Smithsonian Institution, roll 378, frames 983–984. (Lent by Richard Lahey, June 15, 1972.)
4. Edward Hopper, *Edward Hopper* (New York: American Artists Group, 1945), p. 1.
5. Levin, *Hopper,* p. 9.
6. *Edward Hopper 1882–1967* (London: Arts Council of Great Britain, 1980), p. 31.

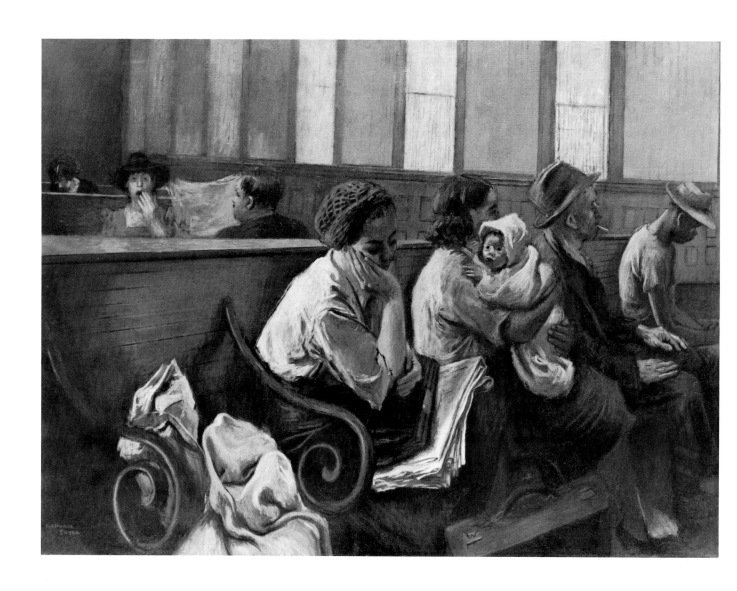

136

55 Raphael Soyer (b. 1899)
Waiting Room, 1939–1940
Oil on canvas
34½ x 45½ in. (87 x 114.9 cm)

Inscribed lower left: *Raphael Soyer*
Museum purchase (William A. Clark
Fund) 43.4
See Color Plate

Set in the 125th Street Railroad Station in New York City, *Waiting Room* is one of many paintings by Raphael Soyer from the 1930s dealing with the unemployed. The muted tones and drab colors accentuate the dreariness of the scene. The painting contains such familiar Depression types as the uncomplaining laborer and the black Southern farm boy, presumably in the city looking for work. But it is the young working-class woman who acts as the focal point of the composition and establishes the mood of the picture. Immediately drawn to the woman by the red of her hairnet and the diagonal thrust of the benches that divide the occupants of the room into distinct social classes, the viewer sees exhaustion in the bend of her body but also notices its soft womanly shape. Despite her weariness, she strikes a life-affirming note and shares a kinship with other sensuous women Soyer painted in the early 1930s.

A Russian Jewish immigrant whose early life was filled with hardship and disappointment, Soyer was a socialist and an advocate for change. Although social comment is implicit in his portrayal of the working class and the unemployed, he did not use his art to promulgate his political beliefs. "By temperament, probably," he wrote, "I chose to paint these silent, non-demanding figures rather than the demonstrations and the clashes with the police so often painted by my fellow artists."[1] Upon seeing his retrospective exhibition at the Whitney in 1967, Soyer was struck by the consistent attitude toward humanity displayed in his work. Speaking of the people depicted, he observed:

Their costumes may differ slightly, but . . . there is the same detachment, the same involvement with oneself. . . . I was struck by a sense of the static. . . . There is a feeling of waiting for something that is not expected to come. Beckett's "Waiting for Godot" suddenly came to my mind.[2]

Waiting Room in subject and tone, as well as in title, embodies the essence of this view of mankind: psychologically and physically isolated, the men and women endlessly wait for something. It further expresses a frame of mind which could also be taken as a metaphor for the Depression itself.

JRM

1. Raphael Soyer, *Self-Revealment: A Memoir* (New York: Random House, 1967), p. 95.
2. *Ibid.,* pp. 103–104.

56 **Martin Lewis** (1881–1962)
Chance Meeting, 1941
Drypoint
10½ x 7½ in. (26.6 x 19 cm)

Inscribed lower right: *Martin Lewis*
Society of American Etchers
membership print 41.104

Martin Lewis was another chronicler of New York City life. Born in Australia in 1881, he briefly attended art school in Sydney and then emigrated to New York in 1900. He began making prints in 1915. His earliest subjects were river scenes, but after 1925 he turned increasingly to views of people in urban settings. Lewis had no particular interest in the poor as subject matter. He did, however, focus on one segment of the population—the single working girl striving mightily to be glamorous. *Chance Meeting* provides an example.

A creation of the movies, the glamour girl was seen as a seductress who was herself driven by passion. Popular magazines like *True Love,* a copy of which is hanging in the store to the right, fanned the flames with such torrid articles as "Not Without Sin" and "When Love Must Hide." To get your man, these sources implied, you must be glamorous. In an effort to achieve that image, the girl in *Chance Meeting* strikes a stagey pose: with arms pulled back and body thrust forward, she gazes at the young man with a "come-hither"

look. He, on the other hand, appears nonchalant. This juxtaposition of casual and dramatic poses, the pointed contrast between the girl's seductiveness and her girlish dress, and the melodramatic title all seem calculated to comment in a playful but evocative way on contemporary attitudes toward romance.

Chance Meeting is unusual in Lewis' oeuvre in its focus on a specific incident. Its night-time setting is, however, typical of his work. Lewis was fascinated with the city at night, because of the many moods it evoked and also because of the possibilities its lights and darks offered for "harmonic design," [1] as he called it. In *Chance Meeting* the quiet of the evening's semi-deserted streets and the warmth of the lights as they pierce the soft darkness add greatly to the romantic effect of the image.

JRM

1. Childe Reese, "Martin Lewis," *Prints,* 4 (March 1934): 8.

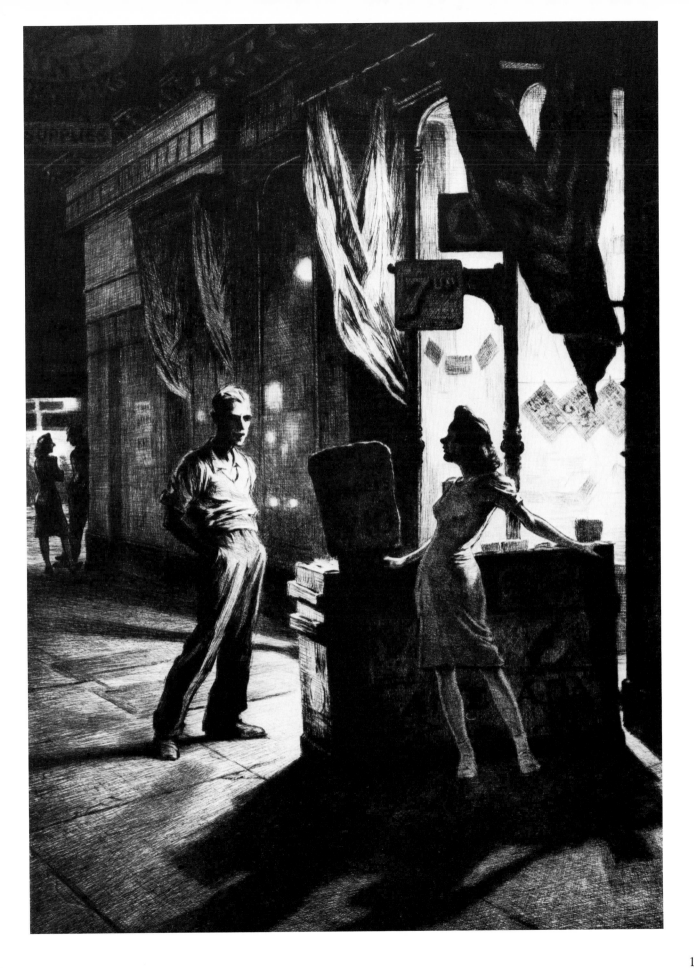

57 **Charles Wheeler Locke** (b. 1899)
Third Avenue El, 1943
Oil on canvas board
12 x 16 in. (30.5 x 40.6 cm)

Inscribed lower left: *C. Locke 1943*
Museum purchase (Anna E. Clark Fund)
45.8

Unlike his mentor Joseph Pennell, who frequently depicted the architecture of New York, Charles Wheeler Locke portrayed the city through the varied lives of its citizens.[1] In small vignettes, often including no more than two persons, he captured fleeting pictures of New Yorkers in restaurants and shops, at entertainments, and in the city streets. Locke avoided extremes of emotion in his work; he at times treated his subjects with a gentle, almost loving satire. In *Third Avenue El* the mood is subdued. A black woman and a white man rest quietly, presumably on their way home from work. New Yorkers on public transportation, a recurrent theme in Locke's oeuvre, was also a favorite subject of the Ash Can School and its descendants, among whom Locke must be grouped.

Locke was greatly influenced by the work of his friend Kenneth Hayes Miller, the leader of the Fourteenth Street School and, like Locke, an instructor at the Art Students League. Miller is best known for his monumental, almost classical interpretations of working-class women. During the late 1920s Locke adopted Miller's simplified and rounded figurative style. Locke's painting style was also influenced by another friend and member of the Fourteenth Street School, Reginald Marsh (Cat. No. 48). Like Marsh's work, *Third Avenue El* is sketchily handled; its figures and objects are drawn in rapidly with the brush.

Locke's urban paintings are somewhat unusual in that they were not painted in the city but in rural New York state. Most of his paintings of city themes were not done from life but rather are reworkings of his lithographs. Primarily a graphic artist, he did not begin concentrating on painting until the 1940s, some years after his move to Garrison, New York, in 1936. *Third Avenue El* seems to have been based on a print of the same title executed around 1928.[2]

JRM

1. I would like to thank Mr. Locke for discussing his work with me.
2. Reproduced in Charles Locke, "A Group of Character Drawings," *Scribner's Magazine,* 83 (February 1928): 168. The woman in the lithograph is not black. One can only speculate why this change was made.

58 **Isabel Bishop** (b. 1902)
Two Girls Outdoors, 1944
Oil on composition board
30 x 18 in. (76.9 x 46.2 cm)

Inscribed lower right: *Isabel Bishop*
Museum purchase (Anna E. Clark Fund)
45.6

Isabel Bishop's main source of subject matter throughout her career has been the working-class women who spend their leisure time around the Fourteenth Street–Union Square shopping district in Manhattan. Her frequent depictions of pairs of girls generally explore the theme of female friendship. In *Two Girls Outdoors* the sharing of secrets and the eating of ice cream impart a sense of intimacy and innocence, qualities reinforced by the subtle blending of surface texture and the delicacy of color.

Bishop once stated that she wanted to paint people who "appear trivial on the outside and show how they are decent and good on the inside."[1] Following the lead of her teacher, Kenneth Hayes Miller, who also painted Fourteenth Street subjects, Bishop looked back to the art of the Renaissance—to the age which saw, as she put it, "man as hero."[2] In *Two Girls Outdoors,* this influence is apparent in the scale of the figures, the idealization of the faces, and the solidity of the forms. In addition, the image of the girls with arms entwined gazing into each other's eyes is suggestive of Visitation scenes with their deep sense of communion between women. By these means Bishop has transformed a commonplace subject into an image of beauty and dignity.

Bishop was also fond of Baroque painting and wanted her works to have the "mobility" of Rubens' works, by which she meant that the viewer should feel that her figures could move. To provide this quality, "there had to be created in the onlooker . . . a sense of physical continuity as by a subtle and deliberate web throughout the picture."[3] In *Two Girls Outdoors* the "web" is created by the interwoven veils of paint which cause the surface to vibrate and indeed give a sense of movement to the picture.

Bishop's concern for mobility had social overtones. She believed that "if they [working-class women] wanted to move into another class, they can," and she intended that the physical mobility of her figures should imply the possible social mobility as well.[4] Unfortunately, the viewer is not really able to make this connection. Nevertheless, Bishop's desire to suggest what the girls could be (as opposed to simply portraying what they are) coupled with her reliance on the art of the Renaissance marks her as an idealist and demonstrates her belief in the essential nobility of man. In *Two Girls Outdoors,* by means of monumental figures set in an isolated and timeless space, she embodies that belief in paint.

JRM

1. *Isabel Bishop* (Tucson: University of Arizona Museum of Art, 1974), p. 14.
2. Karl Lunde, *Isabel Bishop* (New York: Harry N. Abrams, 1975), p. 26.
3. University of Arizona Museum of Art, *Bishop,* p. 24.
4. *Ibid.,* p. 23.

143

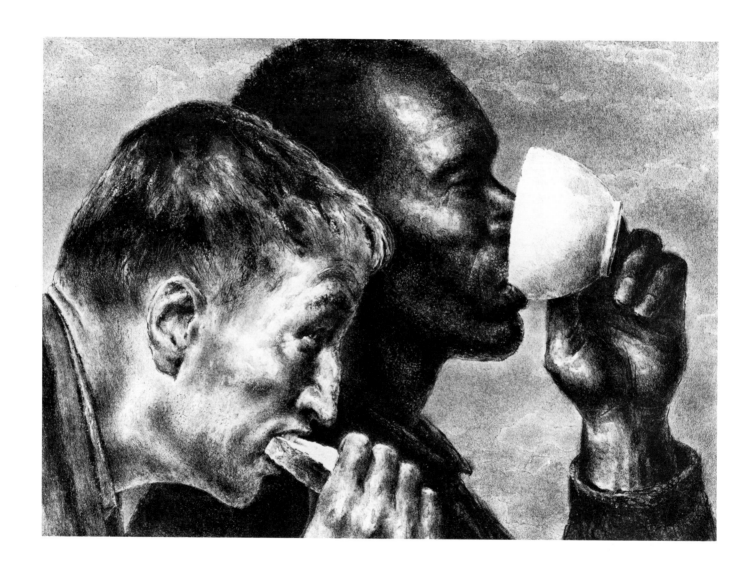

144

9 **Joseph Hirsch** (1910-1981)
Banquet, 1945
9¾ x 13¾ in. (24.8 x 34.8 cm)

Inscribed lower right: *Joseph Hirsch*
Bequest of Frank B. Bristow
66.26.284

During the Depression, Joseph Hirsch, like a great many American artists, was a socialist and took up his brush to protest injustice. Son of a liberal-minded Philadelphia family, Hirsch was still in art school when the Depression hit. He began his artistic career amidst the miseries and protests it spawned. His inclination to produce socially relevant art was strengthened by a trip in 1936 to the Orient, where he was outraged to see the exploitation of the working class. He returned determined to use his art as a weapon for change. When once asked what he did for a living Hirsch replied, "I make cudgels."[1]

Hirsch was particularly concerned about the problems of blacks in American society. Solidarity with black workers was, in fact, a major issue of the left during the 1930s. During World War II, when he served as a combat artist, the U.S. Army was segregated, and Hirsch was struck by the incongruities this produced: for example, units of black medics could not live with but were allowed to save the lives of white combat troops. At that time he was "preoccupied with the social issues of blacks and whites."[2] *Banquet* reflects this concern. Writing about the print, Hirsch has noted that the two heads were placed together because they "suggested an interesting stroboscopic impression of one person eating."[3] The artist's intent went beyond simply showing men of two races eating together as friends; he wanted to suggest that black and white are one, unified by their common physical needs. Furthermore, the specter of the capitalist enemy is evoked by the title, *Banquet.* Hirsch frequently gave such satiric titles to his works.

A painted version of *Banquet* also exists, and a small drawing of the same subject was published in 1945 in *The New Masses,* a socialist periodical to which Hirsch occasionally contributed.[4]

JRM

1. *Joseph Hirsch* (Athens: Georgia Museum of Art, 1970), n.p.
2. Diane G. Cochrane, "The Vision of Joseph Hirsch," *American Artist,* 36 (October 1972): 29.
3. *Ibid.*
4. *New Masses* (October 30, 1945). The painting is in a private collection.

60 **Rockwell Kent** (1882–1971)
Wake Up, America [*It's Later Than You Think*], 1945
Lithograph
15⅞ x 11 in. (40.4 x 28 cm)

Inscribed lower right: *Rockwell Kent*; lower left: *Wake Up, America*
Gift of James N. Rosenberg 59.33

In 1959 Rockwell Kent wrote that *Wake Up, America* "or as I have sometimes called it, *It is Later Than You Think* aims to call attention to the decay of the structure of democracy that threatens while the citizen sleeps. The initials that appear on the post behind the sleeper are those of the signers of the Declaration of Independence. It was motivated by that threat to our democratic freedom which is known as McCarthyism."[1] Although Senator Joseph McCarthy's anti-Communist crusade did not begin until 1950, anti-Communist activity, which had abated somewhat during World War II while Russia was America's ally, began to increase as the war drew to an end. Kent, as a Communist and active supporter of Soviet Russia, had a great deal to fear from this change in feeling.

Two specific events probably relate to Kent's creation of this print in 1945. During that year the House Committee on Un-American Activities recommended the dismissal of some 3800 government employees because of their alleged Communist sympathies. In April of 1945 President Roosevelt died. Kent, who greatly respected Roosevelt, felt that his tolerant views had "at least kept the federal government from leading the campaign against political 'deviates,' " wrote his biographer David Traxel. "He had no such faith in Harry Truman."[2] Kent's sense of foreboding was well founded. Like many other Americans, he suffered great hardships during the Cold War. In 1953 he ap-

peared before Senator McCarthy's committee.

In *Wake Up, America* Kent communicates his meaning by means of symbols. The hourglass denotes time running out; the ramshackle porch signifies the decaying democratic structure. The figure symbolizes America itself. During the nineteenth century the habit of sitting tilted back in one's chair was considered an American practice and "became a kind of symbol standing for the country at large."[3] Behind this symbol was a complex of ideas having to do with the Yankee, that stereotypical American who was brazenly self-confident, fiercely independent, and disdainful of convention, particularly of good manners. Kent, in employing this symbol, mockingly exaggerates the Yankee's self-confidence into grinning self-satisfaction and thus communicates America's complacency in the face of the destruction of its rights.

JRM

1. Letter from Kent dated October 10, 1959, to the curator of prints of the Corcoran Gallery, in the possession of the Corcoran Gallery.
2. David Traxel, *An American Saga: The Life and Times of Rockwell Kent* (New York: Harper and Row, 1980), p. 188.
3. Joshua C. Taylor, *America as Art* (Washington, D.C.: Smithsonian Institution Press, 1976), pp. 39–47.

148

61 Thomas Hart Benton (1889–1975)
Gateside Conversation, 1946
Lithograph
9⅞ x 13⅞ in. (25.2 x 35.5 cm)

Inscribed in plate lower right: *Benton*;
lower left: *Benton*
Bequest of Frank B. Bristow 68.26.45

Gateside Conversation, which is based on a drawing Benton did in Southern Louisiana in the early 1940s,[1] depicts the visit of a white landowner to his black sharecropper. Benton, who visited the South many times, felt, as did many contemporary intellectuals, that the sharecropping system was "one of the major sores of our civilization."[2] He did not, however, take the view of the socialists that the landowners were evil oppressors who needed to be overthrown by the proletariat. He felt that both groups were victims of a system perpetuated by ignorance and prejudice.[3]

Despite his awareness of the evils of the sharecropping system, Benton was not exposing them in *Gateside Conversation.* The hideous aspects of rural poverty are in fact subordinated to the artist's mythic love of the land. The print does evoke a sense of desolation; both black and white, boss and worker, are irrevocably bound to the poverty of the worn-out land. But we are also aware of a quiet beauty in this bond. Desolate or not, the repeating rhythms of the land and sky, animal and figures are visual equivalents of the rhythms of nature and speak eloquently of man's never-ending relation to the soil.

Benton's belief in the value of rural life stems at least in part from his family background. Born in Neosho, Missouri, into a prominent political family, he grew up immersed in the history and traditions of rural and frontier America. In his painting he initially followed contemporary French trends. However, in the 1920s, reacting strongly against what he saw as the elitist aestheticism of contemporary art as well as against the corrupt materialism of American business, Benton abandoned modernism and turned to subjects of the working class, particularly the rural working class. He saw this group as the backbone of America. Not intellectual but hardworking, practical, and basically decent, they represented for him the values that America was losing in an era of rapid change.

Gateside Conversation mirrored conditions still extant, if changing, in parts of the rural South in 1946. Nevertheless, it presents a vision of rural harmony which had appealed strongly to the people of the troubled 1930s but which was increasingly irrelevant to the prosperous 1940s.

JRM

1. Creekmore Fath, *The Lithographs of Thomas Hart Benton* (Austin: University of Texas Press, 1969), pp. 158–159.
2. Thomas Hart Benton, *An Artist in America* (Columbia: University of Missouri Press, 1968), p. 192.
3. *Ibid.,* pp. 187–192.

62 **George Biddle** (1885–1973)
Dancing Elephants, 1949
Oil on masonite
25⅛ x 30¼ in. (63.7 x 76.8 cm)

Inscribed reverse center:
Biddle/680/Dancing Elephants
Gift of Mr. and Mrs. Allen J.
Rappoport 1978.75

Dancing Elephants is based on drawings Biddle did in 1948 on a two-week visit to the Ringling Brothers winter headquarters in Sarasota, Florida. The work is one from a series of circus pictures done in 1948–1952 which also includes paintings of clowns, midgets, and equestriennes. Circus subjects were fairly standard fare in American art by this time. Indeed, circus series had been done by such diverse artists as Alexander Calder, John Steuart Curry, and Yasuo Kuniyoshi. In 1929 the Whitney held an exhibition called Circus in Paint complete with tents, sawdust, and peanuts. The heyday of the American circus was from 1880 to the Depression, and by 1948, when Biddle turned to the subject, only two traveling companies were left, providing at most a once-a-year outing for the public. Biddle therefore was not viewing the circus as an essential part of American life; rather he painted it because it was an exotic world.

Biddle's interest in the exotic, which lies at the very core of his art, was integral to his rejection of what he saw as his repressive Main Line Philadelphia background. As a young man he abandoned a law career and took up painting because he wanted in his time to have lived life to the fullest, to have "sucked it dry."[1] A tireless traveler, he visited and painted Tahiti, the Caribbean, Mexico, and India, among other places.

Discussing his visit to Sarasota, Biddle wrote: "When I start . . . saturating myself in a new environment, I become intoxicated, sexually stirred in an effort to identify myself . . . in new surroundings."[2] Biddle found himself particularly attracted to the circus girls: "They are as little spoiled as can be imagined, so utterly different from Broadway chorus girls. They are gay and friendly and informal as college students, as serious and intent on their work as school boys in training for the football team."[3] *Dancing Elephants* stresses their naturalness and ease as they bounce on the backs of the lumbering animals. Moreover, Biddle's angular treatment gives them a perky quality that corresponds perfectly to his verbal description. The artist was interested in elephants from a purely visual standpoint, and he frequently pictured them without riders. Like frogs and cows, which he also depicted, they had "such a strange relation of bulk to extremities that they become fascinating graphic material."[4]

Dancing Elephants displays a number of stylistic traits that are characteristic of Biddle's oeuvre. Strongly influenced by Japanese prints and by the French artist Jules Pascin, Biddle found line to be his most important tool in creating form and as an expressive device. Here flat patterning—the repetition of shapes and colors—makes a picture that, apart from any other expressive impact, is delightfully appealing to the eye.

JRM

1. Carl Zigrosser, *The Artist in America* (New York: Knopf, 1942), p. 92.
2. George Biddle Papers, "Diary 1948–1963," Archives of American Art, Smithsonian Institution, entry for March 1, 1948. (Lent by George Biddle 1966–1970.)
3. *Ibid.*
4. Interview with George Biddle conducted by Harlan Phillips, 1963, Archives of American Art, Smithsonian Institution, Sec. 2, p. 4.

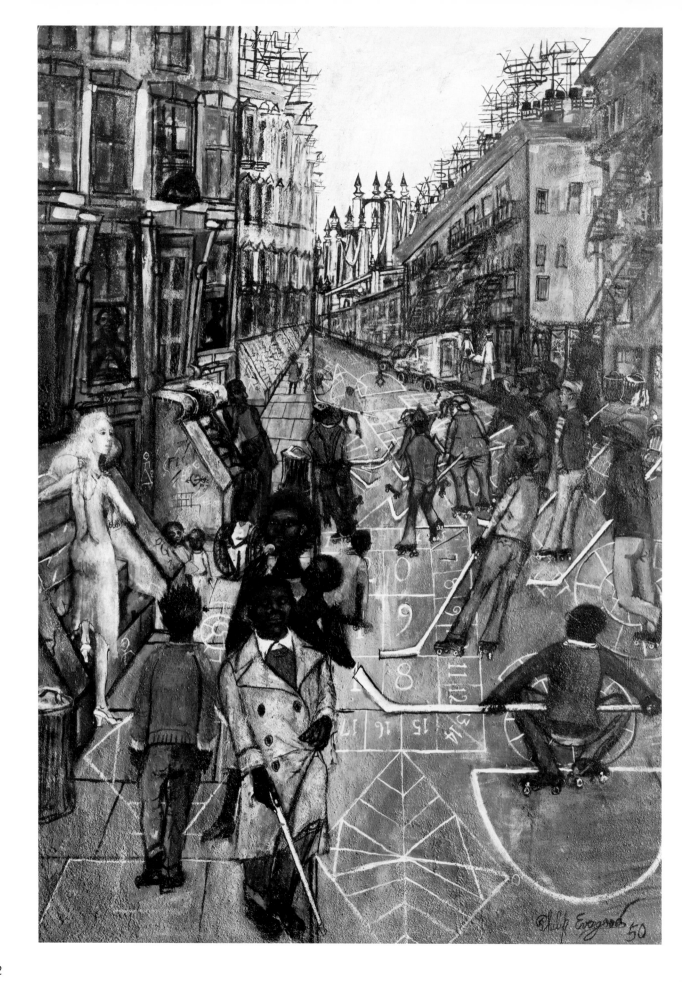

63 **Philip Evergood** (1901–1973)
Sunny Side of the Street, 1950
Egg-oil-varnish emulsion with marble
dust and glass on canvas
50 x 36¼ in. (127 x 92.1 cm)

Inscribed lower right: *Philip Evergood,*
50
Museum purchase (Anna E. Clark Fund)
51.17

Philip Evergood, who first turned his attention to social issues during the 1930s, remained an advocate of liberal causes for the rest of his life. Like Joseph Hirsch (Cat. No. 59), he was particulary sympathetic to the problems of blacks in a racist society; he painted a number of works on this theme. *Sunny Side of the Street* shows a black section of Brooklyn where Evergood was living in 1949–1950. The white woman, who resembles the artist's wife, Julia, was perhaps included to indicate his presence there. In reference to this painting, he wrote,

There, sick people, maimed people and sad people abounded. One side of the street there was generally a patch of sunlight. A crippled woman always sat at a window in that patch and a blind man at noon generally fumbled his way out of a dank, odious hallway (scratched and chalk-marked by kids) to the world of noise, aggression, sunlight and danger. Kids were everywhere on roller skates, uncollected garbage was everywhere and gave off a sour smell. Within this framework people existed, smiled, laughed and were mostly kind to one another.[1]

Evergood abhorred the living conditions of poor blacks and admired their good-natured cheerfulness in the face of such adversity. The painting's title, which comes from the song ("If I never had a cent, I'd be rich as Rockefeller/ Golddust at my feet, on the sunny side of the street"), thus seems to be simultaneously sarcastic and sincere.

Sunny Side of the Street also functions on a symbolic level. The focal point of the painting is the two women with babies and the blind man in the lower left quadrant. Evergood frequently painted mothers with their children. He greatly respected women who worked hard to make their children's lives better;[2] in their babies he saw the hope of the future.[3] By juxtaposing the blind man and the woman with the visionary look in her eyes, Evergood seems to be comparing one who is stuck in today's hideous reality with one who "sees" a better future for her child and even "tastes" its sweetness—as symbolized by the sucker in her hand. The inclusion of the white mother, who looks back at the black mother in silent understanding, makes the painting's message more universal and stresses the common aspirations of blacks and whites. Despite its outward bleakness, the painting suggests hope.

JRM

1. Undated letter from Philip Evergood to Henry B. Caldwell, Corcoran Gallery of Art, Washington, D.C.
2. Kendall Taylor, *Philip Evergood: Selections from the Hirschhorn Museum and Sculpture Garden* (Washington: Smithsonian Institution Press, 1978), n.p.
3. An important related painting is *The Future Belongs to Them* (Terry Dintenfass Collection, New York) in which a black baby and a white baby, who have their arms around each other, are raised into the air by their parents.

64 **David Park** (1911–1960)
Sophomore Society, c. 1953
Oil on canvas
38 x 46 in. (96.5 x 116.8 cm)

Inscribed lower right: *David Park*
Gift of Lydia Park Moore 1971.4.3

In 1952 David Park wrote: "I like to paint subjects that I know and care about: people, singly and in crowds, in commonly seen attitudes. I like to paint my friends."[1] *Sophomore Society* portrays something Park cared about. With some of his friends he was in a jazz band, and the painting is based on the dances they played for. The band itself and other dances were the subject of a number of paintings made in the early 1950s. Park's work from that period was figurative at a time when Abstract Expressionism dominated the avant-garde art scene on both shores. Park, who lived in the Bay Area in California, had painted in the Abstract Expressionist style in the late 1940s, but in 1949, dissatisfied with these works, he destroyed them and reintroduced the figure into his paintings. "I have found," he wrote, "that in accepting and immersing myself in subject matter I paint with more intensity and that the 'hows' of painting are more inevitably determined by the 'whats.' "[2] In pursuing this new figurative style, he chose subjects from his own life: musicians and dancers, his home and family, streets and parks, social events, portraits of his friends. His aims in painting had not changed. He continued to be concerned with "big abstract ideas like vitality, energy, profundity, warmth. They became my gods. They still are."[3] However, now he found he could capture these qualities by using subjects to stimulate his imagination.

Sophomore Society incorporates a number of stylistic devices carried over from Park's Abstract Expressionist phase. In addition to the thick paint and active application of pigments, he used what has been called the expanding space device, a concept distinct to California Abstract Expressionism in which the major forms of the painting are thrown to the edges to give the work "an exploded, expanded look of great energy" and to imply that the forms had their "inception outside the canvas."[4] Bowing to the modernist creed of devotion to the picture plane, Park tilted his ground plane so that it is read simultaneously as surface and floor. Especially exciting visually is the centrally placed woman whose step into depth is stretched into an energetic stride by the distorted perspective. The checkerboard pattern of the floor and wall, which also enhances the surface, is a remnant of Park's experiments with Cubism in the early 1940s. The color of *Sophomore Society* is dissonant—a combination of the complementaries red and green with lavender and touches of brown, yellow, and peach. All elements—texture, space, surface pattern, and color—combine to communicate the vibrancy and festive quality of a college dance.

Park's simple genre subjects differ radically from the cosmological and angst-filled works of his contemporaries, the New York Abstract Expressionists. This difference is partly determined by geography—the relaxed life style of California contrasted with the pressured atmosphere of New York. As Peter Plagens has pointed out, the Californians took from the New Yorkers only the action painting aspect of Abstract Expressionism, not any of its tragic overtones.[5] More fundamentally, Park's painting was determined by his own casual and tolerant temperament. He once said that he painted because "It's fun," and went on to describe his life: "We have a lot of good friends whom we see frequently. Both our daughters are married and live nearby—we have five grandchildren and the two oldest call me 'old painthead'. . . . Music is very important to me."[6] The loving acceptance of life and the genuine sense of contentment expressed here are strongly felt in the paintings of 1950–1955. Park's later works communicate his gods—vitality, energy, and warmth—in a more universal way by means of massive and monumental nudes, but the works of this half-decade express similar concepts through personally relevant events of everyday life.

JRM

1. *Contemporary American Painting* (Champaign: University of Illinois College of Fine and Applied Arts, 1952), p. 220.
2. *David Park, 1911–1960* (Newport Beach, Calif.: Newport Harbor Art Museum, 1977), n.p., under section "David Park: Unyielding Humanist."
3. *Ibid.*
4. *Ibid.,* under section "Early Work: 1935–1949."
5. Peter Plagens, *The Sunshine Muse: Contemporary Art on the West Coast* (New York: Praeger, 1974), p. 42.
6. *David Park: Recent Paintings* (New York: Staempfli Gallery, 1959), n.p.

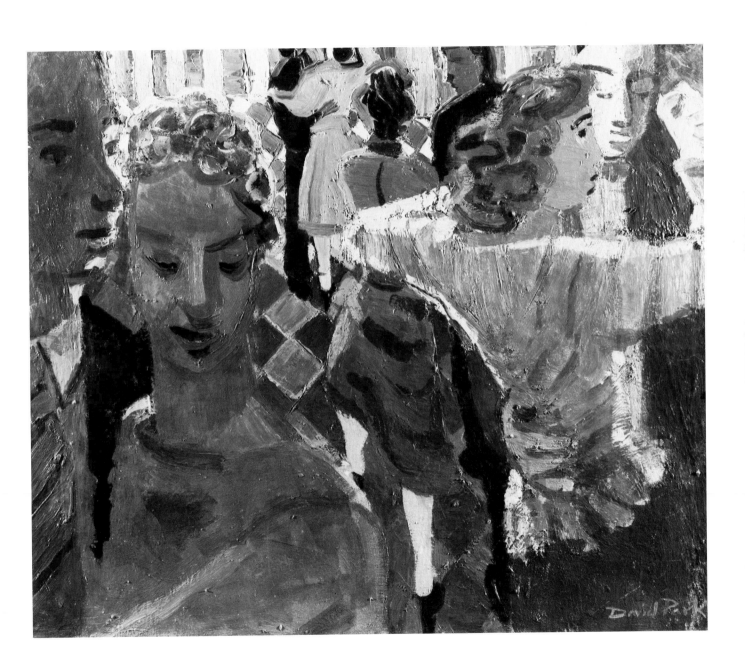

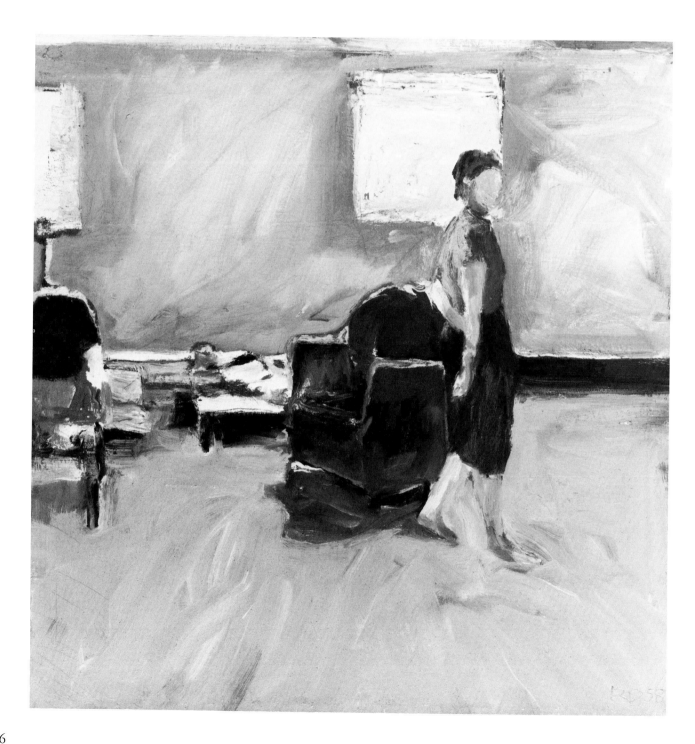

65 Richard Diebenkorn (b. 1922)
Girl in a Room, 1958
Oil on canvas
27⅛ x 26 in. (68.8 x 66 cm)

Inscribed lower right: *RD 58*
Gift of the Woodward Foundation
1977.7
See Color Plate

In 1955, after ten years of working as an Abstract Expressionist in California's Bay Area, Richard Diebenkorn turned to representational art and for the next twelve years pursued this course. The works of the early phase (1955 to around 1960) generally depict one, sometimes two, persons—usually female—in an interior or on a terrace. They often express a sense of isolation and perhaps of tension. *Girl in a Room* typifies this stage and demonstrates Diebenkorn's interest in using the relationship between the figure and its surround as an expressive device. Regarding this, he wrote: "It is the opposition and interrelation of the environment with its particular attitude and the figure with its distinct and concentrated psychology which concerns me at present. I find that this 'person' I deal with creates a surrounding which in turn modifies, changes and sometimes even engulfs him."[1]

The psychological state of the woman, implied by her lack of features, is one of alienation. Furthermore, the space has been manipulated and the objects arranged to create a sense of emptiness which enhances the woman's isolation. The jarring colors lend a note of tension, while the composition, based on a grid from which no elements deviate, is stark and taut. The suggestion of tension appears as well in the figure's pose: one hand grasping the other arm subtly expressing care or anxiety. This gesture frequently recurs in Diebenkorn's figurative work, as do a number of other elements including the faceless figure, the rigid architectonic composition, and the expressive use of space and color.

Barren and introspective works such as this one owe a debt to Edward Hopper—an early influence on the artist. Diebenkorn abandoned his abstract style in part because he was impressed by the figurative work of his friends David Park (Cat. No. 64) and Elmer Bischoff, who had returned to a representational style in the early 1950s. But he also made the change because:

I came to mistrust my desire to explode the picture and super-charge it in some way. At one time the common device of using the super-emotional to get 'in gear' with the painting used to serve me for access to a painting, too, but I mistrust that now. I think what is more important is a feeling of strength in reserve—tension beneath calm. I don't want to be less violent or discordant or less shocking than before but I think I can make my paintings more powerful this way.[2]

"Tension beneath calm" seems an apt description for *Girl in a Room.*

JRM

1. Herschel B. Chipp, "Diebenkorn Paints a Picture," *Art News,* 56 (May 1957): 46.
2. Santa Barbara Museum of Art, "Artist of the Month," *Gallery Notes,* 2 (October 1977): n.p.

66 **Robert Vickrey** (b. 1926)
Signs, 1961
Tempera on board
27¾ x 41¾ in. (70.5 x 106 cm)

Inscribed lower left: *Robert Vickrey*
Gift of Roy C. Markus through the
Friends of the Corcoran 65.18.5

Robert Vickrey's elusive painting *Signs* begs for multiple interpretations. The artist has said the work is about conformity, a subject of personal relevance[1]—Vickrey was a realist at the time when abstraction was in its heyday and he felt great pressure to join the mainstream of art. In more general terms the painting is concerned with the conflicting pressures and lack of freedom felt by the individual in contemporary society. These ideas are symbolized by the huge authoritarian traffic signs and the claustrophobic picture space, which, without sky and blocked in the front by two signs, hems in the young man on all sides.

The stark landscape filled with minutely depicted but illogical objects gives *Signs* a surrealistic, nightmarish quality that speaks of the youngster's inner confusion. The sinister suggestion of some exterior evil also makes the painting an indictment of modern society. Certainly *Signs* presents the quintessential image of the alienated man, a major theme of twentieth-century art and literature, and Vickrey has described the painting as having the "Kafkaesque atmosphere of contemporary society."[2]

The ominous tone evident in *Signs* pervades much of Vickrey's work. A recurring theme is that of a child innocently playing in an empty street encroached upon by a large threatening shadow. Other works deal with death and decay, frequently symbolized by posters peeling off old buildings; in this painting they are implied by the fallen signs and the cracked sidewalk. Vickrey's obsession with decay and inexplicable terrors probably goes back to his childhood. His mother died when he was ten, after which he lived with his father in New York. He was very close to his grandmother, who was excessively afraid of burglars and booby-trapped her entire yard with bizarre contraptions. While one can only speculate on the effect these experiences had on Vickrey, they do seem to have played a significant role in his art.

Vickrey's work developed out of the Surrealist tradition. His children playing in abandoned streets directly recall the work of Giorgio de Chirico. Moreover, he seems to have been influenced by a group of American Surrealists called Magic Realists—particularly by Ivan Albright, whose work also deals with death and decay—and by Andrew Wyeth, like Vickrey a tempera painter, whose paintings of the 1940s are similar to his in their imagery. Not all of Vickrey's oeuvre is disquieting, but *Signs* is typical of his early work from about 1950 to the early 1960s.

JRM

1. From a telephone conversation with Vickrey.
2. Robert Vickrey and Diane G. Cochrane, *New Techniques in Egg Tempera* (New York: Watson-Guptill, 1973), p. 9.

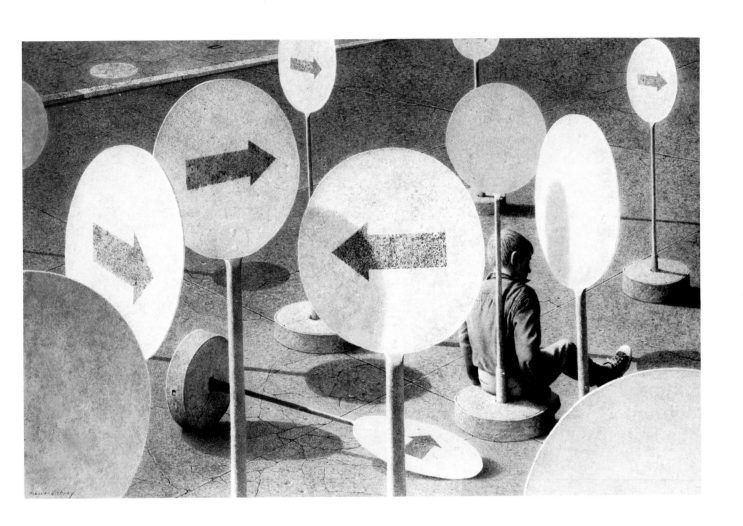

159

67 **Garry Winogrand** (b. 1928)
World's Fair—New York City,
New York, 1964
Photograph
8⅝ x 12⅞ in. (21.9 x 32.7 cm)

Inscribed lower right of support: *Garry Winogrand*; lower left of support: *15/75*
Gift of Raymond W. Merritt
1979.85.7

*W*orld's Fair—New York City, New
York, taken in 1964, was published
in 1975 in Garry Winogrand's book
Women Are Beautiful. This collection
had its inception around 1960, a time
when his marriage was failing and he obsessively began to photograph women
he was attracted to in the streets. His
vision of women is entirely happy.
Generally young, casually dressed, and
relaxed, they are often counterculture
types or more overtly sexy than the
ones in this picture. But these women
certainly have the cheerful vitality
characteristic of all of Winogrand's
women.

In the preface to *Women Are Beautiful*
he wrote:

Whenever I've seen an attractive woman,
I've done my best to photograph her. . . .
By the term "attractive woman," I mean a
woman I react to, positively. . . . I know
its not just prettiness or physical dimen-
sions. I suspect that I respond to their ener-
gies, how they stand and move their bodies
and faces. In the end, the photographs are
descriptions of poses or attitudes that give
an idea, a hint of their energies.[1]

Certainly a concern with energies is of
great importance in this photograph. It
is ostensibly a scene of repose—resting
from touring the World's Fair. But the
repetition of figures across the surface
of the picture as well as the active configuration of lines cut by arms, legs, and
torsos focuses attention on the energy
implicit in the simple act of crossing the
legs or turning the body. Yet the picture
is not only about physical energies; it is
also concerned with enthusiasm and involvement, with mental energy. Winogrand has an extraordinary ability to
quickly capture telling gestures. For
example, one woman holds up her hair,
indicating she is trying to cool off on a
hot day, while another, fatigued from
touring, yawns. The picture is amusing:
the viewer smiles to see the girl peering
at the old gentleman's newspaper and
the confidential whispering of two
other women. Affection is expressed by
a girl sleeping on the bosom of her
friend. Tod Papageorge has rightly referred to the "density of meaning" in a
Winogrand work, in which "the subject
is not interpreted but presented as if it
had been anatomized in terms of its
energy."[2]

Interest in energies is not limited to
his series on women. In fact, Winogrand's style has in some measure been
determined by the desire to include increasing amounts of activity in his photographs. In the early 1960s he began
using a wide-angle lens, which allowed
him to take in a wider field of vision. His
pictures increased in complexity, involving the intricate orchestration of
large numbers of details. There was a
new emphasis on gesture as a means of
explicating narrative content. The pictures, each containing a number of small
incidents, had only a weak compositional focus, which corresponds to the
undifferentiated quality of vision and
thus gives the pictures a strong sense of
immediacy. This stylistic development
came to a climax in the *Public Relations*
series of 1967–1973 but is already evident in *World's Fair.* Winogrand's style
seems to reflect his personality. An intense person, he has a "preposterously
consistent quality of attention to everything around him."[3] Leo Rubinfien
sees in his images a reflection of
the "frantic, flamboyant" 1960s; his
works "mimicked the loquacity of that
decade."[4]

JRM

1. Garry Winogrand, *Women Are Beautiful* (New
York: Light Gallery, 1975), n.p.
2. Garry Winogrand, *Public Relations,* intro. by
Tod Papageorge (New York: Museum of Modern
Art, 1977), p. 16.
3. *Ibid.,* p. 8.
4. Leo Rubinfien, "The Man in the Crowd,"
Artforum, 16 (December 1977): 3.

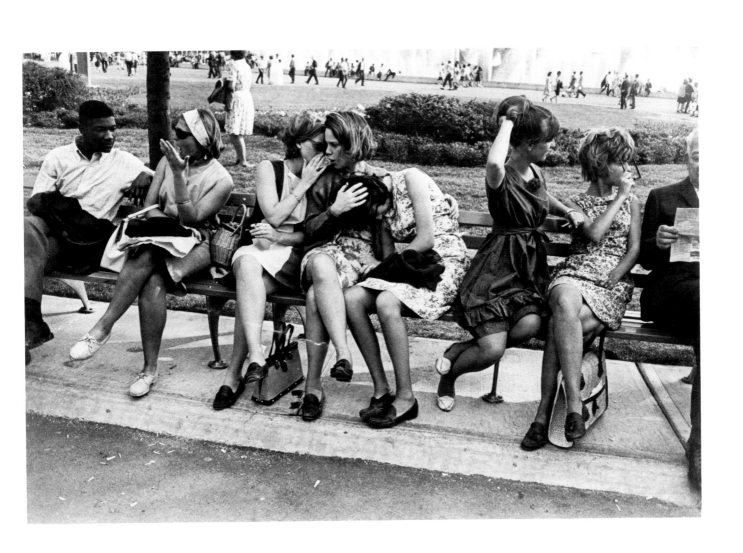

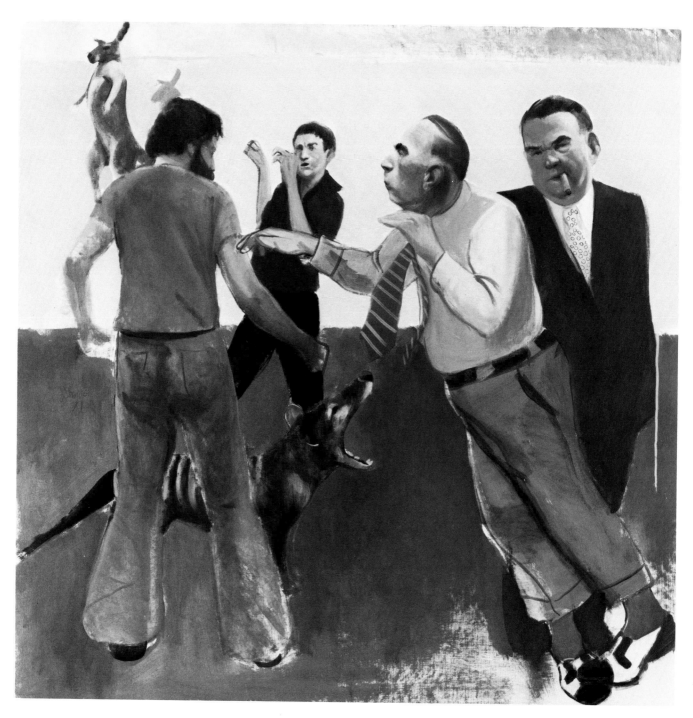

8 **Joseph Shannon** (b. 1933)
Tasmania, 1971
Polymer on canvas
48 x 48 in. (122 x 122 cm)

Inscribed center left: *JShannon/71*
Gift of the American Academy of Arts
and Letters, Childe Hassam Fund
1972.1

Tasmania is one of Joseph Shannon's social works,[1] paintings which do not protest any particular social ills but which reveal a "universal malaise."[2] Typically a social subject seems to represent a specific scene but is in fact comprised of objects which suggest numerous possible scenarios. The ambiguity is intentional. Shannon feels that modern art since Mallarmé has been dominated by ambiguity[3] and wants the viewer to draw on his own experiences in interpreting the social works.[4] These mysterious paintings are like dreams in that they incorporate symbols that respond to analysis, an apt analogy in view of the artist's interest in psychoanalytic theory.

Shannon begins the creation of a social work by choosing a "lead role" figure around whom the images and ideas in the piece gravitate.[5] In *Tasmania* the lead figure is the man to the far right. Shannon sees him as a "gangland leader or petty criminal, someone not completely clean, involved in graft or shady activity."

The animals, a kangaroo and a Tasmanian wolf, are indigenous to Australia. Animals symbolize for Shannon the innocence that humans, with their self-knowledge, lack. A visual pun is intended between the "underworld figure" and the land "down under."

The stumbling figure to the right has been described as a "middle manager,

petty bureaucrat, a flunky under the thumb of the gangster." Of a similarly posed figure in another painting, the artist has written that his action "could mean anything from the man being startled, or about to have a stroke, to beginning a violent action. Or just innocently stumbling."[6] Moreover, this figure reflects the artist's fascination with the idea of "sudden death" as a "caprice of nature." The man to the left is Shannon himself, while the man to the rear, a "witness," is expressing horror at what is happening in the foreground.

Shannon's statements concerning the painting do not explain the situation depicted, nor will the viewer from looking at the image necessarily be able to deduce the significances enumerated. On the other hand, the viewer may see things in the work not specifically intended by the artist. Regardless of any individual interpretation, a number of elements—the disreputable look of the "gangster," the discombobulated pose of the "flunky," the ferocity of the wolf, and the horrified gesture of the "witness"—convey a feeling of unease, of threatened violence, which is heightened by the unexplained nature of the event. Violent actions or the threats of violent actions are frequently used as symbols for psychological violence—the anger and brutality an individual perpetrates and is victimized by in daily life. Shannon has written: "It

is an obscene luxury in this time and in this place not to paint about this time and place,"[7] and in his emphasis on aggression he graphically expresses one of the most characteristic features of life in the later part of the twentieth century.

JRM

1. *Joseph Shannon: Paintings* (Charlotte, N.C.: Mint Museum of Art, 1979), n.p.
2. "Joseph M. Shannon Interviewed by Joseph M. Shannon," *Sun and Moon: A Quarterly of Literature and Art* (Summer 1976): 47.
3. *Ibid.,* p. 58.
4. From a conversation with the artist. Quotations not footnoted within this essay are taken from that conversation. I'd like to thank Mr. Shannon for discussing his work with me.
5. "Joseph M. Shannon Interviewed," p. 57.
6. *Ibid.,* p. 47.
7. *Paintings and Drawings by Joseph Shannon* (Washington, D.C.: Corcoran Gallery of Art, 1969), n.p.

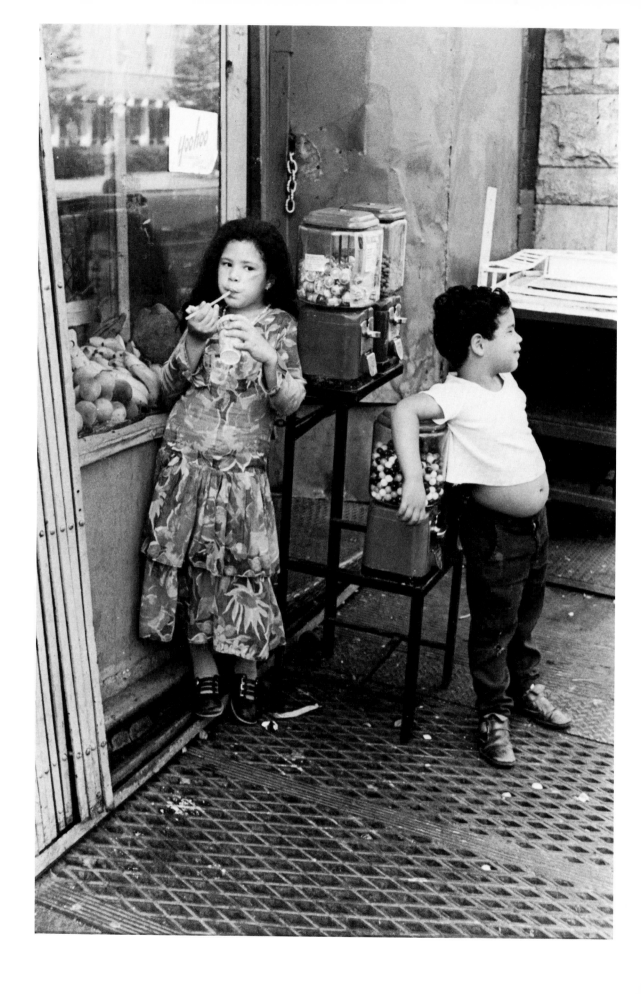

69 **Helen Levitt**[1]
Puerto Rican Child and Gumball Machine, 1971
Color photograph
13⅞ x 9⅛ in. (35.3 x 23.2 cm)

Inscribed verso, center left: *N.Y. 1971/Helen Levitt*
Museum purchase with aid of funds from the National Endowment for the Arts, Washington, D.C., a Federal agency, and the Polaroid Corporation 1980.49

Puerto Rican Child and Gumball Machine is set in New York City's Spanish Harlem, an area northeast of Central Park chiefly inhabited by Puerto Ricans. Spanish Harlem, the Lower East Side, the East Village, and other poor ethnic neighborhoods are the setting for most of Helen Levitt's works, both the black and white pictures of the late 1930s and 1940s and the color pieces of the 1970s. (Levitt, who is also a professional film editor, did little still photography in the 1950s and 1960s.)

Because of her subject matter Levitt has frequently been cast as a documentary photographer (she has even called herself one), but when asked to explain, "she admits—with visual embarrassment—that poetry is what she is after."[2] The poetry in Levitt's pictures frequently comes from her ability to capture on film the conjunction of things which are not actually or logically related but which create a new meaning when joined. In *Puerto Rican Child and Gumball Machine* the juxtaposition of the child's floral print dress with the blue-walled store and the fruit takes on a meaning not implicit in the scene itself. One cannot look at this photograph without thinking of Gauguin; its peculiar combination of elements creates a tropical island paradise—the blue suggests water—in the middle of Manhattan. Other photographs in this exhibition, those by De-Carava and Kramer, for example (Cat. Nos. 70, 75), have meaning through the combination of nonrelated items, but this occurs only occasionally in their photographs. Levitt's work, however, is distinguished by a self-conscious search for such moments; as James Agee put it, she is "collaborating with . . . luck."[3]

Puerto Rican Child and Gumball Machine should not be seen as a pat statement about the exoticism of Latin races caged in the iron city, though this is certainly one aspect of it. The photograph takes on richer meaning if seen in the context of Levitt's early works: children wearing masks, fighting with crude weapons or fists, playacting, or in strange postures or inexplicable situations. Viewed as a group, these photographs have mythic overtones; the children's spontaneous play seems to be the modern equivalent of the mysterious rituals of primitive man.[4] It is as if the artist, through the untamed activities of slum children, is exploring man's primitive side and commenting on its continued, if hidden, existence in modern man.

The works of the 1970s dealing with children tend to share with the earlier photographs an interest in the child as natural man. However, children are not the primary concern of these later works, which generally seem to be about leisure in New York's slums. Levitt presents relaxed moments, portraying people when they are not doing much of anything. *Puerto Rican Child* certainly fits this description. In the final analysis the themes of leisure and of children as primitives are related. The photographs delight in spontaneity and imply, perhaps not consciously, an indictment of the success-centered and highly organized dominant culture of white middle-class America.

JRM

1. Helen Levitt's date of birth cannot be determined with certainty.
2. Owen Edwards, "Her Eye in on the City," *New York Times Magazine* (May 4, 1980): 54.
3. Helen Levitt, *A Way of Seeing: Photographs of New York,* with an essay by James Agee (New York: Viking Press, 1965), p. 8.
4. *Ibid.,* pp. 1–8, 73 ff.

70 **Roy DeCarava** (b. 1919)
Asphalt Workers, 1975
Photograph
9¼ x 12⅞ in. (23.2 x 32.7 cm)

Inscribed lower right: *DeCarava*
Museum purchase 1976.37.3

*A*sphalt Workers resonates with significance about the subject of the black man in American society.[1] With head down, the central figure seems bowed by the weight of years of labor; but strong and still carrying on, he serves as an eloquent metaphor for the endurance of blacks in the face of oppression. Ray DeCarava's man is comparable to the peasants of Jean François Millet in his monumentality and in the universality of the statement he makes about the nobility of the oppressed. The photograph also works on the level of contemporary social commentary. Since it includes no white men doing physical labor, it highlights the fact that blacks are often assigned the most menial and backbreaking jobs. Moreover, although the presence of the white policeman and foreman is obviously coincidental, they call to mind prison roadwork crews and strengthen the theme of oppression.

In his work and in his life DeCarava has always felt a deep commitment to his fellow blacks. He grew up in poverty in Harlem in the 1920s and 1930s, and in high school and as an art student in New York he was discriminated against because of his race. Early he began to feel that the black artist had a responsibility to act "as a spokesman for the voiceless masses of the black community," and that his art should "speak to and for black people in a way that enriches their lives and lifts them to a level of true dignity."[2] Although DeCarava has been an activist against discrimination, his art has not been devoted to social protest. Rather than focusing on the grim conditions existing in Harlem, he has presented blacks as part of the human community by expressing their emotions. He may depict homes with no electricity and scant furniture, but his emphasis is on the warmth of the family and the strength and pride of individuals.

Although labor is one of DeCarava's major themes, *Asphalt Workers* is in some ways atypical of his oeuvre. Most of the artist's pictures are straightforward depictions of the everyday life of blacks without the symbolic overlay created in this picture by the conjunction of whites and blacks. However, DeCarava's work is not free of irony. Particularly bitter is his photo *Stern Brothers* (1953),[3] in which a black beggar woman sits in front of a huge stone pillar labeled Stern Brothers, a symbol of financial power. *Asphalt Workers* is also compositionally more self-conscious than is typical of DeCarava's work. In some street scenes from the mid-1970s overlapping forms flatten out space; in *Asphalt Workers* these overlappings create a kind of frieze in which the alternation of stooped and standing figures expresses the lively rhythm of the street,[4] which surrounds the stoic and enduring figure of the central black man.

JRM

1. During the Bicentennial DeCarava was asked to participate with eight other photographers in the Corcoran Gallery's project *The Nation's Capital in Photographs, 1976.* Each artist was to photograph the city during a period of at least one month. After a showing in 1976, four photographs by each artist were earmarked for a Tricentennial exhibition in 2076. *Asphalt Workers* is one of these photographs.
2. Elton Fax, *Seventeen Black Artists* (New York: Dodd, Mead, 1973), pp. 175,187.
3. Reproduced in *Art News,* 78 (October 1979): 105.
4. Anne Middleton Wagner, "Manuel Alvarez Bravo and Roy DeCarava at the University of Massachusetts Art Gallery," *Art in America,* 63 (May 1975): 78–79.

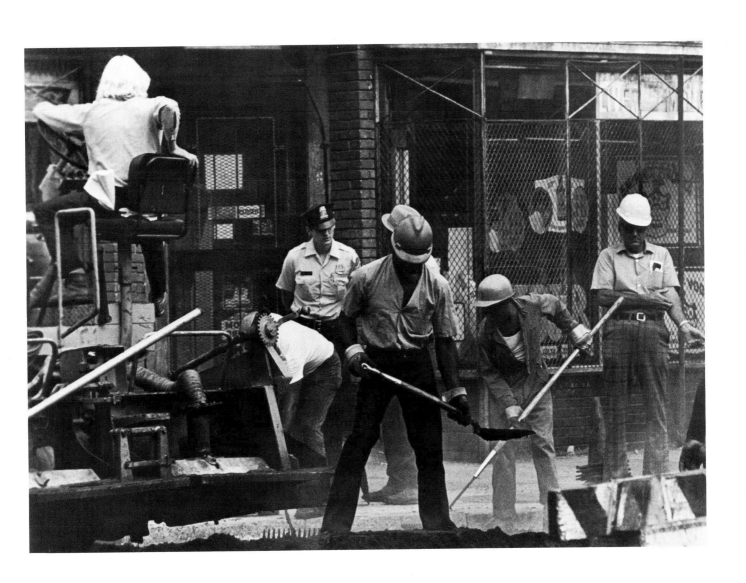

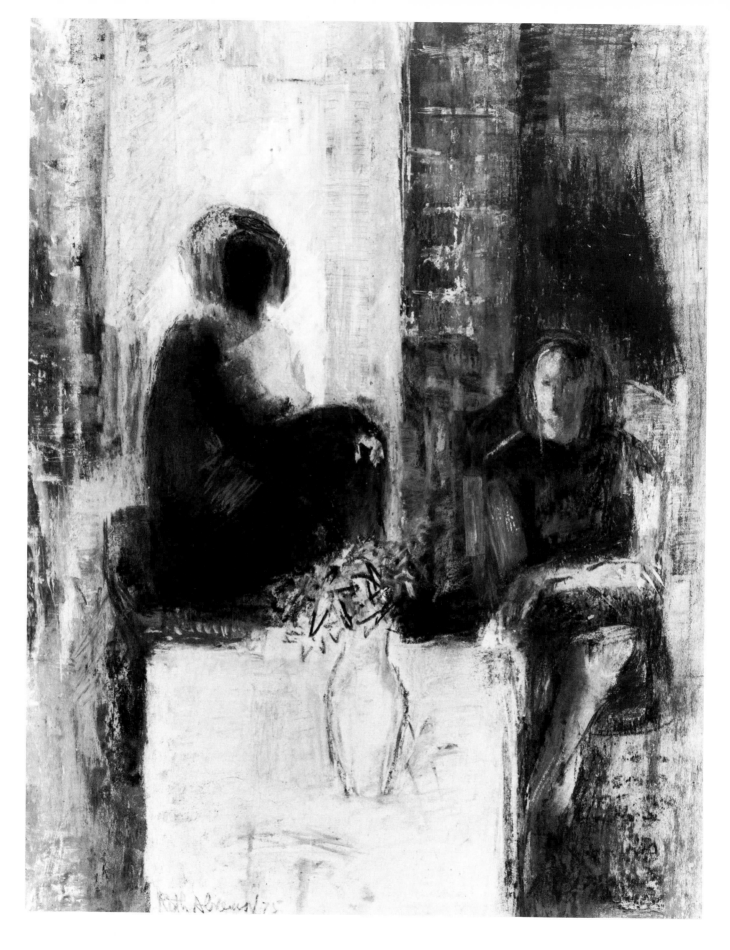

168

71 Ruth Abrams (b. 1912)
Conversation Series, 1975
Pencil, craypas, charcoal, acrylic on
Japan paper
19⅜ x 15¼ in. (49.3 x 38.8 cm)

Inscribed lower left: *Ruth Abrams/75*
Gift of William H. G. FitzGerald,
Desmond FitzGerald, and B. Francis
Saul II 1978.129.2

*C*onversation Series is the generic title
for a group of eight studies begun
in the late 1960s but created primar-
ily in the 1970s, each depicting two fig-
ures in an interior. The title *Conversa-
tion Series* is perhaps ironic, for the fig-
ures do not communicate; they are, ac-
cording to the artist, "not together, or
better, alone together."[1] She has de-
scribed the women in the series as
having

*. . . an appearance of passivity, an off-
guard expression of meditative loneliness
that I often see in women. . . . It is a re-
ticency, a concealment, a mysticism. . . . I
am aware they are waiting in the intervals
of loving or being loved—waiting for
something or someone—for the flow of life to
carry them. These are the women of the
1950s. If I were of a more recent era would I
express a different subjective self?*

The configuration of elements in this
work—figures and table with flowers in
front of a window—recurs repeatedly in
Abrams' oeuvre, starting as early as
1948. The nearly abstract works of the
early 1960s consist of swirls of colors
with the figures calligraphically
sketched in; in those of the late 1960s
the figures, table, and window are
floating geometric shapes and hardly
recognizable as objects. The rounded
forms of one woman's head and shoulders
in this work are vestiges of that style.
The works of the *Conversation Series* are
clearly representational and more
structured than the earlier pieces. This
painting, for example, is organized by
verticals which divide the surface into
light and dark sections. Space is denied
by the merging of the back plane (the
window) with the front plane (the table
painted in distorted perspective). The
resultant spatial ambiguity gives the fig-
ures a sense of buoyancy; like the

geometric forms of the late 1960s, they
almost seem to float, and this quality in-
creases the work's mystery. The piece is
painted almost entirely in black (the
color of mystery for Abrams) and white.
The contrast of these tones helps create
luminous surfaces that project what the
artist has refered to as "heavenly or
glimmering light."

With its palpable air of mystery,
Conversation Series reflects Abrams' in-
terest in Oriental philosophy and Jungian
psychology. These interests she shared
with the New York Abstract Expres-
sionists, with whom she is often as-
sociated. Although interiors such as this
have not been the primary focus of her
work, they relate to the artist's visions
of primordial women and outer space,
two recurring themes that deal with
inner and outer mystery.

JRM

1. From a conversation with the artist. The fol-
lowing quotations from Abrams were taken either
from that conversation or from a letter written to
the author in the possession of the Corcoran Gal-
lery. I would like to thank Ruth Abrams for dis-
cussing her work with me.

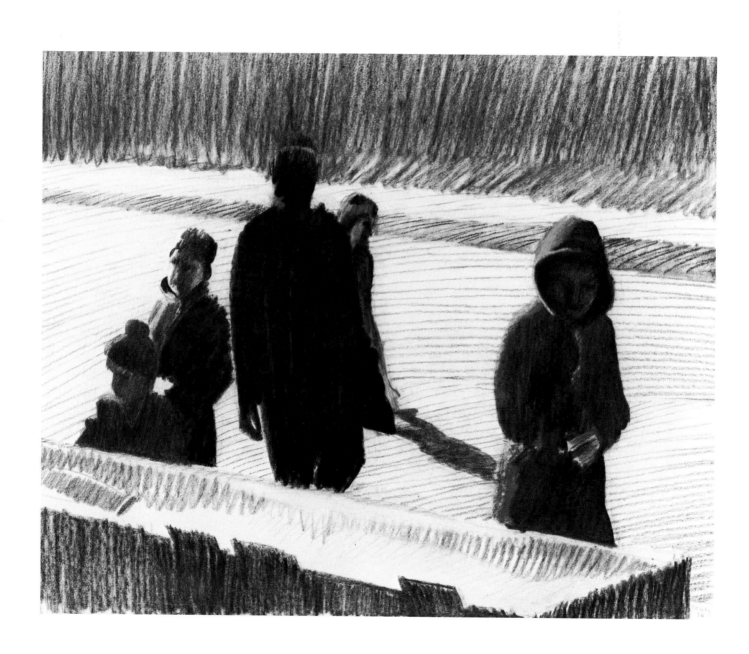

170

William Clutz (b. 1933)
Untitled (Street Scene), 1976
Pastel
22⅞ x 28¼ in. (57 x 71.7 cm)

Inscribed lower right: *Clutz 76*
Gift of William H. G. FitzGerald,
Desmond FitzGerald, and B. Francis
Saul II 1978.129.61

Upon graduation from the University of Iowa in 1955, William Clutz, originally from Gettysburg, Pennsylvania, moved to New York. Since that time his subjects have been the people of that city as they walk through its streets and parks. "My paintings are not about buildings or cars, but . . . about the city—its humanity. . . . The whole place is alive with humanness."[1] Clutz's street scenes have an air of detachment. He is uninterested in the emotions of passers-by, and he rarely depicts interaction between people. Nor is he concerned with the hustle and bustle of masses of people. His rhythm is rarely quicker than that of a fast walk. Instead, Clutz tries to capture the impression of the street through a concise analysis of human motions and through the elimination of all detail extraneous to that analysis. In this work the figures are extremely simplified: large areas are treated as masses of light and shadow, and the surround is severely defined with parallel lines describing wall, sidewalk, and street. This reductive definition of persons and places focuses attention on movement. The girl in the right, for example, seems to have just stopped to look at something, an action implied by the direction of her torso and the slight extension of her left leg. The central figure apparently has turned from that same point of interest and is resuming his course, indicated by the turn of his head and the lifting of his right leg. It is very characteristic of Clutz's style that though this figure's face is not shown, his intentions and motivations are as clear as the forward-facing figures.

Clutz is also very much concerned about communicating the aura of a place at a specific moment. He has, for example, painted the same scene at different times of the day and year. This drawing is particularly effective in its visualization of a sunny but cold winter day, the crisp clarity being conveyed by the white of the paper and the strong value contrasts between the complementary colors blue and orange.

The psychological detachment in Clutz's work has been interpreted by some writers as commenting on the isolation and anonymity of modern urban life.[2] Clutz denies this. He feels that his paintings express not loneliness but man's basic condition of being alone. Concerning this he has said:

Nobody talks about existentialism anymore, but every person is born alone, lives alone, dies alone. . . . People . . . live their own lives by themselves. This is what liberation is all about: when you live your own life, you are alone. . . . that's man's basic condition. And expressing that basic reality is certainly a function of painting.[3]

The two central figures in this work, physically related but moving in opposite directions, graphically express this existential reality.

JRM

1. Doreen Mangan, "William Clutz Captures the Soul of a City," *American Artist,* 42 (February 1978): 7,36.
2. *Ibid.,* p. 36.
3. *Ibid.*

171

73 **Bruce Davidson** (b. 1933)
Cafeteria, 1976
Photograph
9⅜ x 9¼ in. (23.8 x 23.5 cm)

Gift of Sandra and David Berler
through the Sandra Berler Gallery
1978.121

Set in the Garden Cafeteria in Manhattan's Lower East Side, this image shows an elderly Jewish couple eating breakfast. Bruce Davidson was introduced to the cafeteria by the Yiddish writer Isaac Bashevis Singer, who was the subject of a 1972 television documentary by Davidson. Singer often sat in the cafeteria and wrote, and Davidson found the atmosphere equally compelling. During the 1970s he made this the setting for a series of photographs. As is typical of his working method, he spent a great deal of time over several years in the cafeteria getting to know his subjects, immersing himself in their lives.

Davidson has said that the cafeteria photographs are about "death, dying and surviving."[1] He graphically described the people there as "remnants of a past age. . . . Some were survivors from the concentration camps; others had lived on the Lower East Side their entire lives or had come as young immigrants before the war."[2] These two people had owned a candy store on the Lower East Side for years and had seen the area decline as a vibrant center of Jewish life (see Cat. No. 45). By using a direct flash "that caused the background to go black,"[3] Davidson created a visual analogy between their white faces and the globes of the light fixutres. He sees this analogy as a symbol for the couple's ultimate death, for the diminishing of their existence until there is nothing left.[4] The darkness also evokes a sense of the anonymity from which they have come and into which they will return. However, the image is not without hope; the man and the woman are not despairing. Though marked by the years, they seem responsive to life, especially the man with his soft cow eyes and half-smile.

Davidson frequently takes his subjects from the less fortunate members of society. He does not protest their situations, however, but champions the human spirit, showing that love, compassion, humor, and wisdom exist in spite of adversity. Davidson also sees his work as a process of self-exploration. He wrote, "I felt the need . . . when I took pictures . . . to discover something inside myself."[5] He found in the cafeteria a way of life evocative of the Warsaw ghetto from which his own grandfather came and of the Lower East Side where so many Jewish immigrants began their lives in America in the early years of this century. "It is important to know where you come from,"[6] the artist has said, and in the cafeteria series he tried to discover a part of his own heritage.

JRM

1. From a conversation with the artist. I would like to thank Mr. Davidson for discussing his work with me.
2. Bruce Davidson, *Photographs* (New York: Agrinde Publications, 1978), p. 14.
3. *Ibid.*
4. From a conversation with the artist.
5. Davidson, *Photographs,* p. 9.
6. From a conversation with the artist.

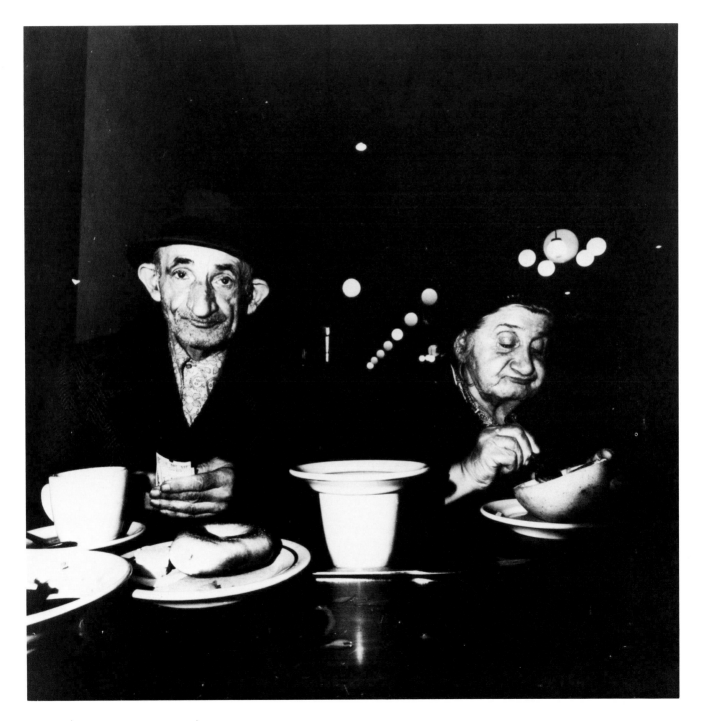

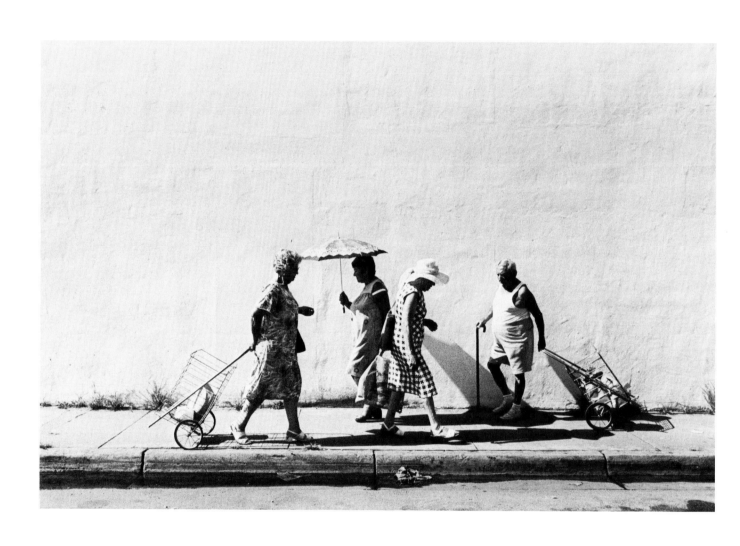

74 **Gary Monroe** (b. 1951)
Untitled, Miami Beach, 1978
Photograph
8⅞ x 13½ in. (22.5 x 34.3 cm)

Inscribed verso, lower right: *Miami Beach 1978 Gary Monroe*; verso center: *610*; on inside front of mat: *4 Monroe*
Gift of the artist 1979.3

*U*ntitled, Miami Beach was taken as part of the Miami Beach Photographic Project. Conducted by Gary Monroe and Andy Sweet, the continuing project has as its goal a complete photographic record of the many life styles of Miami Beach. First conceived during the mid-1970s when the photographers were still undergraduates, the project has focused much of its attention on the city's South Beach area, where this photograph is set. The community consists largely of elderly Jewish people, many of them Eastern European immigrants, who worked in New York City and then retired to Florida. As Monroe sees it, South Beach is the "final chapter" in the history of Jewish immigrants in America.[1]

Monroe's approach is documentary, and he lived in South Beach in order to study and record its folkways in depth. There he found much that he admired: a community of people who, despite an average age of seventy-two, have remained actively involved in life. His photographs tend to emphasize the pride, optimism, and energy that he sees in the residents. He has photographed exercise clubs, the Senior Citizen Orchestra, religious activities, and private homes along with the public life of the beaches, hotels, parks, and streets. The eagerness for life seen in these pictures seems especially moving when one realizes that the community is being dismantled and many of the elderly are being relocated to accommodate new tourist facilities. Monroe's work is in part motivated by a desire to document South Beach with its communal spirit before it no longer exists.

Untitled, Miami Beach is something of an anomaly in Monroe's oeuvre. It depicts a characteristic South Beach scene—elderly people out shopping—but it differs from his other work in its lack of a defining environment. The stark, harshly lit surround gives the image a slightly surrealistic feel. Small in scale, the figures do not dominate their environment but are dominated by it. Frozen in a static composition, they seem like toys on a shelf. Monroe did not intend for the image to have this impact. Concerning it he wrote: "This photograph is among my favorites from the South Beach work because it is so responsive to the subject. I believe it so astutely relates, decisively and essentially, the folkways or better lifestyles of these people."[2] This, of course, is true; their dress, physical appearance, and characteristic activity are recorded. But overwhelmingly the image speaks of the figures' smallness, thus serving as a potent metaphor for the powerlessness of the aged in our society.

JRM

1. From a précis of the project written by Monroe in the vertical file of the Corcoran Gallery.
2. Letter from Monroe to the author dated April 16, 1981, in the possession of the Corcoran Gallery.

75 **Arnold Kramer** (b. 1944)
Untitled (Venice, California), 1979
Photograph
12⅞ x 19¼ in. (32.7 x 48.9 cm)

Inscribed lower right of support: *Arnold Kramer 1979*
Museum purchase 1979.92

This photograph was shot in Venice, California, when Kramer, a Washington, D.C. artist, was there for a week's vacation in the summer of 1979. It is among his earliest works in color. Kramer went to California in part because he felt that he could find in the Los Angeles area vivid colors on which he could practice his new technique. The California pictures are unusual in the artist's oeuvre in that they are street photographs. Street photography, according to Kramer, is like net fishing: you draw in many photographs and only later in editing find out if any are good.[1] The artist further cultivated the element of chance inherent in street photography by shooting this series "from the hip," without looking through the viewfinder; he self-consciously has attempted to loosen his control and let accidents happen.

The *trompe l'oeil* mural in this photograph is a landmark of Venice, a bohemian community near Los Angeles. The illusion that the painted street is an extension of the actual street exists within the context of another illusion—the photograph itself. Objects in the foreground, such as ropes and the white painted section of the parking lot, make it difficult, at least initially, to distinguish where reality begins and ends. This momentary confusion gives potency to the photograph's true subject: the question of what is real and what is illusion. Intellectually the issue is of paramount importance to Kramer, who insists that photographs, though they seem to reproduce the world exactly, are "radical distortions of reality." To the artist, "Every photograph is a work of fiction."

Kramer has described the man in the bathing suit—"Mr. California"—as "hedonistic, fascinated with the body and concerned about his image." As both viewer and viewed, the man embodies the illusion/reality question. The unreality of the scene that engrosses him raises questions about his own reality. The artist provides no answers; the question as applied to the man is ambiguous, open to personal interpretation. Kramer treated similar subjects in the other photographs he took in Venice—images of Muscle Beach, the winners of a roller-disco contest, and a gigantic service station. All these works explore the myth as much as the reality of Southern California.

JRM

1. All the quotations in this entry come from a conversation I had with the artist. I would like to thank Mr. Kramer for talking with me at length about his work.

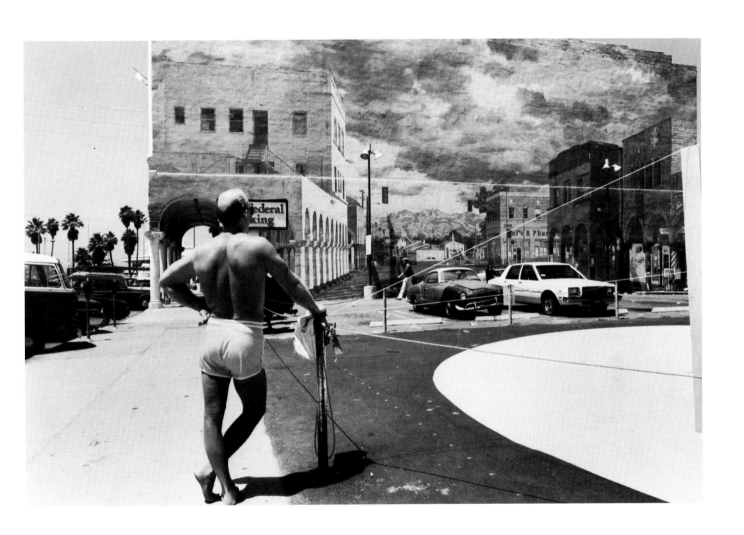

The Not-So-Simple Observation of Daily Life in America

Peter C. Marzio

A painter's studio should be every where,
wherever he finds a scene In the black
smith's shop, the shoe maker's, the tailor's,
the church, the tavern, or Hotel, the mar-
ket, and into the dens of poverty and dis-
ipation, high life and low life.

William Sidney Mount
Diary, 1847

. . . . human life has everywhere, now as in
times past—in America as in Greece, as in
Italy, as in France—all the requisites for
great art.

George W. Sheldon
American Painters (1881)

There is a magic at the end of an artist's
pencil when he portrays, in the right spirit,
the scenes and types of his native land.

Edward King
"The Value of Nationalism in Art,"
Monthly Illustrator (June 1895)

Mirror to the American Past

The seventy-five works of art in this exhibition span 160 years of American history. The earliest, *Mishap at the Ford,* was painted by American-born Alvan Fisher in 1818; the latest, Arnold Kramer's photograph of Venice, California, is dated 1979. All are from the Corcoran's permanent collection and belong to a category of fine art that historians call *genre.* Today *genre* means "a style of painting concerned with depicting scenes and subjects of common everyday life, " but originally it was a French term applied somewhat scornfully to paintings and prints of low life during the reign of Louis XIV (1643–1715). *Genre* did not appear in Noah Webster's *American Dictionary* until 1865, and—as far as current research shows—the word was first set in type in America in 1849, when a show of paintings from Dusseldorf, Germany, opened in New York City.[1]

Before the mid-nineteenth century, this kind of art was called "domestic," "comic," or "humorous" by some writers, while others saw it as "rustic," "descriptive," or "fanciful history." American art critic James Jackson Jarves in *The Art-Idea* (1864) preferred to label it "home painting," because "there is no other word which includes so entirely, to the Anglo-Saxon ear, all those feelings, sentiments, and ideas which have their origin and growth under the family roof and in social training."[2] This "home painting" received scant encourage-

ment from critics or from well-established art academies in Europe or fledgling institutions in America. But, more important, it resonated with a populist attitude which had prevailed from the start of our national history: to paint or draw a scene of everyday life was a natural and a good thing to do.

But why? While there is no simple answer, several broad cultural trends contributed to this attitude.

First, the popularity of genre art in America was based in large part upon a visceral love of storytelling. Whether in the tall-tale style of legends like Davy Crockett and Mike Fink, or fictional vignettes of historical figures along the lines of "Parson Weem's" *George Washington,* or the morality sketches of McGuffey's *Eclectic Readers,* or the endless stream of vaudeville routines, Americans placed high value on a good story and a good storyteller. This oral tradition, with its wide range of vernacular types, emphasized that real knowledge—truth—came from everyday life.[3]

Second, genre became a symbol of American nationalism—cultural, social, and political freedom from Western Europe. Beginning at the start of the nineteenth century and continuing through the Great Depression of the 1930s, this pursuit of a unique national identity traversed numerous routes. In literature, fine arts, and education a debate persisted for nearly a century and a half concerning the relative merits of European styles and methods versus the

evolution of a truly American way. Genre usually represented the latter. It symbolized the use of American subject matter for the establishment of an American art.

Third, genre has tended to be seen as democratic (and therefore good) because it is deeply rooted in the populist tradition of the graphic arts and came into its own during the late 1820s and early 1830s when America became the most radically democratic nation in the world. This unique state of affairs did not occur overnight with the 1828 election of Andrew Jackson but rather evolved slowly and relentlessly during the first two decades of the nineteenth century. While a plebiscite empire developed in France and a Tory oligarchy in England, the United States nurtured a constitutional democracy. This helps to explain why paintings of average people doing common tasks should take such a firm hold on American taste at that time.

Genre has had both a radical and a conservative influence on American culture. It established itself as an independent art form in the face of a powerful neoclassical tradition and defined its basic goal to delineate the vital qualities of American life. While modern historians usually cite the work of the seventeenth-century Dutch Masters as the historical precedent for American genre, the differences between the traditions are stark. Compared with the Dutch, the Americans appear sentimental and modest. The Dutch humor is often ribald, while the American seems innocent. Even nineteenth-century observers, however, made the link. According to one theory, genre was a Protestant form ideally suited to a new, independent democracy. Jarves wrote in *The Art-Idea:*

As soon as Protestant art freed itself from the control of rulers sensual and papal at heart . . . it identified itself by degrees with the people, assuming their level of thought, and their liking for the homely and common . . . The Dutch school . . . was the base of the democratic revolution of art growing out of Protestant freedom. . . .[4]

But a "revolution" did not occur; most serious painters and sculptors moved cautiously. They made genre an artistic mediator among numerous forces, traditions, and needs in American life. Genre brought vernacular subjects into fine art, and by doing so, helped to make paintings and sculpture expressions of that democratic spirit about which Americans never seemed to cease boasting. Genre also proved to be a happy meeting ground between fine art conventions and the gradual evolution of self-images which occupied so much of American thought. If it could not give a simple answer to the question "Who is that new man, the American?" it did eventually comprise a catalogue of American types derived both from real life and from the visual traditions of more than two thousand years of Western art. By expressing the democratic impulse as well as the urge for a clear national identity, genre became a blend of time and timelessness, the specific and general, real and ideal.

Genre was also a mediator between fine art and literature. Popular plays, magazine stories, poems, essays, novels—virtually any literary document about the American scene could either be illustrated for purposes of enlivening the text or be translated into paintings, that is, converted into fine art. For centuries artists had mined Ovid's *Metamorphoses* in order to paint mythological scenes; now American genre painters looked to folk tales, the theater, even dime novels. American literary characters often became subjects for genre painters; painters, in turn, occasionally illustrated the literature. There are a host of visual images in both paintings and prints inspired by writers like Washington Irving, James Fenimore Cooper, John Greenleaf Whittier, Henry Wadsworth Longfellow, Nathaniel Hawthorne, Herman Melville, Walt Whitman, and Mark Twain.

The full history of American genre art is still to be written. What follows are a few observations which may eventually lead to a more comprehensive treatment. The subject easily expands

into a history of American art, or even of the American people themselves. In 1973, when the director of the Corcoran Gallery of Art, Hermann W. Williams, titled his survey of nineteenth-century genre art *Mirror to the American Past,* he expressed this inseparable relationship.

The Nineteenth Century

The neoclassical style and the American definition of truth

During the last quarter of the eighteenth century, when oil painting first secured a foothold in America, professional artists found themselves in the midst of a neoclassical revival which was sweeping Western Europe. The discoveries of archaeologists had stimulated the imaginations of historians, poets, sculptors, and painters, especially after the successful excavations of Pompeii and Herculaneum. These ancient sites yielded actual physical remains of the classical past and presented the eighteenth-century Europeans with aesthetic guidelines for the contemporary painter: for them, classical art served as the ultimate standard of form and design.

This neoclassical revival reached its peak just when American painting was coming into existence. Sir Joshua Reynolds, president of the Royal Academy, was in the process of lecturing over an eleven-year span (1769–1780) on the "grand style." He emphasized formality, balance, and rigid structure based on his interpretation of classical art. Great art, by Reynolds' definition, transcended the barriers of time and place and looked to eternal themes of justice, ideal beauty, and truth. History painting, depicting either mythological events or great moments in Western history, he defined as the highest form of art. Genre, on the other hand, was considered a lowly art form.

During Reynolds' heyday there were few artists or critics who debated the English master. And yet, among the numerous anecdotes that fill the early history of American art, there was a

mild confrontation between Reynolds and the American painter Benjamin West which reflected the American preference for "realistic" pictures of modern life. The subject of debate was the proper mode of contemporary history painting. According to Reynolds' neoclassical tradition, all costumes were to be either Greek or Roman—regardless of the time or the place being painted—because standards of aristocratic taste in England found the attire of antiquity to be most becoming to the greatness of a noble subject. Benjamin West, a Pennsylvanian who had been in London since 1763, disagreed and in 1771 painted *The Death of Wolfe* with all figures clothed in modern military dress. His reasons were simple and forthright: "The classic dress is certainly picturesque, but by using it I shall lose in *sentiment* what I gain in external grace. I want to mark the *place,* the *time,* and the *people,* and to do this I must abide by truth." Reynolds was slow to respond, but after a close study of *The Death of Wolfe,* he reportedly announced: "I retract my objections. I foresee that this picture will not only become one of the most popular, but will occasion a *revolution* in art."[5]

Evolution would have been more ac-

Fig. 22. Horatio Greenough (1805–1852), George Washington, 1840, marble, 136 in. (354.4 cm). Courtesy National Museum of American Art, Smithsonian Institution.

Fig. 21. Cotton commemorative handkerchief, roller-printed in sepia, first quarter of nineteenth century, 12⅜ x 11½ in. (31.9 x 29.3 cm). Courtesy Division of Textiles, National Museum of American History, Smithsonian Institution.

curate. Reynolds influenced American artists more than any other writer of his day because his beautifully written *Discourses* were more accessible than works written in French, German, and Italian, and because London was a mecca for aspiring American artists. Their pilgrimages were facilitated by the presence of West, who became historical painter to King George III in the 1770s and succeeded Reynolds as president of the Royal Academy in 1792. Despite his preference for contemporary dress, West practiced most of the neoclassical theories of Reynolds and trained three generations of Americans, including Mathew Pratt, Charles Willson Peale, Gilbert Stuart, Rembrandt Peale, John Trumbull, Samuel F. B. Morse, Washington Allston, and Thomas Sully.

It is not surprising, therefore, to see that while genre was growing rapidly as a popular art form, the grand style and a passion for classical motifs also found a host of expressions in the United States. These styles developed side by side as painters and sculptors sought to give America and American heroes the familiarity of an egalitarian society as well as the dignity of ancient Greece and Rome. George Washington, for example, was shown both as a boy who destroyed a cherry tree and as a Roman emperor, complete with sword and toga (Figs. 21, 22). Log cabins became important symbols for politicians just when banks and state houses were springing up disguised as the Greek Parthenon, the Roman Pantheon, or some combination of both. Artists Washington Allston, John Vanderlyn, and Samuel Morse painted familiar American scenes as well as esoteric subjects like *Diana in the Chase, Ariadne Asleep on the Island of Naxos* (Fig. 23), and *The Muse*.

These dual traditions paralleled one another throughout the nineteenth century. But as genre grew in volume and popularity, the neoclassical exerted a more subtle influence, particularly in the area of art education. The grand style provided the critical guidelines for painting everday life.

The grand style of genre

In his lectures on the grand style, Sir Joshua Reynolds had dismissed any work that was rooted in the temporal and mundane world. In the fourth *Discourse* he wrote: "Present time and future may be considered as rivals, and he who solicits the one must expect to be discountenanced by the other." Reynolds derided the painting of subjects which were "degraded by the vulgarism of ordinary life," everday affairs, or "particularity."[6] At the start of our national history, this attitude strongly countered the American predilection for a particular beauty derived from contemporary life. The new nation needed a fine art that reflected the unique values and life styles of its citizens, an art that captured time, place, people, and sentiment.

One example illustrates the differences between the two artistic forces. In 1792 the citizens of Charleston, South Carolina, commissioned John Trumbull, artist of the American Revolution, to paint a portrait of George Washington. Trumbull had

Fig. 23. John Vanderlyn (1775–1852), Ariadne Asleep on the Island of Naxos, 1809–1814, oil on canvas, 68 x 87 in. (172.7 x 221 cm). Courtesy Pennsylvania Academy of Fine Arts, Joseph and Sarah Harrison Collection.

181

worked with Washington during the early period of the Revolution and then studied painting under West in London. His battle scenes of the Revolution included *The Battle of Bunker Hill* (1789), *Death of General Montgomery at Quebec* (1786) (Fig. 24), and *The Capture of the Hessians at Trenton, New Jersey, 26 December 1776* (1792). All in contemporary dress but formally composed in the grand style, they received mixed reviews from Americans who were grateful for the effort but uneasy with the product. Trumbull's heroes were not true, one critic wrote; they "resemble the fruits of the hot-house" of Europe. The South Carolinians who hired Trumbull were also dissatisfied. When he unveiled their commission, they denounced it unanimously and demanded a new portrait that would in-

clude "a more matter-of-fact likeness, such as they had recently seen" of Washington, as well as "a view of the city in the background, a horse, with scenery, and plants of the climate." They wanted a heroic portrait with a down-home accent set in Charleston, South Carolina, precisely in 1792: even images of the demi-god George Washington could not escape the basic passion for time and place in American art.[7]

This confrontation between Trumbull and his various audiences was created by a fundamental dilemma in the philosophy of American art: artists respected the values of the past, yet they could not deny the vitality of contemporary life. Public opinion favored the latter; traditional academic life demanded the former. William Dunlap, artist and author, addressed the prob-

Fig. 24. John Trumbull (1756–1843), Death of General Montgomery at Quebec, engraving by W. Ketterlinus, 1808, 18¾ x 23⅛ in. (47.6 x 58.9 cm). Courtesy Prints and Photographs Division, Library of Congress.

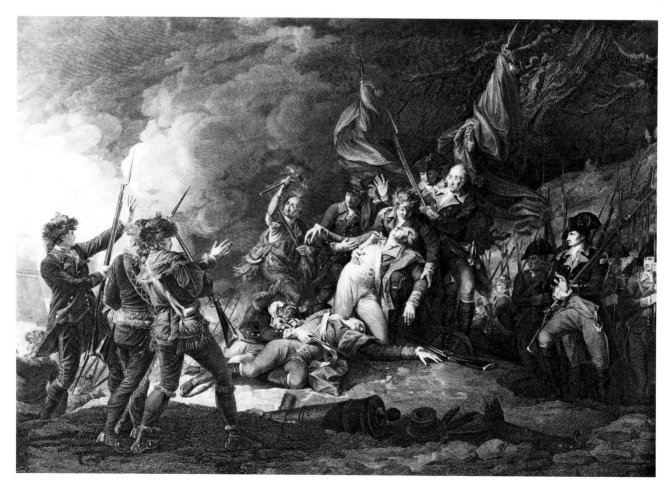

lem in the introduction to his *History of the Rise and Progress of the Arts of Design in the United States:*

. . . we have no standard of beauty, but that which is derived from the country of Homer and Phidias. The sculptors and architects of Greece are our teachers to this day, in form; and he most excels who most assiduously studies the models they have left us. This seems to contradict the precept that bids the artists study nature alone. But it must be remembered that we speak only of that form, the perfection of which the ancients saw in nature.[8]

Somehow, the American artist was to study the Greek ideal and then translate it into contemporary American life. Achieving the proper balance eluded Trumbull: where does the truth of everyday life end and the harmony of the neoclassical style begin?

When West said that his paintings must show time, place, people, and sentiment, he created the elements for nineteenth-century genre painters. This formula did not mean that artists should simply hold a mirror to everyday life; they had to select, intensify, and establish an iconography of American culture. This is essentially what the major nineteenth-century genre artists did. Henry Inman, William Sidney Mount, Richard Caton Woodville, George Caleb Bingham, David Claypoole Johnston, David Gilmour Blythe, Eastman Johnson, Winslow Homer, and Thomas Eakins looked closely at American life and catalogued what was unique, grand, essential, and typical in society. Lesser artists followed in their traditions, and if they often lacked a fresh eye, they did at least impress upon the popular mind the special significance of the subjects. Collectively these were genuinely American pictures, symbols of a national art, a grand style of genre.

Although artists stopped reading the *Discourses* by the time of the Civil War, a diluted and popularized version of Reynolds' fine-art schema persisted for decades. For instance, a heavy emphasis on drawing from plaster copies of classical and Renaissance sculptures continued in academies and professional art schools throughout the country well into the twentieth century. This was as Reynolds prescribed. Even in popular drawing manuals published before the Civil War, students were urged to study the past. John Gadsby Chapman's *The American Drawing Book* (1847–1858) cited the Farnese Hercules, the Antinous of the Vatican, the Laocoon, the Apollo Belvedere, the Venus de Medici, and the Grecian Shepherdess at Naples as ideal forms possessing the elements of true beauty.[9] This was all part of a broad notion calling for art to feed on art. It held on so tenaciously that as late as the 1930s art teachers and critics were begging painters to turn to real-life *American* scenes for their subjects. John F. Weir, head of the Yale School of Fine Arts, observed in the *Princeton Review* (1878) that American artists who painted a "panathenaic procession" that had "once a meaning for the Athenians" were engaging in nothing more than a "sort of epicurean dilettantism." Art should come from the American present, insisted a contemporary of Weir's:

We cannot doubt that human life has everywhere, now as in times past—in America as in Greece, as in Italy, as in France—all the requisites for great art. If the art instinct be properly directed—not to seeking in Nature for that which corresponds to our preconceived notions of what makes a picture, but rather with the conviction that what interests us in Nature will surely interest us in the picture, and make *the picture, in spite of all that may be read about masters, and schools, and discipline, and method, and vehicle, and what not, which have their place but not the preeminence. . . . Art is not alone for artists, but for man.*[10]

Another critic complained: "We are sick of Greek myths, we are weary of artificialities. Go out into the highways of life, artists of today, and paint us the tragedies, the comedies, hopes, aspirations and fears that live. . . ."[11]

The simple truth is that nineteenth-century genre artists composed their works according to classical principles, they drew their figures by the book, and they followed the conventions for color and chiaroscuro. Also, at least until the mid-1870s, they usually worked on a small scale as the Dutch had traditionally done or as their printmaker patrons prescribed. This respect for tradition resulted in artistic training. Many artists went abroad to study under European masters, and there they learned to see and think and create in a certain way. Most of them could not have jettisoned the lessons they had learned even if they had wanted to. Their training remained an integral part of their minds. For those who did not go abroad, such as William Sidney Mount, the end result was the same. He learned to draw figure types by copying the casts of classical and Renaissance figures in the National Academy of Design in New York City, and it is no coincidence that his best figures have the solidity and permanence of a statue from the Acropolis.

The concept of "types" defined by Reynolds was basic to nineteenth-century aesthetics. A type was a form representing a group of persons or things that shared common characteristics; it stood as a symbol for an identifiable group or class. Virtually everything had a type, even facial expressions. When the English immigrant John Rubens Smith published *A Key to the Art of Drawing the Human Figure* in 1831, he included pictures of human heads and other anatomical parts. Plate II, for example, illustrated twenty eyes, each a type for illustrating an emotion: one for "astonishment," another for "anger," a third for "bodily pain." There were types for almost all human qualities and situations, and artists learned to draw them just as writers absorbed the correct spelling and accepted meaning of words in their native language.

When artists looked to American life for their themes, they were forced to invent new types which expressed an American sentiment. If this sounds farfetched or unconvincing, one has

only to read Mount's descriptive letter (December 5, 1837), to Robert Gilmor of Baltimore who commissioned *The Long Story* (Cat. No. 2):

The man puffing out his smoke is a regular built Long Island tavern and store keeper, who amongst us is often a Gen. or Judge, or Post master, or what you please as regards standing in society, and as you see has quite the air of a Citizen.

The man standing wrapt in his cloak is a traveller as you supposed, and is in no way connected with the rest, only waiting the arrival of the Stage—he appears to be listening to what the old man is saying. I designed the picture as a conversation piece. The principle interests to be centered in the old invalid who certainly talks with much zeal. I have placed him in a particular chair which he is always supposed to claim by right of profession, being but seldom out of it from the rising to the going down of the sun. A kind of Bar room oracle, chief umpire during all seasons of warm debate whither religous, moral, or political, and first taster of every new barrel of cider rolled in the cellar, a glass of which he now holds in his hands while he is entertaining his young landlord with the longest story he is ever supposed to tell, having fairly tired out every other frequenter of the establishment.[12]

A barfly, a traveller, and a tavern keeper were only three of Mount's numerous types. In essence, what he and our other artists did was to move across the continent and catalogue types that made up distinctive elements of the population, thus building a genre vocabulary. The most vivid example in this exhibition of how many types could be placed in one painting is Horace Bonham's *Nearing the Issue at the Cockpit* (Cat. No. 17), but nearly every work shows an American type in an American scene. Look, for example, at how the *Missouri Republican* praised this type in one of Bingham's paintings in 1847:

. . . he has taken the simplest, most frequent and common occurrences on our rivers—such as every boatman will encounter in a season—such as would seem, even to the casual and careless observer, of

very ordinary moment, but which are precisely those in which the full and undisguised character of the boatman is displayed.[13]

There were types for Indians, as in Seth Eastman's *Lacrosse Playing Among the Sioux Indians* (1851), and for pioneer settlers traveling west as painted by Benjamin F. Reinhart in 1867. The black appeared repeatedly in genre art, even in the limited sampling of our exhibition, with numerous types ranging from Johnston's slaves to David Norslup's *Negro Boys on the Quayside* (c. 1868) and Richard N. Brooke's black family in *A Pastoral Visit, Virginia* (1881). There are types for introspective women by masters like Eastman Johnson, Winslow Homer, and Enoch W. Perry, immigrants by Charles Ulrich, and street people captured by John George Brown (Fig. 25).

Brown, for example, has often been given credit for being "one of the first to direct public attention to the artistic possibilities of lowlife and *genre* in America," as a writer for the *Magazine of Art* wrote in 1882.[14] While this statement ignores the accomplishments of the generations preceding the Civil War, it does reflect the enormous popularity that Brown enjoyed during the 1870s and 1880s. To his contemporaries, however, he was most important because he understood the use of types in defining American life. As critic and historian S. G. W. Benjamin wrote in 1882:

The immigration from Europe had now been going on for so many years that it had begun to modify the types of human nature in the streets, while the increasing number of poor foreigners accustomed to out-of-doors occupations introduced new effects. Street vendors and booths, groups of strolling musicians, and other characters common to European cities, also began to show themselves in the cities of America, and nowhere more than in New York, modified in its turn by the condition of things in the United States. Mr. Brown was quick to perceive the artistic possibilities of these effects, and to reap profit from his observations.

His art struck Americans as being distinctly and emphatically native to the soil; "wholly American in subject and treatment."[15]

While some modern scholarship has been published on the meaning of types for blacks, Indians, ethnics, and women in American paintings and prints, the depth and breadth of the subject is virtually unstudied. The comments of nineteenth-century critics suggest the richness of the material. *The Art Journal* of 1876, for example, analyzed Thomas W. Wood's watercolor *American Citizens* by its ethnic composition:

There are four nationalities represented, namely: The negro with his swelling eyelids and laughing countenance, the paper ballot grasped in his fingers, exhibiting the emotions of a child with his first toy; the Dutchman, with his face and form square-built, indicating resolution; the Irishman, his facial lines short, and nose turned up, indicating mirth and good humor; and the Yankee, with a face full of craft, which is implied by the sharp nose and thin eyelids.[16]

If and when the research on types is carried out, I feel certain that the American practices will show an artistic attitude which is significantly different from the classical. Traditionally, a type was a fixed concept; its value lay in the fact that it represented some fundamental quality or trait. It was ordained by time. The American types, on the other hand, seemed to change with the seasons; they were the product of a short-lived social environment. As work styles, social attitudes, and the composition of the population changed, so did the figure types that embodied these elements. Given the mobility and rate of progress in America, chances were good that a type, easily understood in 1850, would be a mysterious anachronism in 1900.

I would also argue that this rapid rate of change in American history has helped to give genre painting its longevity and popularity. There always seemed to be new subjects appearing and thus new types in need of being re-

Fig. 25. John George Brown (1851–1913), The Bootblack, *etching, 25 x 18½ in. (63.4 x 46.8 cm). Courtesy Prints and Photographs Division, Library of Congress.*

corded. Genre kept pace with social growth, and artists found themselves in a vital atmosphere of challenge, trying to express the sentiment that animated men of their generation. Their mission, as defined by the *Atlantic Monthly* of 1860, was to "illustrate the character of the age."[17]

The real novelty and experimentation in nineteenth-century genre art was the search for figure types which were both typical of and unique to American culture. Some observers insisted that the nation was not old enough to have evolved true American forms or personalities. The *Cosmopolitan Art Journal* (1860), for example, claimed that

Genre painters, in this country, are an impossibility; if we consider exposition of stereotyped local life and manners as necessary material for this class of artists. As a people the Americans have not lived long enough in one spot to gain strongly local as well as national peculiarities. We are made up of everybody from everywhere. We stay nowhere, and live just as the caprice dictates. We change everything, from our hats to our houses, as often as twice a year; and the artist in pursuit of American 'cottage life'—American 'low life' or 'high life'—American 'boatmen' or 'fishermen'—American dogs, cats, mothers and babes—would have to break his rest-stick in despair.

Nevertheless, they did see

. . . a certain class of subjects which are peculiar to American cities and shores— news-boys, street-sweepers, wood-sawyers, immigrants, dock-loafers, strolling organ-men, Yankee peddlers, butcher-boys, negroes, Irish laborers, German lager-beer guzzlers, etc., etc., whose appreciation of humor and emotional expression is keen and ready.[18]

Graphic art pioneers genre

The genre tradition gained both strength and depth from the graphic arts. Beginning with colonial almanacs, a few newspapers, magazines, and early books, a host of simple (and often crude) depictions of domestic scenes,

people at work, and unusual village occurrences (e.g., the arrival of a dwarf) made their way into tens of thousands of colonial homes. Printed from type metal or wood, these "cuts" made up a large portion of our earliest visual vocabulary. They had little competition beyond printed currency, official seals, and tradesmen's signs, because the traditional repositories of "public" pictures in Europe, namely churches and government buildings, were purposely barren and plain in America.

The images in almanacs and magazines were used year after year until the blocks wore down or split apart. Thus, while the crude vignette did not always represent a specific time and place, it did give visual form and acceptance to common activities: a man plowing a field, people sitting by a fire and reading, field hands taking in a harvest, or a joyful group dancing to the music of a single instrument (Figs. 26, 27). By the start of the nineteenth century, these images of everyday life were the only kind of visual art that most people saw. It soon became true that artists who painted genre scenes were more likely to find both patrons and a paying audience than were historical painters or even the now more famous landscapists.

If the graphic arts of the eighteenth century served as a foundation for popular taste, the printed images of the nineteenth century built a structure

which at times threatened to dominate the fine arts entirely. Two new print media, wood engraving and lithography, were introduced to Americans at the start of the nineteenth century. The former made it possible to print fine-line images simultaneously with type, and the latter made tonal (and eventually color) pictures available by the millions. Each offered high-quality art, in large quantities, at low prices. Both media were used commercially for many purposes, but genre scenes were a specialty from the start, and the American public never tired of them. Whether in the form of wood engravings in early-nineteenth-century books and magazines, inexpensive single-sheet lithographs, gift books, music covers, or pictorial news journals, by the third quarter of the nineteenth century genre was a staple of the American artistic diet, and one could argue that it has never really declined in popularity since then. As late as 1901, Sadakichi Hartmann wrote in his *History of American Art:* "Even the best of the picture-loving public still prefer story-telling to any other style in painting. . . . They can understand it."[19] The commercial success of *Life* and *Look* in the twentieth century, as well as the continuing appeal of magazine covers like Norman Rockwell's, cartoons, comic strips, motion picture films, and television programs, expresses in our own day the American passion for

everyday life as an art and entertainment form.

This emphasis on genre in the graphic arts has been overlooked by those who see the printed image as always lagging behind painting. Even William Dunlap, our first historian of American art, defined the traditional line of progress: "architecture is first in order, sculpture second, painting third, and engraving follows to perpetuate by diffusing the forms invented by her sisters."[20] In the broad field of genre art in the nineteenth century, graphic art, to the contrary, led the way and remains a constant force which no painter can ignore. It is therefore no coincidence that many of America's genre painters were either trained as apprentices in graphic art shops or employed by printmakers and printers to supply images. Successful artists like Henry Inman, Eastman Johnson, and Winslow Homer spent part of their careers either drawing on stone or cutting the block, and nearly all of their contemporaries had genre pictures reproduced as illustrations or separate prints.

The linkage of wood engravers and lithographers to genre painters is important for two reasons. First, as businessmen, the printmakers had to keep their fingers on the popular pulse. They purchased paintings that would sell, and thus they influenced to some degree the kind of genre art that was produced. Second, wood engraving and lithography were the technical means for popularizing genre art. Too often genre painting has been proclaimed "art for the people," as if the public would somehow have more access to the original of Alfred Jacob Miller's *Election Scene, Catonsville, Baltimore County* (Cat. No. 8) than to one of Gilbert Stuart's portraits of George Washington.[21] The rhetoric of the artists themselves has contributed to this misconception. Mount's phrase "paint for the many, not the few" has a democratic ring, as does Bingham's goal to paint "our social and political characteristics."[22] Without some means to distribute their images, however, neither of these artists could have reached the audience they claimed

Fig. 26. Alexander Anderson (1775–1870), Calendar of Nature, *1815, wood engraving, 5⅞ x 3½ in. (14.8 x 8.8 cm). Courtesy Department of Rare Books and Special Collections, Princeton University Firestone Library.*

FOURTH-MONTH, (APRIL.)

Fig. 27. Tea-Table Dialogues, 1789, wood engraving, 4¾ x 3 in. (12.2 x 7.7 cm). Courtesy Department of Rare Books and Special Collections, Princeton University Firestone Library.

to be addressing. Mount, for example, had ten of his oil paintings lithographed in a business arrangement with New York dealer William Schaus, and Bingham's *The County Election* (Cat. No. 5) and *The Verdict of the People* were engraved to reach a popular market.

Both artists participated in the American Art-Union (1839–1852), an organization which distributed steel engravings and orginal paintings by living American artists. According to Maybelle Mann's account of the Art-Union, it was Alfred Jones' engraving of Mount's *Farmers Nooning* in 1843 (Fig. 28) which gave the organization a clear bias for American subject matter and nationalistic themes. In subsequent years works by other genre painters were reproduced, including two by Francis William Edmonds, three by Woodville, and one by Bingham. While some artists eventually split with the Art-Union, there is little doubt that it did spur a popular interest in genre. As the corresponding secretary wrote to Bingham in the mid-1840s, the Art-Union favored pictures "taken from the everyday scenes of life."[23] At its peak in 1849, the Art-Union counted nearly 19,000 members; for 5 dollars, each member was entitled to several engravings as well as a chance to win one of the 460 original works being offered.

The Art-Union was only one of innumerable channels for the distribution of genre images. By the second half of the nineteenth century, the advertising industry began to display its products and services against the backdrop of everyday life; today, the genre ad is a staple of the trade. Print dealers distributed genre images via salesmen, bookstores, premium systems, and mail orders. Magazines and newspapers added more and more American-life scenes until pictures dominated text in the battle for the reader's attention.

The Twentieth Century

The twentieth century challenged three aspects of conventional genre. First, it encouraged artists to paint city rather than country life and to re-evaluate the

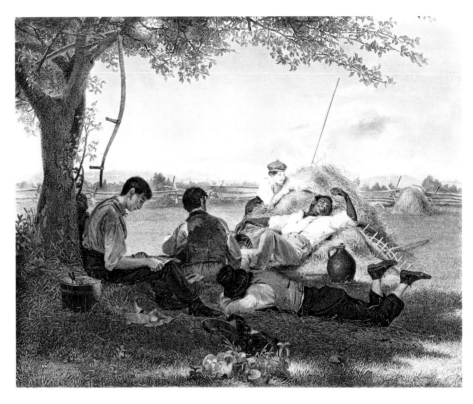

older, rural ideals. Second, it insisted that a genre picture did not have to "tell a story" or rely on conventional types, for the primary concern of the artist was to convey his own personal vision. Third, it sanctioned new art forms ranging from abstract images to sketch-like compositions, and thus threatened the older tradition of precise and correct drawing.

Everyday life has become a dominant subject of modern art. The "schools" and "movements" and "groups" seem endless in number: Philadelphia Realism (late 1890s), New York Realism (1900–1920), the Ash Can School (1905–1920), The Eight (1904–1910), the Fourteenth Street School (1900–1925), Social Realism (1920s), American Scene painting (1930s), Regionalism (1930s), Pop Art (1960s), and photographic realism (1960–1980) are just a few of the better-known genre expressions. Some of the artists that made up these fluid groups included Robert Henri, John Sloan, George Luks, Everett Shinn, Jerome Myers, George Bellows, Arthur

Fig. 28. William Sidney Mount (1807–1868), Farmers Nooning, *engraving by Alfred Jones, 1843. Courtesy Prints and Photographs Division, Library of Congress.*

B. Davies, William Glackens, Ernest Lawson, and Maurice Prendergast. They focused on one of the oldest traditions in American art: the belief that the artist is a public man, a moral leader, and teacher imbued with a social consciousness.

At the beginning of the twentieth century, this attitude was articulated most clearly by Robert Henri, who argued that American art had gone off course in the final quarter of the nineteenth century, mistaking either French styles or intensely sentimental renderings of rural and domestic views as relevant to modern life. He advocated, instead, a vigorous, personal portrayal of everyday scenes, even those which refined tastes considered "vulgar."

The rise of the city

Just as the work of William Sidney Mount appeared to embody the rural spirit of Jacksonianism, so the realists of the twentieth century symbolized the urban progressivism of Theodore Roosevelt. Instead of farmers and river boatmen, they looked to the energy of the city, seeking the human spirit of the industrial centers. This countered the popular notion that the modern city was not a fit subject for the artist; nineteenth-century genre painting had ruled it out almost by definition. It is difficult to say exactly when this attitude began to change, but a combination of forces broadened the concept of genre. Journalists led the way, and by 1860 the *Atlantic Monthly* had published a special message to artists that beamed with Whitmanesque enthusiasm:

New York is, perhaps, more of a representative city than any other in the land. It is an aggregation from all other portions of the country; it is the result, the precipitate of the whole. . . New York is artistic just as America is artistic, just as the age is artistic: not, perhaps, in the loftiest or most refined sense, but in the sense that art is an expression, in tangible form, of ideas. New York is a great thought uttered. It is like those fruits or seeds which germinate by

turning themselves inside out; the soul in on the outside, crusted all over it, but none the less soul for all that.[24]

While painters were slow to see New York as a "great thought uttered," graphic artists working for newspapers and magazines had been showing nearly everything of interest in city life long before the start of the Civil War. Immigrant scenes in the port of New York, raging fires, traffic jams, moving days, the exodus for summer vacations, financial panics, and political campaign rallies were but a few of the newsworthy picture stories appearing in *Frank Leslie's Illustrated Newspaper* and *Harper's Weekly* at mid-century. During the 1860s and 1870s, Winslow Homer, of course, actually served as an artist-reporter for *Harper's Weekly*. He and hundreds of others, including photographers like Mathew B. Brady, recorded thousands of scenes from life in the never-ending job of feeding the public's insatiable appetite for illustrated news. This was big business, highly competitive, and forever under an impossible deadline.

This aggressive spirit of American journalism was adopted by the urban-oriented genre artists of the twentieth century. George Luks, William J. Glackens, Everett Shinn, and John Sloan, who had worked as illustrators for Philadelphia newspapers and for a variety of magazines, carried the popular, journalistic traditions into the world of painting. Located in New York and Philadelphia, strongly encouraged by the artist-teacher Robert Henri, they and their followers made urban scenes an integral part of American genre. Although they spoke of the poor as being "nearer the realities of life and so more appropriate subject for art," the first generation of twentieth-century genre artists did not focus on poverty. Later artists did. Philip Evergood, who during the 1930s called himself a "social painter," explained an incident that affected his sensibilities:

I think one of the things I saw that probably drove me faster into this way of thinking was on a cold winter night when

I went out for a walk down Christopher Street towards the North River. It was about ten o'clock. I passed the post office and government building at the end of the street and came to a big empty lot with about fifty little shacks on it, all made out of old tin cans, crates, orange boxes, matresses for roofs. . . . Snow was on the ground, a fire was lit, and a group of Negroes and white men were huddled around the fire. These were the outcasts of New York, the outcasts of civilization. . . . I went over to the fire and talked to them. . . . They were interesting people, but their tragedy hit me between the eyes because I had never been as close to anything like that before. Then I got a brain wave. It seemed to me that I should be involved in my work with this kind of thing. So I . . . got some drawing materials and came back and sat with them and drew all night. . . .[25]

There are similar stories from Edward Hopper, Rockwell Kent, Raphael Soyer, and others who guided the tradition of genre in the twentieth century.

The individual eye

While artists began recording city life with the enthusiasm of good journalists, a firm distinction between painter and reporter was developing. Early in the twentieth century it became the artist's moral obligation to capture life *as he saw it*. This was a departure from the nineteenth century, when artists emerged from the tradition of the grand style and focused on figure types as a way of defining the American quality of a scene. They had sought to freeze, or objectify, those moments of everyday life that were both typical and unique. Henri and those artists who considered themselves his followers were a different breed.

Instead of highlighting the uniqueness of the subject, they stressed the individuality of the artist. Abandoning the solidity and totality of Mount as well as the detailed precision of Brown, artists such as Bellows, Luks, Glackens, Shinn, and Sloan wanted to swiftly record their scenes (often from memory) in a manner which gave the feeling of directness

and ease. Their ideal was to capture an immediate effect, in Henri's words, "Rather paint the flying spirit of the bird than its feathers." The result was a highly personal style of genre that included the mood and feeling of the artist. Henri taught: "What you must express in your drawing is not what model you had . . . but . . . your sensations, and you select from what is visual of the model the traits that best express you."[26]

The didactic or narrative element in art had been one area of agreement between classical historical painters and the artists of nineteenth-century genre. Now, even that was being thrust aside by an influential sector of the fine art community. Many artists of the twentieth century favored this impressionistic genre and agreed with artist George O. ("Pop") Hart, who stated flatly, "Stories are not in my line."[27]

The figurative tradition

During the 1820–1900 period, genre had enjoyed the expression of numerous styles and influences, including the solid draftsmanship of neoclassicism, the warmth and introspection of romanticism, the timeliness of journalism, and the experimental probes of impressionism. Through each "ism" the human figure remained recognizable and the stories comprehensible. The new century would change that eighty-year tradition.

Beginning with Henri and his followers, genre pictures began to lose their objective specificity as rapid sketches drawn with thick crayons, soft pencils, and brushes became the basis for finished paintings. With Cubism, Surrealism, and Abstract Expressionism, the traditional human figure was often obliterated, and paintings with simple titles like Max Weber's *The Visit (A Family Reunion)* (1917) (Fig. 29) became visual mysteries to those who had found a quiet comfort in Mount or his successors. This change was the reverse of what had occurred in the 1800s when a new subject, everyday life, had invaded the calm, balanced style of the neoclas-

sical. In the early nineteenth century a new subject altered a style; in the twentieth century a new style altered the subject. Now the everyday anecdotes were rendered in abstract terms that were so new and different that genre as a figurative art appeared threatened.

The boundaries of genre have always been vague. At what point does a family picnic become a landscape with figures? When is a "woman sewing" considered a genre picture as opposed to a portrait? Where does history painting end and genre begin? Is Charles Demuth's *In Vaudeville: Bicycle Rider* (Cat. No. 37) too abstract to be a genre image? There are no single answers beyond the unsatisfactory rule that the sense of the picture should dictate the classification. But the questions of genre are not just academic fluff. When we ask "What kind of picture is it?" we are expressing a desire to know the artist's intention, and while sophisticated observers might dismiss such a simple question, genre artists themselves puzzled over the answers. This is because the value and meaning of a work of art are not simply in its subject but also in its form. In 1934 the observation was made: "For if it is true that contemporary life is the artist's environment, it is also true that the great tradition of art is his inheritance. He neglects either at his peril."[28]

The older members of the various realist schools agreed with this view. Some began their artistic training in the traditional way, but they were soon caught up in the newer trends that came first out of Munich and then Paris. There the static scene was giving way to a more fluid image wrapped in atmosphere and light, and objective renderings of people and things became secondary as artists pursued other goals within the broad genre field. Shinn looked to Degas; Glackens to Manet and Renoir; Prendergast to Cézanne and Seurat. The spirit of their pictures aimed to have a dominant impression rather than a clear delineation of the individual parts. Their challenge, of course, was to absorb these French techniques and render a true American image. Discussing Henri, Luks, and

Fig. 29. Max Weber (1881–1961), The Visit (A Family Reunion), *1917, oil on board, 36¼ x 30 in. (92.1 x 76.2 cm). Corcoran Gallery of Art, museum purchase through a gift of Mrs. Francis Biddle.*

Glackens, the artist Edward Hopper noted in 1927:

Out of the horde of camp-followers, imitators and publicity-seekers who attach themselves to all movements in art . . . are emerging certain artists of originality and intelligence who are no longer content to be citizens of the world of art, but believe that now or in the near future American art should be weaned from its French mother. These men in their work are giving concrete expression to their belief. The "tang of the soil" is becoming evident more and more in their painting.[29]

"Tang of the soil" may seem an odd phrase for urban genre, but it does convey the new emphasis on a total scene and the artist's reaction to it, as opposed to individual subjects within the scene itself.

The realist painters stated that their objective was to record the modern world. They represented a spectrum of

modern artists, who stayed with genre while other artists, experimenting with Cubism, Surrealism, and Abstract Expressionism, probed new zones of visual experience. The genre painters' affirmation of contemporary life had a steadying influence on the art world: they were daring enough to stimulate curiosity but respected the traditions of the nineteenth century. What did the realists think of the new abstract forms? Some of the artists in our exhibition noted the following:

John Sloan: *"Work which is purely non-representative loses some of the texture of life. Students cannot have too much training in Cubism but there has to be an interest in life before the work takes on a healthy creative vigor."*[30]

William Glackens: *"a great deal of this so-called modern art is pure materialism, the pouring out through symbols of a half-baked psychology, a suppressed adolescence."*[31]

Joseph Hirsch: *"whether the social climate of their times was calm or turbulent the real men of art have invariably been keenly aware of the world about them. So it strikes me that a reaffirmation by today's sincere artist of his faith in the common ordinary man will be as natural as was, for example, the emphasis by El Greco, in his day, on the faith in the church."*[32]

Philip Evergood: against Surrealism because of its *"representation of the living world as decay."*[33]

Reginald Marsh: *"The havoc caused by the tremendous influence of impressionism and expressionism must be overcome before America can go on and paint the substance, not the light and shadow. The struggle to free art from superficial impressionistic style of fantastic nonsense is probably harder now than in the old days when art was strong, simple, and real."*[34]

The Elusive and Changing Quality of Genre Art

Genre art did not flow directly from an American school or a well-rooted European academy; it has never really had a formal aesthetic tradition. It seems to have always been in the air, so to speak, owing a combined debt to history painting, graphic art, theater, journalism, oral tradition, and literature. Taking many forms, genre has never gone out of style; yet it has never been the height of style. One of the reasons for this is the persistence of two notions among artists and critics: each generation believes either that there is no tradition of art from everyday life in America or that the previous generations were hopelessly romantic, uncritical, and totally out of touch with reality.

A psychological imperative often compels the current generation to see the work of the past as insignificant. It has always been this way. For example, critics of the 1850s praised the originality of Mount and Bingham as if the work of Nathaniel Currier and other graphic artists had never been printed. And in turn, a generation later, writers in *The Art Journal* would celebrate Enoch Wood Perry as "one of the first . . . to paint American subjects,"[35] ignoring the massive contributions of his predecessors Mount and Bingham. In 1882 S. G. W. Benjamin simply brushed away the "efforts of such men as Mount, Catlin, and Ranney" because, in his words, they "were almost entirely sporadic, producing little influence on the national art. But the abundance of material entirely fresh and sufficiently pictorial which the country offers—whether it be Indian, Mexican, or vendors—is beginning to attract attention."[36]

Twenty-three years later, Samuel Isham could not even find genre artists in America, even though men like Eakins and Homer were still very much alive. "No one," he wrote, "has painted the political or financial or social habits of today."[37] The protests of Henri, Luks, Glackens, Sloan, Shinn, and Bellows against nineteenth-century romanticism are well known; yet the generation of the 1930s and 1940s would view the works of these self-styled "realists" as overly sentimental. As early as 1914, a writer for *Art and Decoration* observed that Bellows must have painted *Forty-two Kids* (Cat. No. 30) "with a bit of moisture in his eye."[38]

Much of this criticism revolved about the issue of "realism." For Henri and his fellow artists, what was real was the "flying spirit" of a bird rather than the exact details of its feathers. J. B. Brown had earlier emphasized the importance of observation while acknowledging the personal presence of the "good reporter." Historian Frank Jewett Mather analyzed this question when he noted: the "trouble with the word realism is that it must always be followed by the question Whose? And then the word begins to split up."[39]

Change is the dominating force in the American scene. The second half of the nineteenth century is a clear example. In 1860, 20 percent of Americans lived in cities; by 1915, it was 50 percent. During that period the rural population doubled in number, while urban residents increased 700 percent. This shift and growth in population, which also included 25 million immigrants, meant that a new kind of America had arrived. The rural nation depicted by earlier genre artists—all those hard-working, innocent Americans, independent and individualistic, humorous and sentimental, patriotic and proud—began to represent a collective soul at odds with modern life. Is it any wonder that the values and vision of the previous century no longer seemed real, and that the genre paintings of 1830–1900 struck too many artists and critics as romantic fabrications of scenes that never were? Each new generation refuses to march to the rhythm of life as played by earlier artists, so genre has continually had to seek new definitions.

Notes

1. *The American Heritage Dictionary of the English Language* (Boston: Houghton Mifflin, 1976), p. 550. Donald Keyes, "Aspects of the Development of Genre Painting in the Hudson River Area Before 1852," doctoral dissertation, New York University, 1973, pp. 26–28. Frederick W. Fairholt, *Homes, Haunts and Works of Rubens . . . Raffaelle* (London: Virtue and Co., 1871), pp. 167–207. Wolfgang Stechow and Christopher Comer, "The History of the Term *Genre*," *Allen Memorial Art Museum Bulletin,* 33, No. 2 (1975–1976): 89–94.

2. James Jackson Jarves, *The Art-Idea* (New York: Hurd and Houghton, 1864), pp. 220–221.

3. Daniel J. Boorstin, *The Americans: The National Experience* (New York: Vintage Books, 1965), pp. 275–324. Joshua C. Taylor, *America As Art* (Washington, D.C.: Smithsonian Institution Press, 1976), pp. 38–94.

4. Jarves, *The Art-Idea,* p. 155.

5. William Dunlap, *A History of the Rise and Progress of the Arts of Design in the United States* (New York: George P. Scott, 1834), Vol. I, p. 63. Italics have been added to the West quotation.

6. Sir Joshua Reynolds, *Discourses on Art* (New Haven: Yale University Press, 1975), p. 73.

7. John Trumbull, *Autobiography* (New Haven: Yale University Press, 1953), p. 171. The first portrait is at Yale University, the second is in the City Hall of Charleston.

8. Dunlap, *History,* Vol. I, p. 10.

9. Peter C. Marzio, *The Art Crusade* (Washington, D.C.: Smithsonian Institution, 1976), p. 50.

10. John F. Weir, "American Art: Its Progress and Prospects," *Princeton Review* (May 1878). See George W. Sheldon, *American Painters* (New York: Appleton, 1881), pp. 175 and 176.

11. Charles W. Larned, "The Spirit of Art," *Studio,* 1883.

12. Alfred Frankenstein, *William Sidney Mount* (New York: Harry N. Abrams, 1975), pp. 75–76.

13. *Missouri Republican* quoted in John Francis McDermott, *George Caleb Bingham* (Norman: University of Oklahoma Press, 1959), p. 62.

14. S. W. G. Benjamin, "A Painter of the Streets," *Magazine of Art* (May 1882): 269.

15. *Ibid.,* pp. 266 and 267.

16. "American Painters—Thomas W. Wood, N.A.," *The Art Journal,* New York (April 1876): 115.

17. "The Representative Art," *Atlantic Monthly* (June 1860): 690.

18. "Charles Blauvelt," *Cosmopolitan Art Journal* (December 1860): 166.

19. Sadakichi Hartmann, *A History of American Art* (Boston: L. C. Page, 1901), Vol. I, p. 157.

20. Dunlap, *History,* Vol. I, p. 11.

21. Oliver W. Larkin, *Art and Life in America* (New York: Holt, Rinehart and Winston, 1960), pp. 214–223.

22. Hermann Warner Williams, Jr., *Mirror to the American Past* (Greenwich, Conn.: New York Graphic Society, 1973), pp. 68 and 87.

23. Maybelle Mann, *The American Art-Union* (printed privately, 1977), pp. 6 and 22–25.

24. "The Representative Art," *Atlantic Monthly* (June 1860): 690.

25. John I. H. Baur, *Philip Evergood* (New York: Praeger, 1960), pp. 47–48.

26. See Robert Henri, *The Art Spirit* (Philadelphia: Lippincott, 1923).

27. Holger Cahill, ed., *George O. "Pop" Hart* (New York: Downtown Gallery, 1928), p. 1.

28. Holger Cahill and Alfred H. Barr, Jr., *Art in America in Modern Times* (New York: Reynal and Hitchcock, 1934), p. 44.

29. Edward Hopper, "John Sloan and the Philadelphians," *The Arts* (April 1927): 177.

30. Lloyd Goodrich, *John Sloan: 1871–1951* (New York: Whitney Museum of American Art, 1952), p. 49.

31. Quoted in Charles Hirschfeld, " 'Ash Can' versus 'Modern' Art in America," *Western Humanities Review* (Autumn 1956): 363–364.

32. *Americans: Six Group Exhibitions 1942–1963* (New York: Arno Press, 1972), p. 60.

33. "Social Surrealism," *New Masses* (February 13, 1945): 22.

34. Peyton Boswell, Jr., *Modern American Painting* (New York: Dodd, Mead, 1939) contains the reactions of numerous artists to "modern art."

35. "American Painters—E. Wood Perry," *The Art Journal,* New York (1875): 216.

36. S. G. W. Benjamin, "A Painter of the Streets," *Magazine of Art* (May 1882): 268.

37. Samuel Isham, *The History of American Painting* (New York: Macmillan, 1905 and 1936), p. 499.

38. Charles C. Buchanan, "George Bellows: Painter of Democracy," *Arts and Decoration* (August 1914): 371.

39. Frank Jewitt Mather, Jr., "Some American Realists," *Arts and Decoration* (November 1916): 13.

The support of the Charles Urick and Josephine Bay Foundation is gratefully acknowledged. I would like to thank Elizabeth Ellis and Gerrit Craig Cone for assisting with the research for this essay.

Selected Bibliography

Adams, Karen M. *Black Images in Nineteenth-Century American Painting and Literature: An Iconological Study of Mount, Melville, Homer and Mark Twain.* Atlanta: Emory University, Graduate Institute of the Liberal Arts, 1977.

Alper, M. Victor. "American Mythologies in Painting, Part 2: City Life and Social Idealism," *Arts* (December 1971): 31-34.

Baigell, Matthew. *The American Scene: American Painting of the 1930s.* New York: Praeger, 1974.

Baur, John. *The Eight.* New York: The Brooklyn Museum, 1943.

_____. *Revolution and Tradition in Modern American Art.* Cambridge, Mass.: Harvard University Press, 1951.

Benjamin, Samuel Greene Wheeler. *Art in America: A Critical and Historical Sketch.* New York: Harper and Brothers, 1880.

Berkhofer, Robert F. *The White Man's Indian: Images of the American Indian from Columbus to the Present.* New York: Alfred A. Knopf, 1978.

Brooklyn Institute of Arts and Sciences. *The American Renaissance 1876-1917.* Brooklyn: The Brooklyn Museum, 1979.

Brown, Milton. *American Painting from the Armory Show to the Depression.* Princeton: Princeton University Press, 1955.

Brown, Sterling. *The American Negro: His History and Literature.* New York: Arno Press, 1969.

Cahill, Holger and Alfred Barr. *Art in America, A Complete Survey.* New York: Reynal and Hitchcock, [c. 1935].

_____. *Art in America in Modern Times.* New York: Reynal and Hitchcock, 1934.

Clement, Clara and Lawrence Hutton. *Artists of the Nineteenth Century and Their Work.* Boston: Houghton Mifflin Company, 1894.

Cortissoz, Royal. *Art and Common Sense.* New York: C. Scribner's Sons, 1913.

_____. *American Artists.* New York: C. Scribner's Sons, 1923.

Craven, Thomas, ed. *A Treasury of American Prints; a Selection of One Hundred Etchings and Lithographs by the Foremost Living American Artists.* New York: Simon and Schuster, [1939].

Davidson, Marshall. *Life in America.* Boston: Houghton Mifflin, 1951.

Dunlap, William. *A History of the Rise and Progress of the Arts of Design in the United States.* Two volumes. New York: George P. Scott and Company, 1834.

Earnest, Ernest Penney. *The American Eve in Fact and Fiction, 1775-1914.* Urbana: University of Illinois Press, 1974.

Fine, David M. *The City, the Immigrant and American Fiction: 1880-1920.* Metuchen, N.J.: The Scarecrow Press, 1977.

Frederickson, George M. *The Black Image in the White Mind: The Debate on Afro American Character and Destiny: 1817-1914.* New York: Harper Torchbooks, 1971.

Gerdts, William H. *American Impressionism.* Seattle: Henry Art Gallery, University of Washington, 1980.

_____. "Figure Painting in the United States," *From All Walks of Life: Paintings of the Figure from the National Academy of Design.* Circulated by the Smithsonian Institution Traveling Exhibition Service, 1979.

Glanz, Dawn. *The Iconography of Westward Expansion in American Art, 1820-1870: Selected Topics.* Ph.D. dissertation, University of North Carolina at Chapel Hill, 1978.

Goetzman, William H. *The Mountain Man.* Cody, Wyo.: Buffalo Bill Historical Center, 1978.

Goodrich, Lloyd and John Baur. *American Art of Our Century.* New York: Praeger, 1961.

Groce, George and David Wallace. *Dictionary of Artists in America.* New York Historical Society. New Haven: Yale University Press, 1957.

Hartmann, Sadakichi. *A History of American Art.* Revised edition. Two volumes, Boston: L. C. Page, 1902.

Heller, Nancy and Williams, Julia. *The Regionalists.* New York: Watson-Guptill Publications, 1976.

Hills, Patricia. *The Painters' America: Rural and Urban Life, 1810-1910.* New York:

Praeger; in association with the Whitney Museum of Art, [1974].

_____. *Turn-of-the-Century America: Paintings, Graphics, Photographs, 1890-1910.* New York: Whitney Museum of American Art, 1977.

_____. "The Working American," *The Working American.* An exhibition organized by District 1199, National Union of Hospital and Health Care Employees and the Smithsonian Institution Traveling Exhibition Service, 1979.

_____ and Roberta Tarbell. *The Figurative Tradition and the Whitney Museum of Art.* New York: Whitney Museum of American Art, 1980; in association with Newark: University of Delaware Press, and London and Toronto: Associated University Press.

Homer, William Inness. *Robert Henri and His Circle.* Ithaca: Cornell University Press, 1969.

Hoopes, Donelson F. *The American Impressionists.* New York: Watson-Guptill Publications, 1972.

_____. *American Narrative Painting,* catalogue notes by Nancy Dustin Wall Moure. Los Angeles: Los Angeles County Museum in association with Praeger, 1974.

Isham, Samuel. *The History of American Painting,* New York: Macmillan Company, 1905.

Jarves, James Jackson. *The Art-Idea: Sculpture, Painting and Architecture in America.* New York: Hurd and Houghton, 1864.

Larkin, Oliver W. *Art and Life in America.* New York: Rinehart and Company, Inc. 1949.

Lucie-Smith, Edward and Celestine Dars. *Work and Struggle: The Painter as Witness 1870-1914.* New York: Paddington Press, 1977.

Marzio, Peter C. *The Democratic Art. Pictures for a Nineteenth-Century America.* Boston: David R. Godine, 1979.

Nochlin, Linda. *Realism.* Harmondsworth, England: Penguin, 1971.

Pennsylvania Academy of Fine Arts. *In This Academy: The Pennsylvania Academy of Fine Arts, 1805-1976.* Philadelphia: The Academy, 1976.

Peters, Harry T. *Currier and Ives: Printmakers to the American People.* Two volumes. Garden City, N.Y.: Doubleday, Doran and Company, 1929, 1931.

_____. *America on Stone.* Garden City, N.Y.: Doubleday, Doran and Company, 1931.

Quick, Michael. *American Expatriate Painters of the Late Nineteenth Century.* Dayton, Ohio: The Dayton Art Institute, 1976.

_____, Eberhard Ruhmer, and Richard V. West. *Munich and American Realism in the 19th Century.* Sacramento, Calif.: E. B. Crocker Art Gallery, 1978.

Richardson, Edgar P. *Painting in America: From 1502 to the Present.* New York: Thomas Y. Crowell Company, 1965.

Riis, Jacob. *How the Other Half Lives.* New York: C. Scribner's Sons, 1890.

Rugoff, Milton, ed. *The Britannica Encyclopedia of American Art.* Chicago: Encyclopedia Britannica Educational Corporation, 1973.

Schwartz, Barry. *The New Humanism: Art in a Time of Change.* New York: Praeger Publishers, Inc., 1974.

Shapiro, David. *Social Realism: Art as a Weapon.* New York: Frederick Ungar, 1973.

Sheldon, G.W. *American Painters.* New York: D. Appleton and Company, 1879.

_____. *Recent Ideals of American Art.* New York: D. Appleton and Company, 1888.

Szarkowski, John. *Mirrors and Windows: American Photography Since 1960.* New York: The Museum of Modern Art, 1978.

Taft, Robert. *Artists and Illustrators of the Old West, 1850-1900.* New York: C. Scribner's Sons, 1953.

Taylor, Joshua. *America as Art.* Washington, D.C.: Smithsonian Institution Press, 1976.

Troyen, Carol. *The Boston Tradition.* New York: The American Federation of Arts, 1980.

Tuckerman, Henry T. *Book of Artists: American Artist Life.* New York: G.P. Putnam and Sons, 1867.

Weisberg, Gabriel P. *The Realist Tradition: French Painting and Drawing 1830-1900.* Cleveland: The Cleveland Museum of Art in cooperation with Indiana University Press, 1980.

Weitenkampf, Frank. *American Graphic Art.* New York: Henry Holt and Company, 1912.

Williams, Hermann Warner. *Mirror to the American Past.* Greenwich, Ct.: New York Graphic Society, 1973.

Young, Mahonri Sharp. *The Eight.* New York: Watson-Guptill Publications, 1973.

Index

Dates are included for all artists listed. Names in boldface indicate those artists whose works are part of the exhibition, and page numbers in boldface indicate the main catalogue entry. A page number preceded by an asterisk indicates an illustration.